Munchkin · American Curl · Dwel
Shorthair · Ukrainian Levkoy · Chantill
Rex · Brazilian Sh usie · Tha
Siamese · German na · Hima
ules · American Polydactyl · Napoleon · B
on · Russian Black, White, and Tabby ·
y · Singapura · Turkish Van · Nebelung ·
Burmese · Persian · Donskoy · Pixie-Bob
sian Blue · Scottish Fold · York Chocolate
inese · Peterbald · British Longhair · An
Abyssinian · Korat · Dragon Li · Highl
Balinese · Ragdoll · Norwegian Forest ·
Serengeti · Chartreux · Manx · Cymric ·
l Shorthair · Birman · Aegean · Egyptian
panese Bobtail · Bambino · Khaomanee
American Shorthair · Exotic Shorthair
Rex · Oriental Longhair · Toyger · Minskin
Bobtail · Ocicat · American Bobtail · Corni
Bobtail · Snowshoe · California Spangled

Dragon Li · Highlander · Munchkin · A
rwegian Forest · British Shorthair · Ukrai
Manx · Cymric · Devon Rex · Brazilian Sh
egean · Egyptian Mau · Siamese · Germa
· Khaomanee · Ojos Azules · American Po
· Shorthair · Maine Coon · Russian Black
yger · Minskin · Bombay · Singapura · Tur
Bobtail · Cornish Rex · Burmese · Persian
lifornia Spangled · Russian Blue · Scottis
LaPerm · Somali · Tonkinese · Peterbald ·
· Alley Cat · Sphynx · Abyssinian · Kora
· Dwelf · Savannah · Balinese · Ragdoll
y · Chantilly-Tiffany · Serengeti · Chartre
hausie · Thai · Oriental Shorthair · Birm
avana · Himalayan · Japanese Bobtail ·
yl · Napoleon · Bengal · American Shorth
, and Tabby · Selkirk Rex · Oriental Long
· Nebelung · Mekong Bobtail · Ocicat ·
y · Pixie-Bob · Kurilian Bobtail · Snowsho

CATS

An Illustrated Miscellany

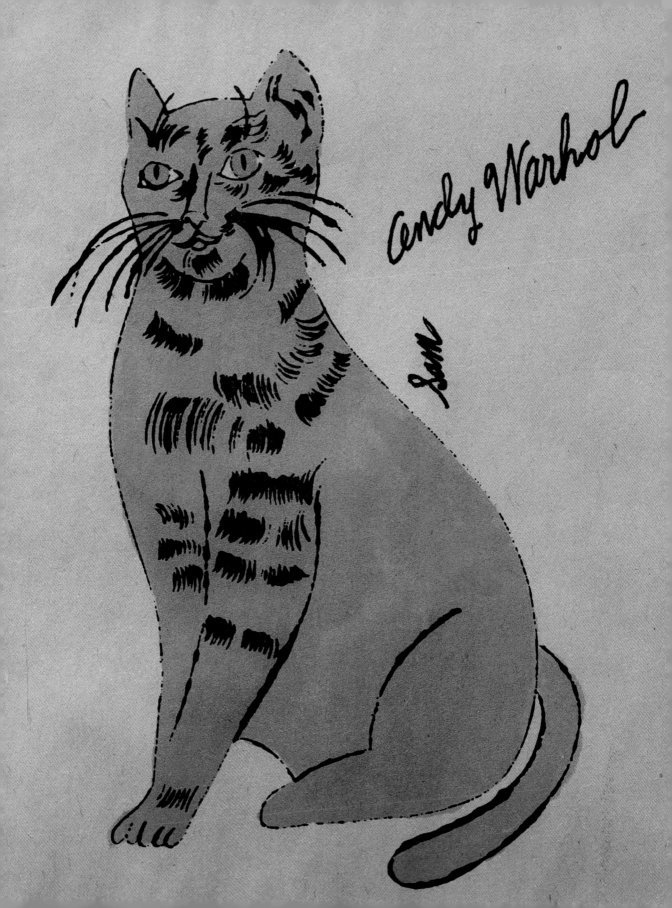

CATS

An Illustrated Miscellany

Frédéric Vitoux
of the Académie française

Series edited by
Jean-Claude Simoën and Ghislaine Bavoillot

Plon | Flammarion

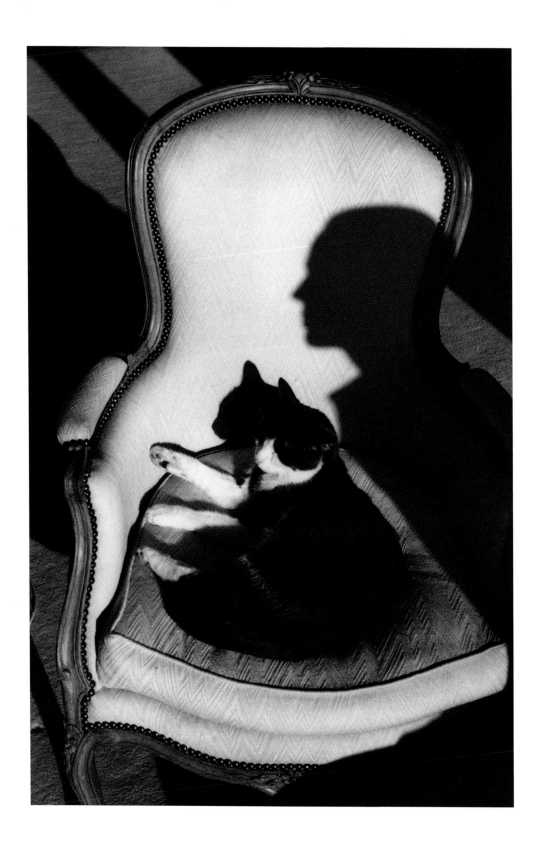

Contents

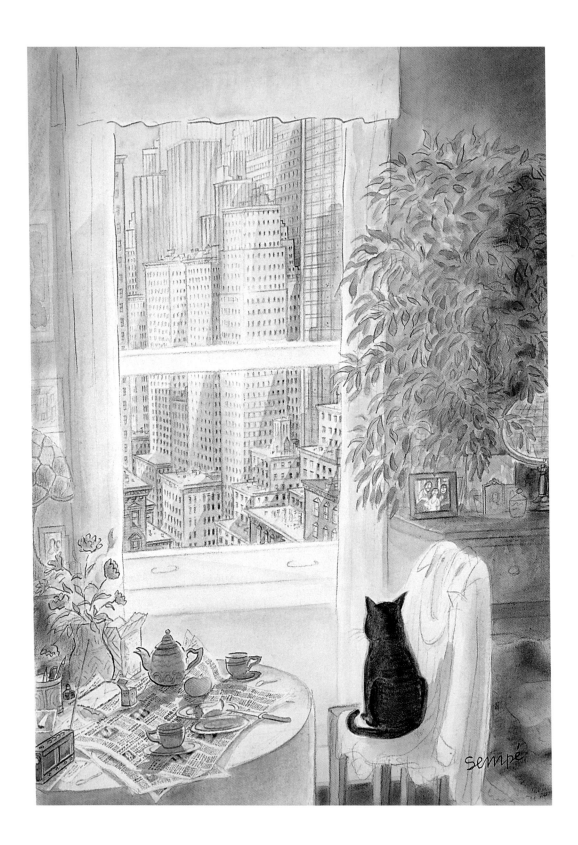

In Praise of Cats

A miscellany is not an encyclopedia. It does not aim to exhaust its subject. And the cat is an inexhaustible subject in any case. Who would dare embark on a complete study of its appearances in painting, music, literature, poetry, etc.? Who would claim to have fathomed its anatomical secrets and its psychic gifts; or to have unraveled its genealogy, to have understood the evolution of its relationship with humankind over the millennia, in every civilization and on every continent? Such an undertaking is destined to fail.

Am I a cat lover? Absolutely! I'm very proud to be one. And cat lovers are often partial, subjective, and therefore unfair or even excessive. I don't deny it.

If you keep this in mind, you'll understand why I haven't particularly expanded, in this book, on the various illnesses of cats (cystisis, panleukopenia, hyperthyroidism, and other afflictions) nor delved into feline hygiene guidelines (frequency of vaccinations, types of litter, necessity of flea collars, etc.). Had I embarked on an affectionate Miscellany of Man and Woman, would you have expected me to elaborate on their feet calluses, digestive troubles, or urinary infections?

On the other hand, in the starry-eyed thoughtlessness—if I may put it like that—of my adoration of cats, I have concentrated on those whose life I've had the honor of sharing, referring along the way to books I have enjoyed, books that have stuck in my memory and in which cats (as fully rounded characters) are essential to the narrative. Then there are writers with whom I identify because they were close to cats. Film lover that I am, I have recalled several movies in which cats play a starring or maverick role. And like an art lover in an imaginary collection, I have selected various works of art in which cats are given pride of place, or at least in which their appearance seems typical.

I have to acknowledge straight away that not all of the hundreds of breeds of cats recognized by the relevant authorities are featured in the present miscellany; this is because I prefer off-the-peg cats to the card-carrying pedigree variety.

More to the point, though, I generally had nothing very original, or, rather, nothing especially personal to say about the Rex, the Oriental Shorthair, the Burmese, the Turkish Angora, and many others that I hereby salute with all the respect they deserve. And, anyway, how could I hope to compete with the excellent journals, special issues, and books devoted to felines? Paraphrasing their findings seemed a pointless exercise.

But let's not labor the point! I'd just like the reader to be able to open this book to any page and, surprised by some portrait or anecdote, join me in an exploration of a subject that forms an integral part of our attainment of civilization. For, in a sense, humankind only became truly enlightened when it accepted the cat by its side. Accepted it as a companion, as an associate, of course, and not as a "tame" or "domestic" animal; cats never wanted that, preferring the role of partner—even of master—in elegance, beauty, and, who knows, of wisdom, in the unspoken knowledge they possess of the most inscrutable secrets of the cosmos.

F. V.

Facing page "Plunging into the deep waters of his cat's eyes, a writer inevitably feels disturbed, and is soon asking himself some fundamental questions." F. V.

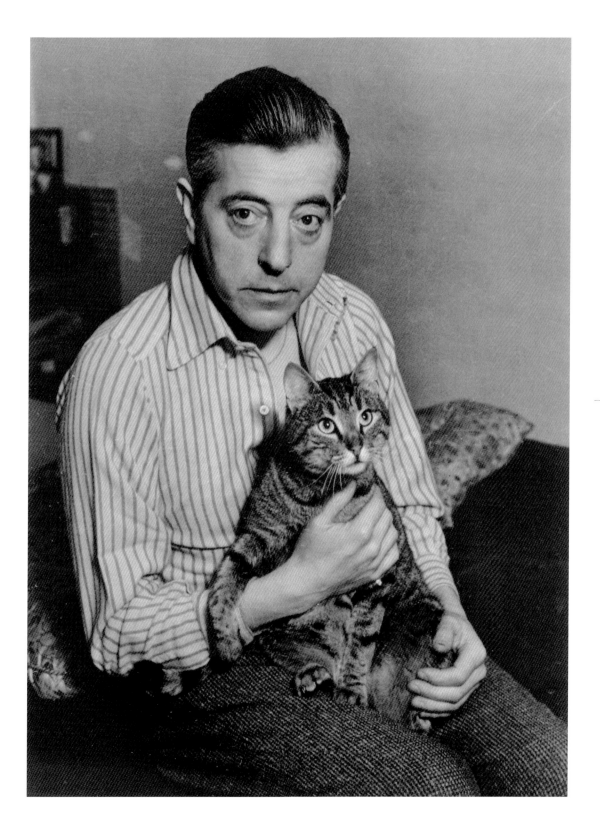

The cat is the only animal
to have succeeded
in domesticating man.

Marcel Mauss

Abyssinian

I may as well admit it. I'm not crazy about pedigree cats. Nor do I know much about the nomenclature of the various breeds thereof.

A high-born puss, a purebred… my goodness, that's a cat you have to lock up in your living room or in the safe to prevent it sauntering about the garden, risking its precious life on the street, exciting the desire of the envious or, worse still, mixing with the hoi polloi, those crossbreeds or alley cats who have no hope of appearing in the society pages. With a shameless cat, a street cat, a moggie that's one of a kind, you don't get all these problems.

Excuse the preamble. I promise to mention this subject only occasionally in the course of this *Miscellany*.

Now I can get cracking on the topic of the Abyssinian.

Well, yes, it's a very fine cat, the Abyssinian, and I can hardly stop myself from admiring one and saying hi (and with no ulterior motive).

It's brisk, elegant, athletic. I like its wary character and even its reputation for misbehavior. I'm impressed by the Abyssinian. Actually, in me at least, it inspires a kind of awe. Faced with an Abyssinian I feel I'm looking at a cat from our early history: an Egyptian cat from the time of the Pharaohs, or, why not, the goddess Bastet in person—one of those felines that, a few millennia ago, emerged from their great open spaces and little by little abandoned their unbridled freedom to settle down with humankind.

For me, this breed, with its fawn-colored coat, the color of sand or savanna burned by the sun, is not so unlike those animals one comes across from time to time in Africa. Or like a miniature puma. Its eyes gaze on you with the gravity, the strangeness, and perhaps with a soupçon of wildness that comes from the mists of time.

This is no luxury cat, as one might call long hairs, or Persians, like glamor girls mollycoddled in their fur wraps. Its coat is short, close, crisp, tough. It's kitted out for adventure. It's as if it bears the marks of centuries and centuries of a life in the great outdoors.

In the last analysis, if I could plumb the secrets of the genetic memory of any one cat, if I could talk to it about its ancestors on the Nile, about the construction of the pyramids, or the temple of Luxor, it would be with an Abyssinian. But I know, alas, that it will keep anything it knows to itself.

Page 10
Girl with Cat (1912).
German Franz Marc,
the celebrated modern
animal painter,
loved cats, and they
feature in many of his
magnificently colored
paintings.

Facing page
"This is a fine-looking
Abyssinian: it looks like
a miniature puma." F. V.

The Cheshire Cat

We know that Lewis Carroll (1832–98), the celebrated author of the no less celebrated *Alice in Wonderland*, had a weakness for March Hares, frog footmen, fish footmen, babies that turn into pigs, and pink flamingos wielded as croquet mallets.

But perhaps his most famous invention was a cat, the immortal Cheshire Cat, which was transformed into … into what? Quite simply: into nothing!

What brilliant intuition on the part of the worthy and respectable mathematician Charles Lutwidge Dodgson (Lewis Carroll was a pseudonym) to bequeath this feline legacy to posterity. Why bother trying to make a cat weird by transforming, disguising, hybridizing, redecorating, or morphing it? It is already strange in itself.

The cat is an endless source of surprise. It belongs to house and home, and yet moves about as if cloaked in secrets of its own. Not for nothing were cats the chosen companions or accomplices of witches for so long. In short, the mere presence of a cat adds vastly to the mystery of life.

Lewis Carroll understood this very well: Wonderland is the realm of the cat by right. And sometimes it may deign to let us in and act as our guide, just as it does for Alice.

One question arises: do cats smile? That's a hard one. I've known jaunty dogs that had the belly laugh of an old trooper. I can think of other animals not overburdened by humor. But the cat?

The cat is possessed of that distance, that silent intelligence, that sense of derision, even, which might perhaps induce it to raise a sort of smile. But, in fact, no, the cat does not smile.

In other words, it does not make us party to its thoughts or mischievousness. It does not share its dismay at our conduct. It keeps its remarks to itself. Likewise with its smile or gibes. It remains remote. Distant. That's what makes it so incredible: the indecipherable majesty of its silence. The suppression of its smiles.

All the same, Lewis Carroll did add *something* to the Cheshire Cat, pushing home the point and making him still more fantastical. He did not stick wings on him like that vulgar Venetian lion, or screw a man's head on him like some common-or-garden centaur of Antiquity; nor add a fishtail, as with those scintillating

Facing page
Engrossed in her book, Alice pays no attention to the Cheshire Cat, or the magic of reading, as illustrated by Adelaide Claxton in *Wonderland*, 1870.

Pages 16–17
The adventures of Alice have been given the movie treatment several times. The first full-length American film dates to 1950 (shown); more recently Tim Burton made a version for Walt Disney Pictures.

maiden-sirens—oh no. He had the modest, bewildering, brilliant idea of merely allowing him to display his inner smile at last.

A cat that grins. Goodness! A cat that, if I might put it like this, cocks us a snook. A cat that stares down at us from the top of his tree or from the corner of the kitchen, and who thus adds his smile and irony to the furious folly of the universe and mankind.

Coming face to face with the Duchess, Lewis Carroll's heroine is justifiably intrigued by this curious characteristic: "'Please would you tell me,' said Alice, a little timidly, for she was not quite sure whether it was good manners for her to speak first, 'why your cat grins like that?' 'It's a Cheshire cat,' said the Duchess, 'and that's why.'" A little later, Alice asks again: "'I didn't know that Cheshire cats always grinned; in fact, I didn't know that cats *could* grin.' 'They all can,' said the Duchess; 'and most of 'em do.' 'I don't know of any that do,' Alice said very politely, feeling quite pleased to have got into a conversation. 'You don't know much,' said the Duchess; 'and that's a fact.' Alice did not at all like the tone of this remark, and thought it would be as well to introduce some other subject of conversation."

Lewis Carroll pushes the formidable notion of the grinning Cheshire Cat to its absurd extreme. When the cat withdraws, when he melts away, gradually becoming invisible and eventually vanishing, what part of him stays the longest? In other words: what is his quintessence? His smile, of course.

Alice is astounded. "'Well! I've often seen a cat without a grin,' thought Alice; 'but a grin without a cat! It's the most curious thing I ever saw in my life!'"

The worthy Cheshire Cat vanishes. Like all other cats. Every cat has this incredible ability: it can disappear and can't be found. He must have slipped into some parallel universe. He will rematerialize in ours when the time seems right.

What's left of a cat when the cat is no longer there?

Its compassionate irony hovers around us. The singular commiseration of the cat for the inept, imperfect beings that we are, for we humans who cannot detect waves, who cannot free ourselves from gravity, who are all at sea in the dark, who age and become ugly.

The cat, the memory of a cat, is a smile.

Poetry in Motion

What is the distinguishing characteristic of the camel, the giraffe, and the cat? What makes them distinct from all other mammalian quadrupeds? What differentiates, in other words, the cat from the ass or the mouse, the giraffe from the poodle or the fox, the camel from the zebra or the hippopotamus?

Has the cat got your tongue?

Well, it's quite simply their gait, their mode of locomotion, their way of walking.

The cat, camel, and giraffe all put the front and hind legs on the left side forward at the same time, followed by the front and hind legs on their right side; other four-legged animals, like a gallant horse at a normal walk, move the left front leg and right hind leg, followed by the right front leg and left hind leg.

But why the cat, camel, and giraffe, you ask? What characteristics do they share, but don't share with the others? I'm not clear whether these three animals might possess other qualities in common—a common gene or strand of DNA, perhaps. The domestic cat, which derives from the wildcat of the species *Felis libyca*, probably has African ancestors, as do the camel and giraffe. But I am not sure that this provides much of an explanation.

One thing I am sure about, though, is how incredibly elegant a walking cat looks, when observed from the side: there's something graceful, sinewy, and nonchalant about the movement. Something relentless, too. Threatening, perhaps. Looking for all the world like Gary Cooper, Henry Fonda, or James Stewart in a much-loved Western, they stride up the main street in a dusty one-horse town toward their adversary, one hand on their Colt, ready to draw.

A cat edges forward, as if in slow motion. First to one side, and then to the other. With incredible flexibility—primed to leap, or shoot; the coolest gun in the West.

Its gait is the stride of an aristocrat, of a sheriff, or hired killer. Of an inexhaustible dancer, at a push. And the cat needs it. It is simply impossible to imagine a cat deprived of this special way of walking—one that ennobles and earns the animal such respect.

Facing page
"Looking for all the world like Gary Cooper, Henry Fonda, or James Stewart in a much-loved Western, they stride up the main street in a dusty one-horse town toward their adversary, one hand on their Colt, ready to draw." F. V.
A photo taken in Naples in 1958 by cat lover and photographer Leonard Freed.

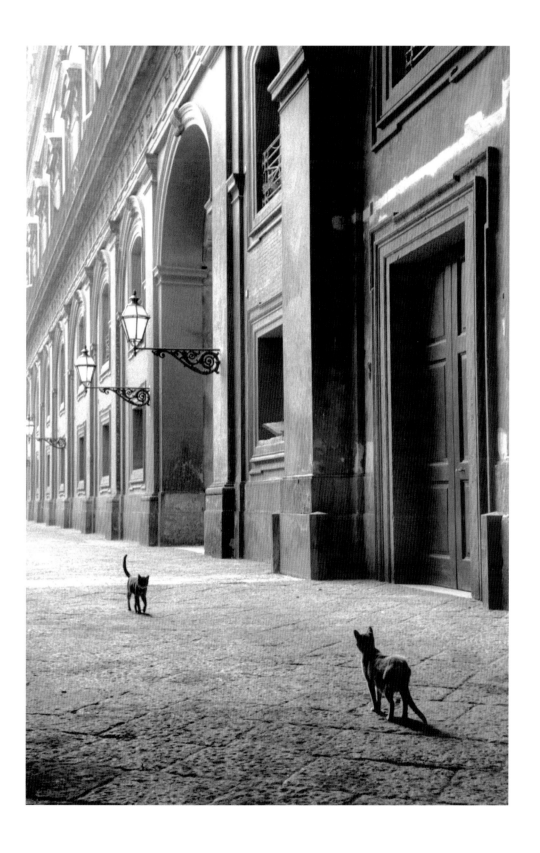

Annunciation

In 1527, Lorenzo Lotto painted an Annunciation that hangs today in the Pinacoteca Communale in the small town of Recanati, in the Marche region of Italy. The painting is not only worth making a detour for, as they say in the Michelin guides, it's worth devoting an entire trip—demands it, even.

It is simply extraordinary in composition and chromatic splendor, in the contrast between the warm, dark hues on the left, where the Virgin clad in a red dress stands facing the viewer, and the cool, luminous tones of the right-hand side, where an angel clad in blue stands out clearly against a portico that leads to wide-open spaces, with some trees in the distance and a patriarch God perched up in the clouds.

The essential thing, however, is something else entirely. A figure in the center attracts the eye like a magnet, in some ways upstaging the divine characters. It is a cat: a superb tabby, ready to leap up and flee the scene, twisting its head round to throw the archangel Gabriel one last, fierce, fiery look. It's impressive, this cat. It's on the move. It vibrates, throbs, when everything around it seems frozen in an immutable, icon-like representation. But what does the presence of the cat actually mean?

In a book dedicated to cats in painting, *The Cat and the Palette*, written in collaboration with Élisabeth Foucart-Walter, Pierre Rosenberg tells us that Lotto's intention—precisely with regard to this picture—was to translate *pensieri strani*: "strange thoughts."

Yes, but what is this glorious, springy, and terrified cat, its ears flattened back, doing here? Why has it camped out in the lower middle part of the canvas? What "strange thought" moved Lorenzo Lotto—the great Venetian painter, as luminous as he was sometimes anxious (tortured even)—when he began this work?

The animal has been seen as a symbol of Evil, a representative of the demon. That seems self-evident. The diabolical cat, with all that entails, a lamentable medieval commonplace that lingered during the sixteenth century. Charged with the task of announcing to the Virgin the salvation of humanity through the future birth of the Savior, the archangel Gabriel descends. Naturally, this divine representative is the enemy of the cat, its celestial adversary, a kind of rival of the feline fallen angel.

Facing page
The Virgin seems as frightened as the cat at the sight of the Angel Gabriel, in Lorenzo Lotto's *Annunciation*, 1527.

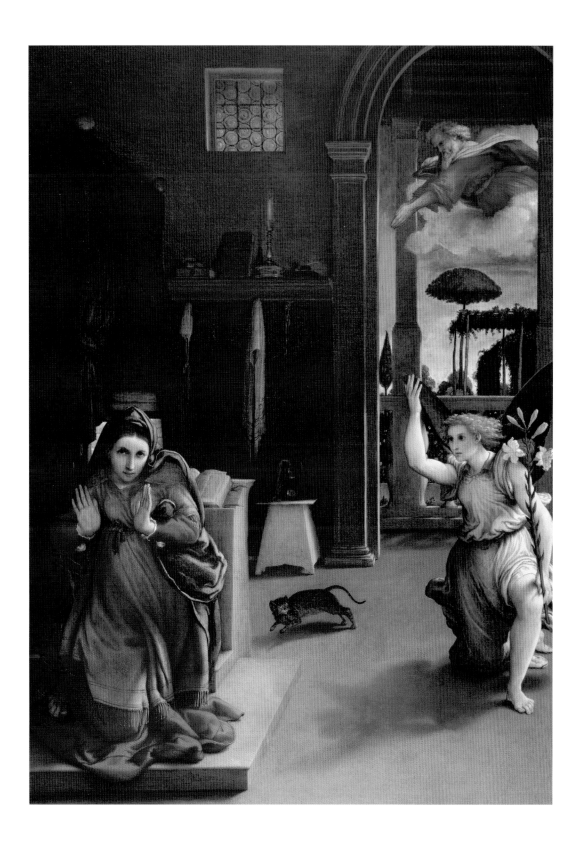

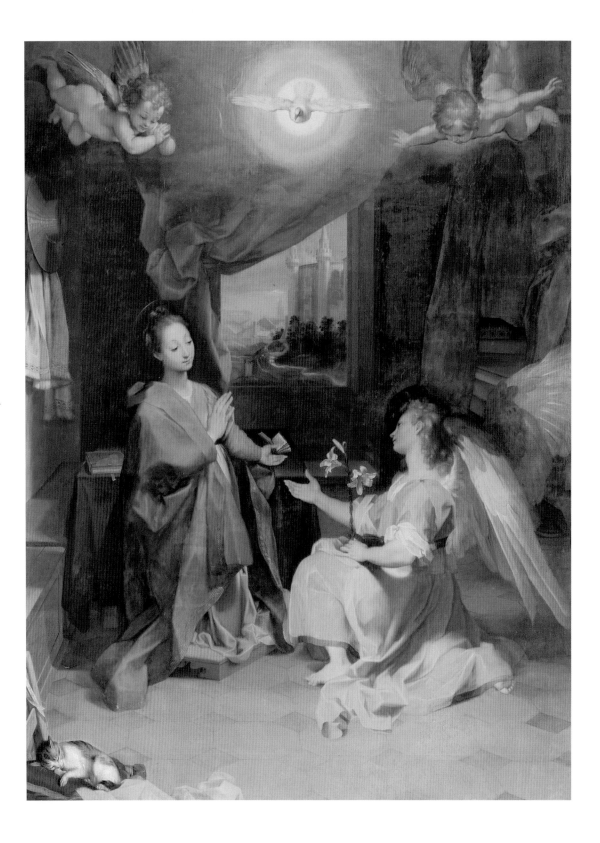

All is calm and harmony
in this *Annunciation*
(1582–84) by Federico
Barocci.
The arrival of the angel
alarms neither the
Virgin nor the peacefully
slumbering cat.

Nevertheless, I just can't accept the idea that this cat is really a representation of wickedness. It certainly doesn't look like one; it harbors none of the threat. Its appearance is far from disturbing. Nothing like the "strange thoughts" that Lotto promised.

Upon closer examination, the cat looks surprised, nervous. It looks at this grandiloquent, rigid fellow with wings, and wonders what on earth he's doing there. We might ask ourselves the same question. The cat seems ready to make a getaway, which seems a very wise decision.

Perhaps, in the end, the cat is the only one gifted with a modicum of common sense in the whole story—and picture. Maybe this was the real "strange thought" of Lorenzo Lotto.

The tomcat has lived peaceably with Mary, trying not to make life too difficult for himself. Then this angel tumbles down from heaven above, radio-controlled from the celestial realm by a guy with a beard, and demands something singularly difficult for Mary—that is, to give birth to a son and yet remain a virgin.

Wouldn't this send anyone into a blind panic? An angel bursting into one's house like that doesn't happen every day, does it? In his situation, our eyes would pop out of our heads and we'd scarper too. The cat, the magic of this cat, is therefore pragmatism itself.

Not Evil, then, but Doubt. Or the incarnation of Common Sense. Everyman, if you prefer, thrown into mysterious goings-on in which he can play no role. Obviously, Lorenzo Lotto could never have explicitly formulated such a "strange thought." How could he dare question the reality of the Gospel story, in all honesty? *Did it really happen like that*, "*really really*," as children say? At the time, if he'd expressed such doubts, he would have quickly felt the flames licking round him.

So Lotto hides behind an alibi. Lotto relies on the contrast between, on the one side, an admirable if stolid representation of a scene drawn from Scripture, with its figures resembling puppets, caught in their traditional poses; and, on the other side, real life—life that observes, asks questions, expresses doubts, that is frightened by all these schemes, by these incredible beings come down from the sky, and which the precious cat, this one cat, embodies.

Lorenzo Lotto is on the cat's side. That's what he's saying; or hints at, at least. The "thought," or the reaction, of the animal is too "strange," or rather too heretical, for it to be expressed under his own name. However, I've no doubt that the cat is him. And that the cat is us.

A cat has absolute
emotional honesty:
human beings,
for one reason
or another,
may hide their
feelings, but
a cat does not.

Ernest Hemingway

Baudelaire on Cats

And now we come to Baudelaire. Charles Baudelaire (1821–67), obviously. Not only because he devoted several of the most beautiful and (better still) best-judged poems in *The Flowers of Evil* to cats, but also—in so far as such a superlative can be meaningful in such a connection—because he remains the greatest poet in French literature.

The lines he dedicated to cats are extremely well known to the French. Many can recite them by heart. Ad nauseam—to the point that they can make the heart sink. They're almost hackneyed. Sublime, certainly, but one might feel one's had enough of them.

It is hard sometimes for readers to regain their innocence and amazement, and learn how to reread Baudelaire's poems on cats as if they had never known or had forgotten them.

Let's try, anyway, as if we were reading them for the first time, and start with the opening quatrain of "Cats":
Fervent lovers and austere dons both,/In their riper season, love cats;/Cats—powerful, gentle, the pride of the house,/Who, like them, loathe the cold,/Who, like them, like a chair.

Or again:
Come, splendid cat, lay on my amorous heart;/Keep your claws back in your paw,/And let me gaze into your beautiful eyes,/An alloy of metal and agate.

And not forgetting:
A cat saunters through my brain,/As if in his own apartment,/a fine and gentle,/Strong and charming cat,/Whose mewling scarcely disturbs.

They're extraordinary lines, aren't they?

All comment on such poems is superfluous because they say it all. To speak of Baudelaire and cats in this sublunary world? Impossible.

His friend Théophile Gautier knew this all too well. He wrote: "Baudelaire adored cats; like him, they adored perfumes, and the smell of valerian threw them into a kind of ecstatic epilepsy. He sought out their tender, delicate, feminine caresses. He loved these charming, quiet, mysterious, and yielding animals, with their

electric shiver, whose favorite attitude is the stretched-out pose of the Sphinxes, which seem to have transmitted their secrets to them. They wander about the house on velvety paws, like *genius loci*, or come and sit on the table next to the writer, accompanying him in his thoughts and gazing out at him from the bottom of their gold-sprinkled pupils."

Whether it is impossible or not, let us offer a couple of simple, common-sense remarks.

Observe first of all that the cat, for Baudelaire, is of course an image of desire, of sensuality. But it also functions as a foretaste of the pleasure promised him—or dangled tantalizingly before him—by the beloved, by the redoubtable figure of woman, as dangerous as desire itself, as inaccessible as the feline symbolizing her:
When my fingers lazily stroke/Your head and your electric body,/In my mind's eye, I see my woman. Her look,/Like yours, loveable beast,/Deep and chill, carves, splits like a lance,/And, from head to foot,/A rarefied air, a dangerous perfume,/Swims around her body brown.

Baudelaire on occasion reverses the roles in this interplay of correspondences. Rather than merging with the woman, the cat becomes to some extent Baudelaire himself. The poet imagines he is a cat, so he can snuggle up closer to the adored, sensual woman. The poet changes scale. He shrinks. He pens verses like he purrs. Or else (and this comes to the same thing), it's the woman who's expanded, a giant creature, with a femininity that engulfs one, chokes, enchants, ravishes, absorbs one. A typically Baudelairean fantasy whose exact measure, as it were, is given in the sonnet "The Giantess":
From the time when Nature with mighty zeal/Conceived each day some monstrous infant,/I would love to have lived near that young giantess,/Like a luxuriant cat at the feet of a queen.

And, in the poem's two triplets, it is as if the women grasp their cats to their bosom, caressing them, letting them drowse against their warm flesh in perfect bliss—the cats, or rather Baudelaire himself, entranced by his dream, a pure phantasm that he best conveys in these at once physical, dizzying, and heady verses:
Taking my time to survey her magnificent forms,/I'd clamber up the slope of her enormous knees,/And sometimes—come summer, when a noxious sun/Forces her to lie down on the land, exhausted—/Carelessly slumber in the shade of her breasts,/Like a peaceful hamlet at the foot of a mountain.

30

Baudelaire on Cats

Facing page
"I am King of Cats," Balthus proclaims in one of his self-portraits. Cats, of which he was so fond, often sit by girls in lascivious poses in his paintings. For Balthus, as for Baudelaire, the cat is an image of desire and sensuality.

Pages 32–33
A symbol of pleasure—in this woodcut by Félix Vallotton, the cat responds to the wanton pose of the young woman (*Idleness*, 1896).

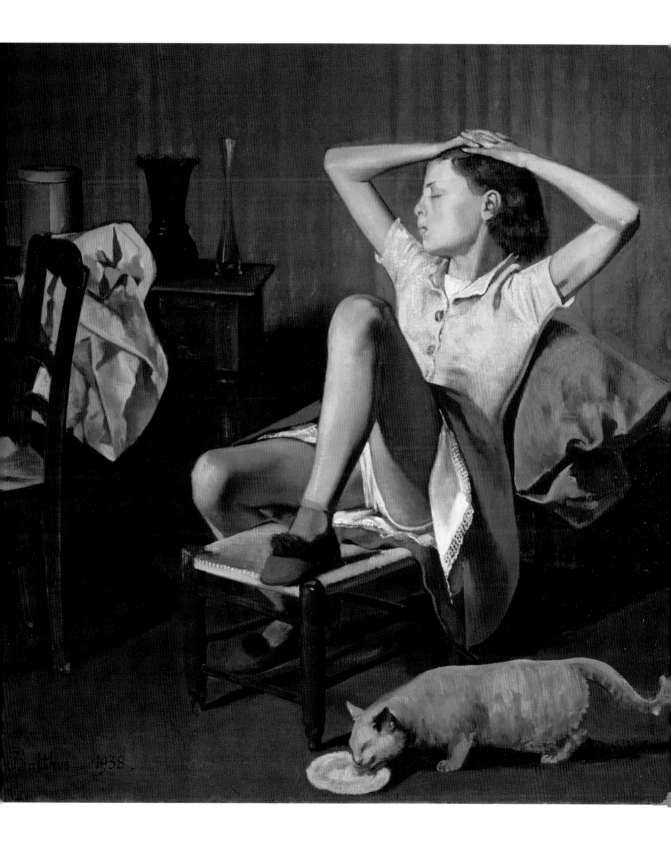

But let us return to the cats, in and for themselves, and not as symbols or substitutions for sexual ecstasy. Let's go back, in other words, to the renowned sonnet "Cats," whose opening quatrain we have quoted. We can simply observe the point to which (using the incredibly novel melodic form he invented, with its assonances and dissonances, its artifices, its images that crackle, its impending sense of vertigo, its gently whirling silences) Baudelaire manages to express the entire *virtuality* of the cat, its contradictions.

Cats, for example, are viewed both as the epitome of voluptuousness and the most demanding, the most arcane form of knowledge; thus are they welcomed with love and complicity by both sensualists and intellectuals, by "fervent lovers and austere dons":
Companions of science and sex/Alike, they search out the silence and horror of the dark:/Erebus would have liked them as hellish outriders,/Had they be able to bend their pride to serfdom./Dreaming, they strike noble attitudes,/Like great prone sphinxes lounging in deepest solitude,/Likely asleep in some endless dream:/Their fecund loins teem with magical sparks/And flecks of gold, like fine sand,/Bespangle their mystic eyes.

What dizzying marvels, what dark horror the cat inspires, and into which he peers: Baudelaire didn't translate Edgar Allen Poe for nothing. The cat and his mythical past, the age of Egypt and its Sphinx. The time of magic.

Something deeply disturbing emanates from this poem, something similar to what the cat may inspire in you.

First comes the amazement sparked by its apparition, its exteriority, by the beauty of a cat on, as it were, its home range; powerful and gentle, liking warmth and indolence. And then, afterward, like a seismic shift, comes the domain of secrecy, an inner world, the pure spirituality it harbors beneath its benign appearance. Those cats that "seem to fall asleep," to wake up in secret worlds.

As for the animal's fecundity, it adds both sensuality and magic, sexual plenitude and esoteric knowledge to those glimmerings of eternity, with the alliterations of "magical sparks" and "flecks of gold," an infinity of fine sand, like the millions of particles that comprise the cosmos.

Whoever evoked the vertiginous nature of the cat better than Charles Baudelaire?

I couldn't possibly comment.

LA PARESSE

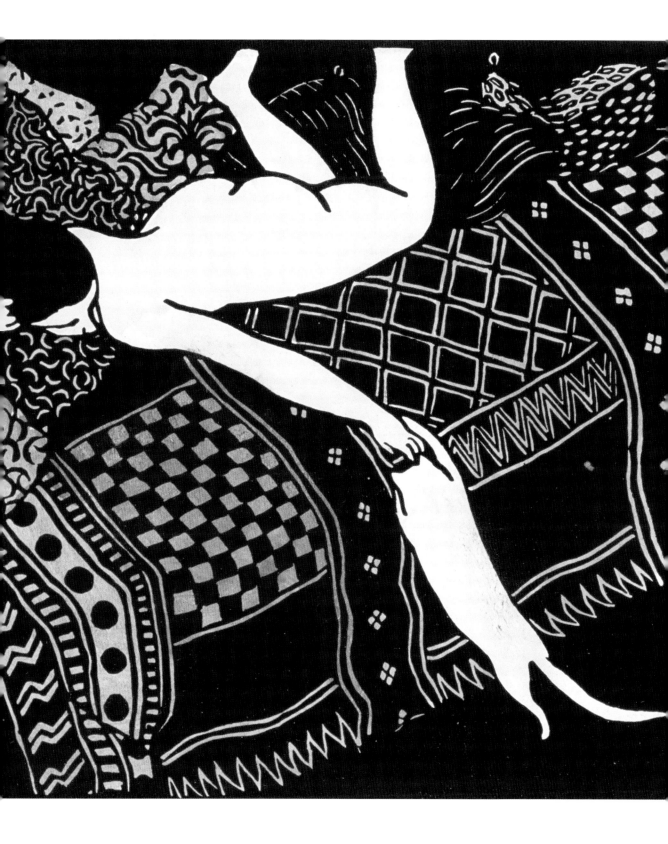

The sky is in its eyes,
hell is in its heart.

Voltaire, "La Henriade"

Facing page "A cat's eyes, so magical, so unfathomable,
that have been believed to possess so many virtues." F. V.

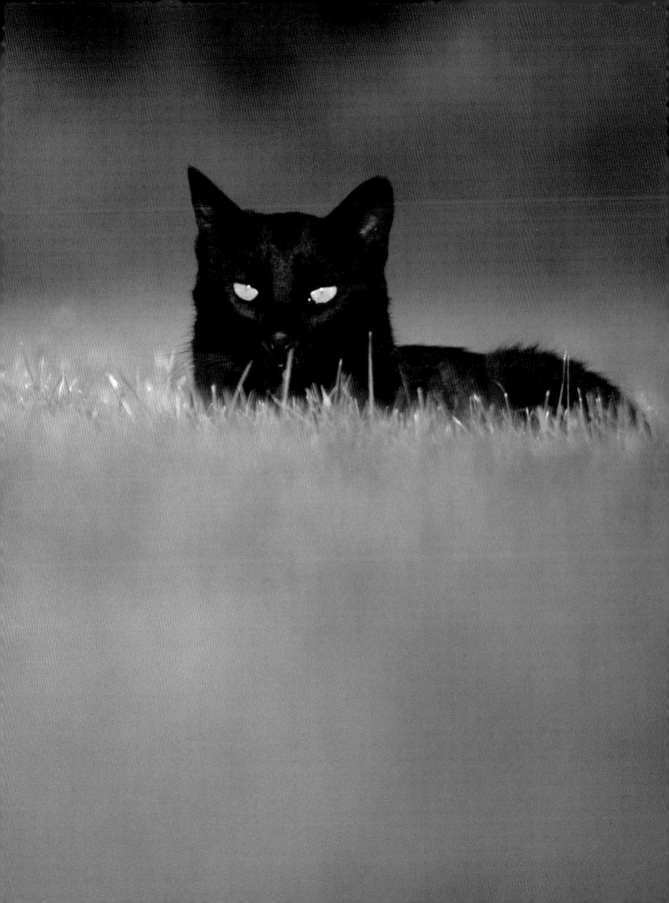

A Feline Odyssey: Bébert

Bébert is a tabby cat, a house cat, an ordinary cat, a cat's cat. He may look just like a thousand, a million other cats, and yet he is actually unique, peerless. Bébert is, in fact, one of the most illustrious cats of the twentieth century—one of the most widely traveled and adventurous too.

To explain: Bébert was the feline companion of the writer Louis-Ferdinand Céline (1894–1961), accompanying him during some of the most turbulent periods in his life. Together with the author and his wife, Lucette, he haunted Montmartre's Bohemian world, was on intimate terms with the author Marcel Aymé (1902–67), the painter Gen Paul (1895–1975), and the actor Robert Le Vigan (1900–1972), went with his owners in tow on their exodus, observed Hitler's Germany carpeted with bombs and blazing in the last months of World War II, took the train (that ran off the rails), tilted his head at senior officers of the Wehrmacht and Marshal Pétain behind the scenes in the castle at Sigmaringen, took refuge in Denmark, hid in a prison, dabbed his paws in the far from clement waters of the Baltic, experienced exile, took a plane, returned to France in July 1951, holidayed in Menton on the Riviera, before ending his days with his master and mistress in a house on route des Gardes in Meudon, in the southwestern suburbs of Paris, into which they'd moved at the end of that year. That's not a life. That's a destiny. Or, better still, an odyssey.

Of course, an odyssey is nothing unless it is transmuted into literature. To an extent, Bébert might be called the "Ulysses" of Céline's odyssey. He makes a personal appearance in the later books. In *Fable for Another Time* and in *Rigodoon*; in *Castle to Castle* and in *North*, he's ever at the novelist's side. He explains him, shows him for what he is. In this sense, Bébert is the best possible introduction to Céline's oeuvre—or to the last period, at least, when the author of *Journey to the End of Night* becomes a *"grand guignol* chronicler" in books that are perhaps his finest creations, insofar as, in these, the madness, the murderous, fantastical delirium of History is at one with the phantasmagoric hyperbole of the writer's vision.

Facing page
The widely traveled Bébert, writer Céline's companion in exile.

Pages 38–39
The drawing by Serge Rezvani of Céline's cat lying on a manuscript is dedicated to the author: "To Frédéric, this Bébert—our cat!"

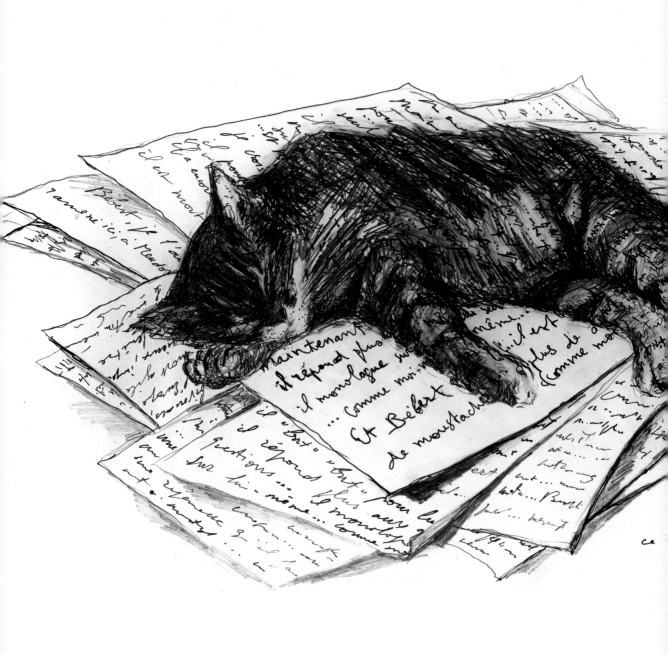

Bébert had been plucked from the animal department of the Samaritaine department store by the actor Robert Le Vigan, who a short time previously had fallen in love with Tinou, a young extra from Algeria. This was in 1935. The cat celebrated their union and then shared their life in Montmartre.

The son of a vet, Le Vigan learned how to speak "cat" with Bébert, his incredible fake mewings making the animal spit fire, as Céline's wife Lucette told me. Thereafter, though, Tinou and Le Vigan entered their own fiery phase and the cat suffered a great deal from their squabbles. Friends of Le Vigan and Tinou used to gauge the couple's emotional state by how plump and prosperous— or skinny and depleted—Bébert looked. When they finally separated in 1942 or 1943, during the Occupation, the animal was taken in by Lucette Destouches.

Her husband, Dr. Louis Destouches, was at that time a physician at a dispensary; he had earned literary fame in 1932 under the pseudonym Louis-Ferdinand Céline with the publication of his debut novel *Journey to the End of Night*. He did not want to be burdened with a cat, even one that had belonged to their Montmartre neighbor and buddy, so the future looked far from rosy. Lucette held firm, though, and within days the cat had become the writer's boon companion. And he now had a name: Bébert.

Immediately after the Normandy Landings, Céline and Lucette, with Bébert concealed at the bottom of a bag punched with some holes for air, made their escape from France. The feline's papers, at least, were in impeccable order. The fugitives' destination was Denmark, where Céline had squirreled away some cash before the outbreak of war. They found it impossible to reach Copenhagen, however, as the German authorities refused to deliver the necessary passes. So they went to Baden-Baden in Germany, then settled in the Brandenburg—the backdrop to the 1960 novel *North*—before moving in autumn to Sigmaringen, close to Lake Constance, where the Germans had corralled some other French collaborators trying to escape the Allies.

Bébert found board and lodging with them in the Hotel Löwen, where he rubbed shoulders with many a top-notch collaborator. No slouch, Bébert managed to soften up a local German grocer. In March 1945, Céline and Lucette finally obtained authorization to travel to Denmark, entrusting Bébert to the grocer. Their escape route through that devastated country looked so hazardous that there could be no question of risking the life of their cat into the

Frédéric
est - notre chat !-
Bv...

bargain. But Bébert had other ideas. On the morning of his owner's departure, he slipped away from the grocer's shop—probably by breaking a window pane—made his way to Hotel Löwen, took the staircase to the correct floor, and went into Lucette and Céline's room where the suitcases stood already packed. There were still shards of glass embedded in his fur. There was not a moment to lose. They popped him into a bag and off they went.

Miraculously, all three fugitives managed to reach the Danish capital. The war was drawing to a close. Not long after, the Germans decamped from Denmark. Céline was safe. But someone got wind of his presence. The French authorities immediately demanded his extradition. As a precaution the Danes arrested him. Bébert stayed at home with Lucette. For two weeks, when his mistress had an operation and remained poorly, Bébert lived with Céline in the prison hospital, a clandestine inmate who hid in a wall cupboard every time a warder or nurse came near his room.

In France, the proceedings against Céline dragged on. The Danes placed him under house arrest. The author found himself cooped up in the modest residence of his lawyer, Mikkelsen, on the shores of the Baltic. Bébert was obliged to accept the presence of the other cats and dogs that the couple took in, but he was not exactly pleased. He lorded it over all and sundry—obviously he was top dog! A top dog entirely devoted to Lucette and Louis, of course, as he had proved over the years. "Still, Bébert, that worst of cantankerous rippers, scratcher scrivener, a tiger!... but really affectionate, in his moments... and terrifically faithful! I saw it throughout Germany... the fidelity of a wild beast."

After a condemnation in absentia followed by an amnesty order in 1951, Céline was able to return to France in July. All three of them boarded the plane. In autumn 1951, the couple acquired a house in Meudon. It was there that Bébert found his final refuge. And it was there, not long after, that he died, ten years before the writer, his master. Weakened, emaciated, he found it hard to enjoy the garden. He sniffed the air at the window then slunk off to snooze in the basement.

The picture we would like to keep of him in our mind's eye is the one provided by his master in *North*: "He died here after many more incidents, dungeons, bivouacs, and ashes... he died nimble and graceful... he was jumping in and out of the window that same morning... we were sitting there laughing, oldsters born!"

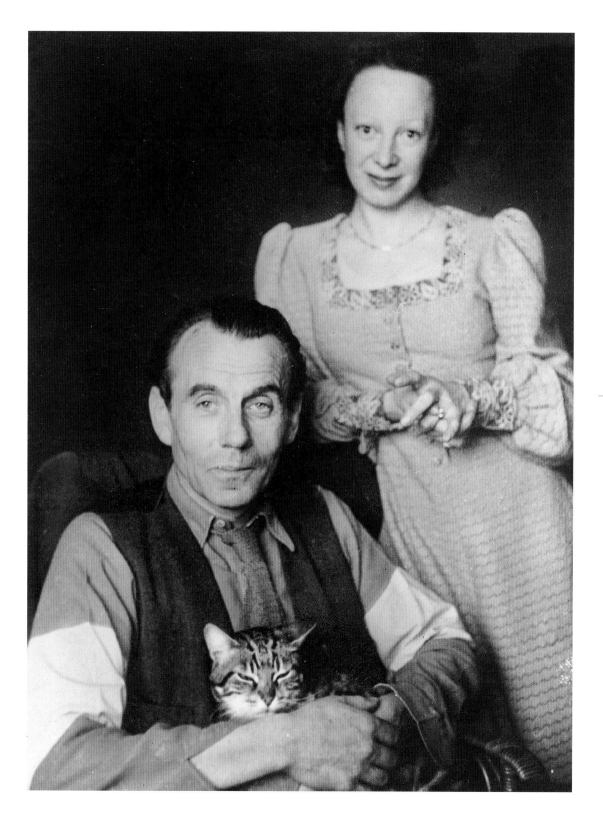

The cat wants nothing
more than to be a cat,
and every cat is pure cat,
from its whiskers to its tail. . . .
Nothing hangs together
quite like a cat.

Pablo Neruda, "Ode to the Cat,"
Odes to Common Things

The Chat Noir Cabaret

Did the Chat Noir—the music hall and even the revue of that name (meaning "black cat"), run by a group of personalities around the painter Rodolphe Salis (1851–97), their founder—really have many dealings with cats, cats of flesh and bone, or even with those in paintings, sculptures, illustrations, symbols, or fiction?

Let us broaden the question a little: would every store, restaurant, hotel, or bar trading under the sign of the cat—and it doesn't much matter what the color of their fur is, black or otherwise—deserve to appear in this *Miscellany*?

No, surely not, but I contend that the Chat Noir was much more than just a cabaret venue, becoming over time a legend, an iconic place in Bohemian Paris—or, more precisely, Montmartre—in the years 1880–1900. The establishment opened its doors in 1881 with an address at 84, boulevard Rochechouart, at the foot of the hill. The following are the words of Maurice Donnay, playwright and French Academician, who is rather neglected today, but who, in his youth, recited poems and composed far-fetched and burlesque tragedies for the famous shadow theater in the Chat Noir, so himself contributing to its vibrancy and fame: "At this time the fashion was all for art cabarets and the Chat Noir had, thanks to its stained-glass windows, its tin pots, its copper pans, its benches and chairs of carved wood, all in the purest Louis XIII style, something of the air of 'old Paris.' . . . Each evening we met up, some recited verses, others sang songs, and the fame of these extraordinary get-togethers quickly spread to all Paris. Soon major financiers, the well-heeled political class, and gilded socialites were making their way to carefree Bohemia, and, especially on Fridays, which became the chic day, ladies of the aristocracy, *grandes bourgeoises*, and also *horizontales* [courtesans], as they were called in those vertical times, were to be spotted at the Chat Noir." All in all, the venue was so successful that Rodolphe Salis soon found himself needing a larger venue, and, in 1885, moved the establishment with great pomp to 12, rue de Laval (today rue Victor-Massé).

But let's return to our cats, or rather, to begin with, to the sign of the Chat Noir that Adolphe Willette (1857–1926) designed for

Facing page
The sign for the Chat Noir, by Adolphe Willette (1857–1926).

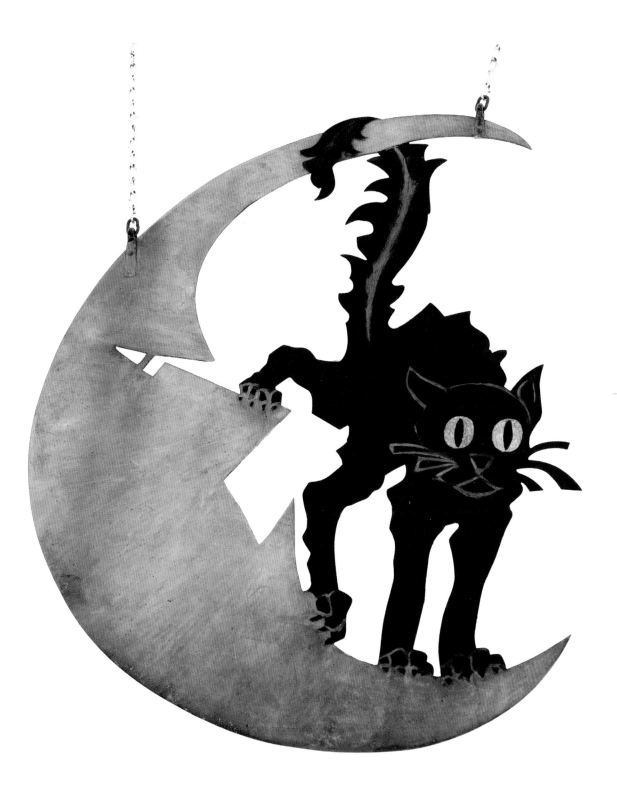

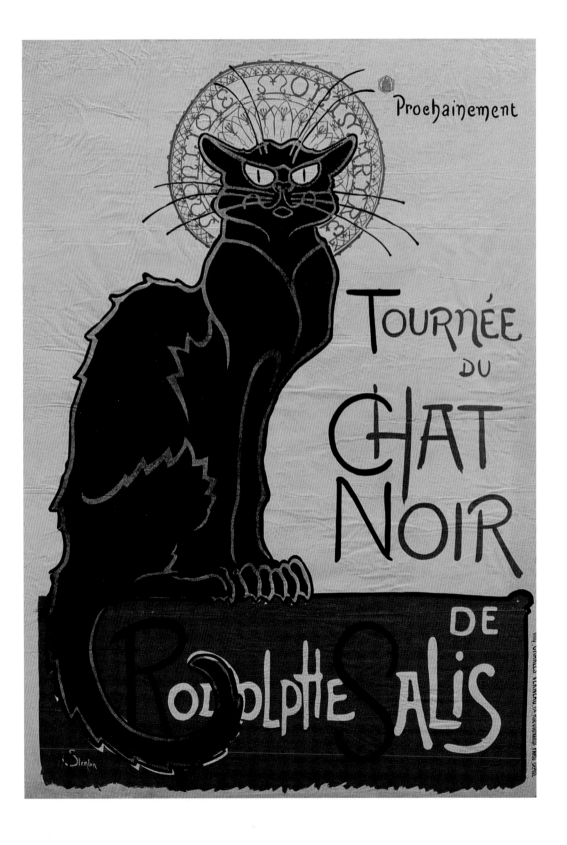

"Magnificent and black,
it's impossible to get
the scrawny, slightly
shaggy feline pictured
in this 1896 lithograph
by Steinlen out of one's
mind. It has a mystery,
a violence tempered by
irony that makes this
poster a masterpiece of
its genre." F. V.

the rue de Laval, and which represented the animal in a crescent moon. The artist, who had in addition collaborated on the revue *Le Chat Noir*, had also decorated the main saloon at the first Chat Noir on boulevard Rochechouart.

Willette had studied for four years at the School of Fine Arts in Paris under the direction of the eminently serious painter Alexandre Cabanel (1823–89), and quickly found himself one of the most talented and sought-after illustrators of his time. Under his given name, as well as under a slew of pseudonyms (Cemoi, Pierrot, Louison, Nox, etc.), he collaborated on a good number of periodicals. He decorated many brasseries, and it is to him that we also owe, inter alia, the ceiling of the variety venue La Cigale. Some have compared him to a kind of Watteau of the Belle Époque.

Ah, the sign of the Chat Noir painted by Adolphe Willette— just imagine the people who must have streamed in beneath it. The Club of the Hydropathes, first of all (whose name, roughly meaning water-haters, requires no comment), which used to hold its sessions and drinking bouts in the Latin Quarter; then the "Hirsutes"—in short a complete roll-call of fin de siècle arty Bohemia. This did not prevent one from bumping into the by now venerable Paul Verlaine, who would evoke, between two absinthes, Arthur Rimbaud. "He's left for Egypt!" he'd cry with sad gravity, raising a finger to the ceiling. Claude Debussy also took part in the shindigs, directing a chorus of guests in musical numbers that were, let's say, not exactly orthodox Debussy!

And let's not forget the dramatist and critic Jules Lemaître, comic writer Alphonse Allais, the young Franc-Nohain, and of course Theophile-Alexandre Steinlen (see p. 205), an admirable draftsman and a painter specializing in cats who made his contribution to the decor of the second Chat Noir.

To avoid a potential mix-up: Willette's design should not be confused with the famous lithograph by Steinlen, dated 1896, that illustrates a "Tournée du Chat Noir," with Rodolphe Salis (see facing page). Surely one of this exceptional artist's masterworks, it shows the animal standing out from a kind of filigree halo, in profile, rather scrawny, opening his eyes wide, with his fur bristling and his head turned toward the viewer.

We have not yet cited one important name: that of Aristide Bruant. It's true that he is rather an odd chap. Born into the middle classes at Courtenay in Yonne in 1851, a onetime employee of the Paris Company Railroad, after the Franco-German war of

1870 he threw caution to the winds and devoted himself exclusively to singing. In 1885 he bought out the first Chat Noir, turning it into an establishment that traded under the sign of Le Mirliton cabaret. It was there that he wrote and sang the majority of his great numbers, in lowlife slang, in praise of local toughs and forlorn girls of unimpeachably tragic destiny from the working-class districts of Montmartre, Belleville, and Ménilmontant.

His best-known piece remains the "Ballade du Chat Noir" (Ballad of the Chat Noir), created in 1884 as a song-cum-anthem to the glory of the cabaret of the same name, where he had initially been taken on by Rodolphe Salis. The music was not his own. Bruant just wrote the lyrics and performed. For "Chat Noir," he took as his starting point a traditional Occitan tune, "Aqueros mountagnos."

The timbre of his unremitting, gravelly, low voice, monotonous and ribald, when he struck up the first verse, whose unlikely and provocatively banal words are richly lurid, is forever etched in our memories:

The moon was serene,/When, on the boulevard,/I saw Sosthène come into view/And he says to me: dear Oscar!/Where have you come from, old codger?/Me, I answered:/It's Sunday today,/And tomorrow it's Monday.

Before belting out the celebrated chorus:

I'm seeking my fortune/Around the Chat Noir,/In the moonlight/In Montmartre!/I'm seeking my fortune/Around the Chat Noir/In the moonlight/In Montmartre, in the evening.

So the question arises: why "Le Chat Noir"? Why did Rodolphe Salis choose that particular name and sign?

I have not unearthed any explicit answer, so we must fall back on the probable, and on the symbolism that has long burdened our animal: the diabolic, nocturnal cat, whose image was popularized during the Middle Ages; the cat, saddled with all the imperfections of the world, with hypocrisy, trickery, theft, lubricity, greed, and all the rest; and, above all, the black cat, the chosen companion or accomplice of witches who, if caught, would willingly slip into the skin of their furry friends to escape their just deserts.

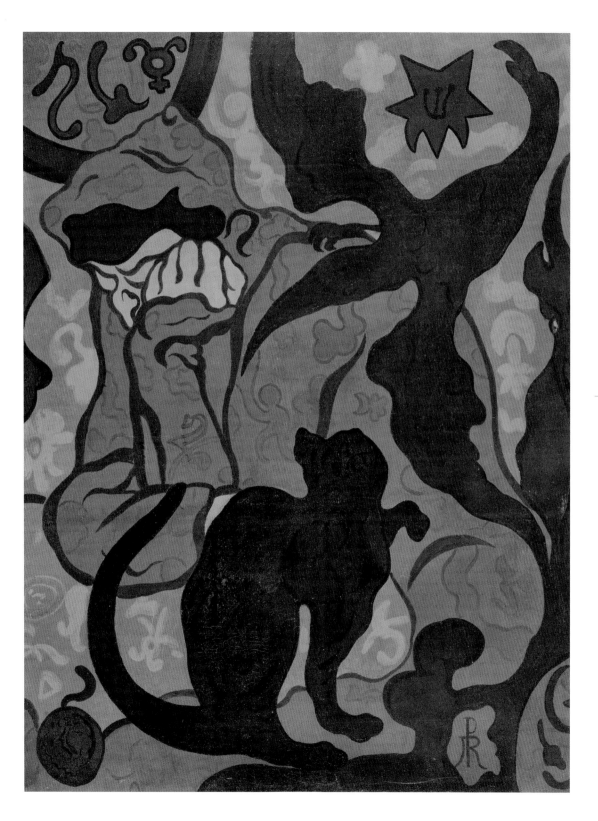

When my cats aren't happy, I'm not happy.
Not because I care about their mood, but because
I know they're just sitting there thinking up ways to get even.

Percy Bysshe Shelley

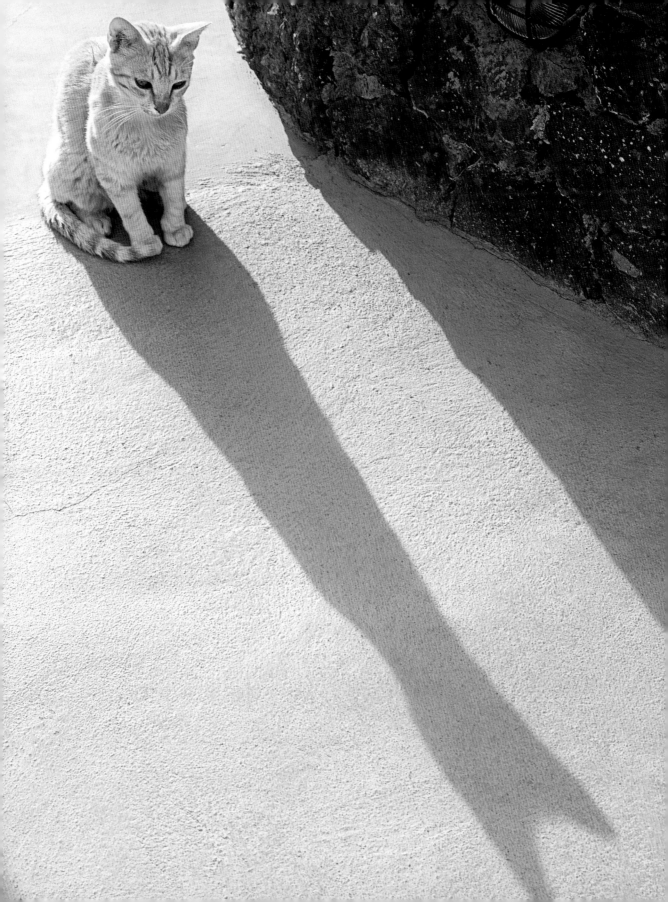

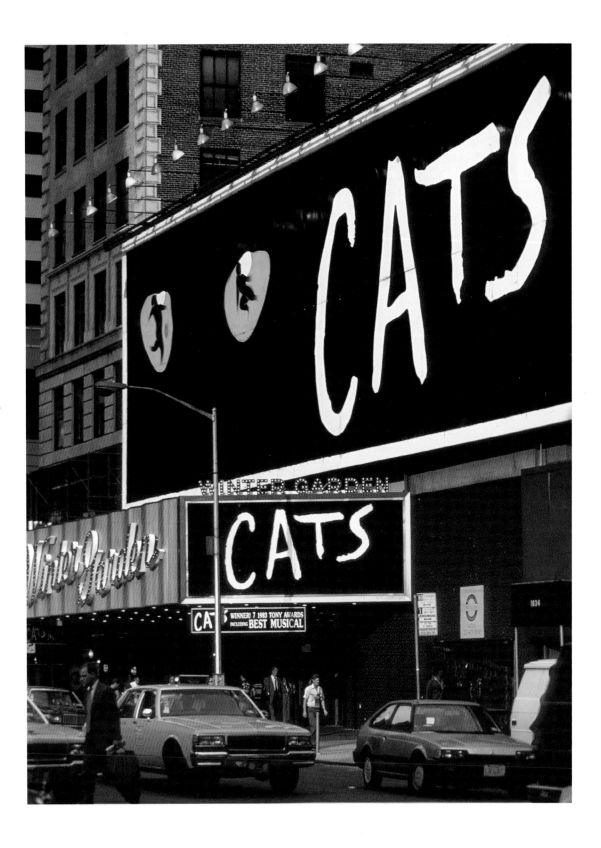

Cats: The Musical

For at least half a century, *Cats* was without question one of the most phenomenal successes in the whole history of the musical, in Britain as well as in the United States. There's something comforting about that. To see cats dancing, singing, in love, at loggerheads, cajoling, seducing, and terrifying—and all applauded to the rafters at the end.

It's difficult to praise highly enough the merits of the author and composer of such a show. His name: Andrew Lloyd Webber. With the assistance of Trevor Nunn, who contributed to the libretto and the lyrics, for *Cats* he took as his starting point the poems of T. S. Eliot, and particularly those anthologized in *Old Possum's Book of Practical Cats*. And this is how, since that first performance in the New London Theatre on May 11, 1981, cats became superstars in theaters the world over.

The story of the production unfolds like a dream: nine thousand shows in London up to June 11, 2002, a record only beaten later by *Les Misérables*. On Broadway it had a comparable triumph. Staged at the Winter Garden Theater with the same production team, on October 7, 1982, *Cats* began its record run for a musical with nearly seven thousand five hundred performances, the last taking place in September 2000. Since then, just one other show has exceeded this number. And that was *The Phantom of the Opera*, after the novel by Gaston Leroux—the composer being Andrew Lloyd Webber, of course.

In short, an audience of millions sat on the edge of their seats watching the exploits of the frightening Macavity, a cat and elusive assassin, the "master criminal," the graceful Grizabella, the patriarch Old Deuteronomy, Gus the elderly actor, all aches and pains, whose exploits are sung by Jellylorum, not forgetting Mr. Mistoffelees, as black and tiny as he is clever at magic, as well as Munkustrap, the narrator. The actors' costumes were remarkably imaginative and fairylike, but realistic too. The spectacle was bathed in a tender, balletic, yet cruel poetry, the whole being held together by seamless melodies and an energetic beat. And always, in the background, was the bizarrely inventive, strange, trenchant, and grave verse of T. S. Eliot, probably the greatest twentieth-century, English-language poet.

Facing page
All-singing, all-dancing cats in theaters the world over—here in New York, in 1992.

Pages 54–55
"The Chartreux is a quiver of magic, the mesmerizing wing of the angel of the bizarre in such a companionable creature." F. V.

Chartreux

I adore the Chartreux breed of cats. They are my favorite (pedigree) cats. They are, more relevantly, my friends. And confidants. They make me feel comfortable and wistful at the same time.

They look like great lumps, really, with puffy faces, beautiful dense fur, silky and gray-blue, like some cuddly toy, and with orange-colored eyes almost too bright, too magical to be entirely honest or to really belong to them.

One pictures them as easy-going, affectionate, sociable, home-loving, and food-loving—perhaps even gluttonous, at a push. And that would not be an entirely unfair portrayal. I have certainly never met a skinny or anorexic Chartreux.

But there is more. The Chartreux is a mystery.

Does it owe its name to the Carthusian monks (in French, Chartreux), who apparently brought it back centuries ago from South Africa so they could breed it in their communities? The cat itself has at least conserved the jovial and rotund appearance of monks, who know what it is to eat, as well as that spark of spirituality and grace, perhaps, which is not invariably irreconcilable with the friar's habit.

There are many doubts over this theory, though. Research has shown that never in all their history have Carthusians bred these felines, and—even worse—they never even set foot in South Africa.

Our cat more probably originated in the Middle East, reaching Europe with the Crusades. Initially called the "blue," it would have earned the name "Chartreux" later, due to the resemblance of its coat to a wool once imported from Spain and dubbed, goodness knows why, "Chartreux pile."

If I had to compare the cat with anybody, it would have to be with the Buddha. The Buddha, who is both cheerful and tubby, with a jovial mien, sedentary, with his legs folded beneath him, floating in ineffable bliss... but also the Buddha whose ideas are detached from earthly concerns, inaccessible in his thoughts, or his absence of thought, in his wisdom and in his familiarity with the Great Oneness—or Great Nothingness.

Such is the Chartreux. Our Buddha with a big belly and ineffable thoughts. A soft Buddha one can stroke. What could be better?

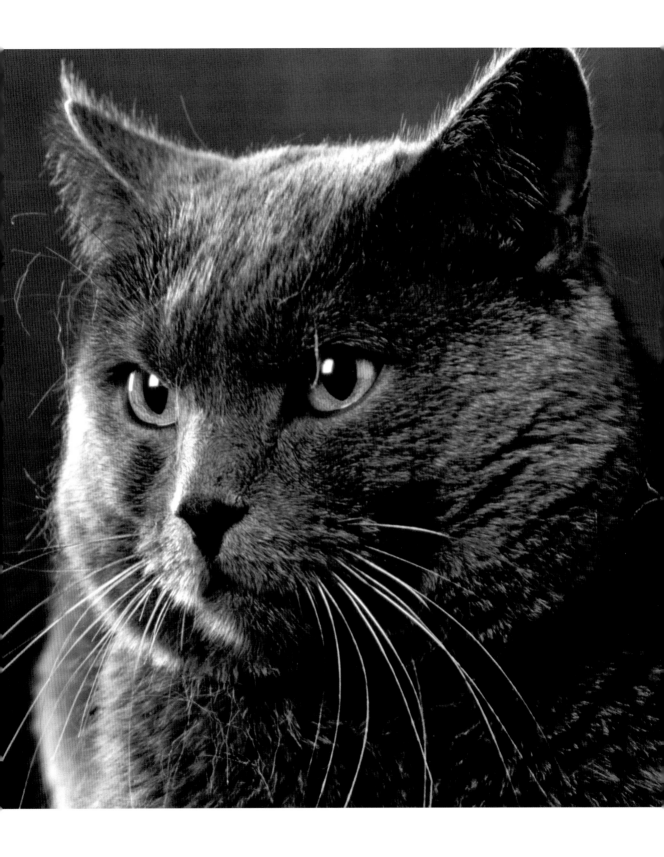

Un Chat
comme on en voit peu

Puss in Boots

Why does this world-famous cat, one of the most celebrated characters in Charles Perrault's no less celebrated *Mother Goose Tales*, wear boots? He was born, or at least he entered the public domain, in 1697, on the publication of *Stories or Tales of Past Time, with Morals*.

The original title of the story in which he starred was "The Master Cat, or the Cat in Boots."

But why does he sport this footwear? Amazingly, this key question seems to have no definitive answer. Looking again at the first lines of his adventures, in Andrew Lang's end-of-century translation, they run: "There was a miller who left no more estate to the three sons he had than his mill, his ass, and his cat. The partition was soon made. Neither scrivener nor attorney was sent for. They would soon have eaten up all the poor patrimony. The eldest had the mill, the second the ass, and the youngest nothing but the cat. The poor young fellow was quite comfortless at having so poor a lot.

"'My brothers,' said he, 'may get their living handsomely enough by joining their stocks together; but for my part, when I have eaten up my cat, and made me a muff of his skin, I must die of hunger.' The cat, who heard all this, but made as if he did not, said to him with a grave and serious air: 'Do not thus afflict yourself, my good master. You have nothing else to do but to give me a bag and get a pair of boots made for me that I may scamper through the dirt and the brambles, and you shall see that you have not so bad a portion in me as you imagine.'"

Let's summarize what happens next: the young man, who had long admired the suppleness and skill of the cat in catching mice and rats, accepts the animal's request.

But why boots? Because the cat likes his creature comforts and doesn't want to scratch his paws when he ventures into the thorny undergrowth?

Advanced by Perrault and the cat himself, this explanation does not seem much of one at all. Was it actually so that the cat might appear more human and thus render his banter, lies, trickery, and imposture—which earn his master fame and fortune—more credible? Maybe. Or because the cat was already booted

Facing page
The cat performs a flattering bow before the king (as illustrated in a popular print).

Pages 58–59
If, in Perrault's fairy tale, Puss in Boots has to deal with one ogre, in this animation he has to deal with another: Shrek.

in the majority of the children's tales and legends that Perrault had collected and enriched? Cats sporting such accoutrements do indeed crop up from time to time in folktales. As in this Russian song, an extract from a story by Afanassiev:

The cat walks on its feet/In red boots;/He wears a sword at his side/And a stick down his thigh;/He wants to kill the fox/And do away with its soul.

As for Grimm, he refers to an old Austrian song:

Our cat put on some little boots;/In them he runs to Hollabrun,/He finds a nurseling in the sun.

But, once again, nothing in the strange words of these verses is reminiscent of the story of Puss in Boots, so the presence of the boots remains unexplained. We could just say that these famous boots derive from an ancient tradition rehashed by Perrault—leave it at that and get back to the folktale.

Perrault gives his feline hero a major role, an essential symbolic charge: he functions as a good-luck charm.

At last, a cat that is neither diabolical, nor terrifying, that is not an ambassador from the powers of Evil! Of course, so as to ensure prosperity and marital bliss for his master (to get him, that is, in a position to marry the king's daughter), our extraordinary puss acquires a criminal record as long as your arm. He flatters the monarch, offering him—on behalf of his master (whom he calls the "Marquis of Carabas")—wild rabbits and partridges. He threatens some peasants with a terrible punishment if they fail to tell the king that the land they look after belongs to the Marquis de Carabas. He tricks an honest ogre of a landowner into taking the form of a mouse so he can then gobble him up, and sets up his master as lord of the manor in his place. But surely this is all for a good cause?

Puss in Boots has strong links to Scapin and Crispin, and all the other irreverent servants of the commedia dell'arte, who perform a range of underhand tricks, ruses, and swindles in the service of their masters, thereby feathering (as if in passing) their own nests.

Perrault had not invented his story out of thin air. It belonged to the back catalog of popular legends in which a cat, though never booted, was often compared to a good genie. More precisely, maybe our author had been directly inspired by two Italian sources from earlier times: *Le Piacevoli Notti (Pleasant Nights)* by Giovanni Francesco Straparola, and *Il Pentamerone* (a.k.a.

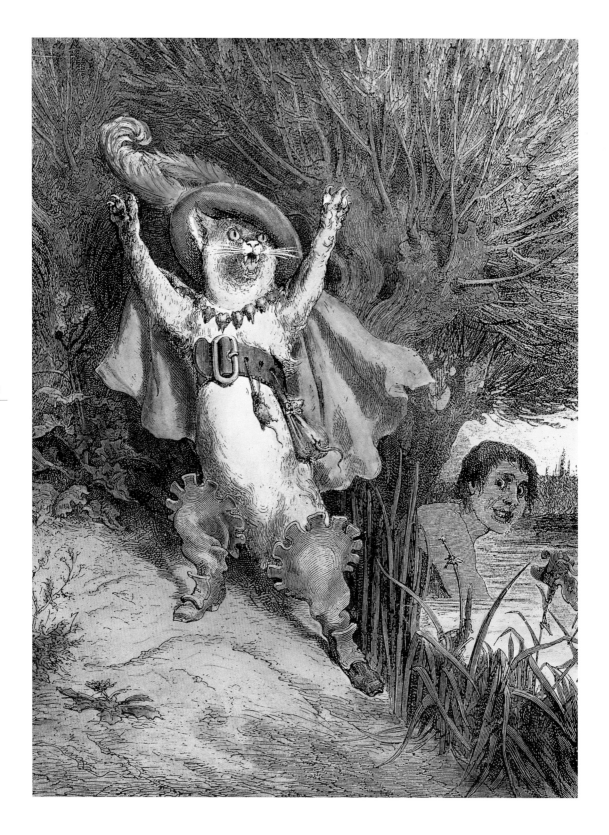

The cat instructs his
master, the so-called
Marquis of Carabas,
whose clothes he has put
on, to dive into the river,
in this color engraving by
Gustave Doré (1832–83).

The Tale of Tales, or Entertainment For Little Ones) by Giovan'
Battista Basile? After our Puss, cats in boots (with substantial
variants) soon sprang up in Denmark, Norway, Russia, etc. But
let us concentrate on this one.

We have just demonstrated how our amiable Puss in Boots is,
for once, the polar opposite of the cat that presages bad news.
Very well. But the fact remains that he is endowed with almost
supernatural powers. We'll leave aside the gift of language: that
comes with the territory. We're in fairyland and speech is a nec-
essary condition for the narrative. But what about his talent for
appearing terrifying? It is ever-present. Remember that the cat
first asks his master to strip and dive into the river, and then
hides his ragged clothes, before—on seeing the king's carriage
approach—telling his master to pretend to be drowning. This
stratagem earns its reward when the king's servants rescue the
unfortunate "Marquis of Carabas" and place him in the carriage
next to His Majesty, who has him dressed in great finery.

"The Cat, quite overjoyed to see his project begin to succeed,
marched on before, and, meeting with some countrymen, who
were mowing a meadow, he said to them: 'Good people, you who
are mowing, if you do not tell the King that the meadow you mow
belongs to my Lord Marquis of Carabas, you shall be chopped as
small as herbs for the pot [more precisely: as a filling for a meat
pie].'

"The King did not fail asking of the mowers to whom the
meadow they were mowing belonged. 'To my Lord Marquis of
Carabas,' answered they altogether, for the Cat's threats had
made them terribly afraid."

Yes, that's what it says. The cat can blithely terrorize these
superstitious rustics since they have always dreaded the animals.
And if Puss is able to turn to his own advantage the absurd ances-
tral terror his fellow felines had long exerted over simple minds,
so much the better!

And how happy we are to learn at the end of the tale that the
cat's master, the self-promoted Marquis of Carabas (in real life,
the third son of a miller), does indeed wed the beautiful princess.

And the cat?

"Puss became a great lord, and never ran after mice any more
but for his diversion."

In the present context, that's the supreme luxury.

Cats are like paper, they get ruffled easily.

Guy de Maupassant

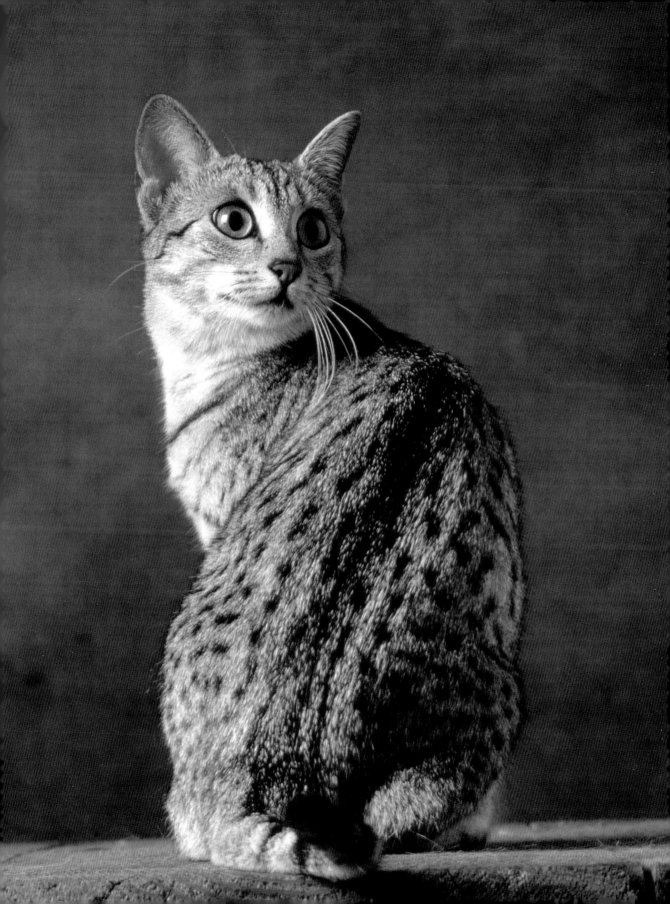

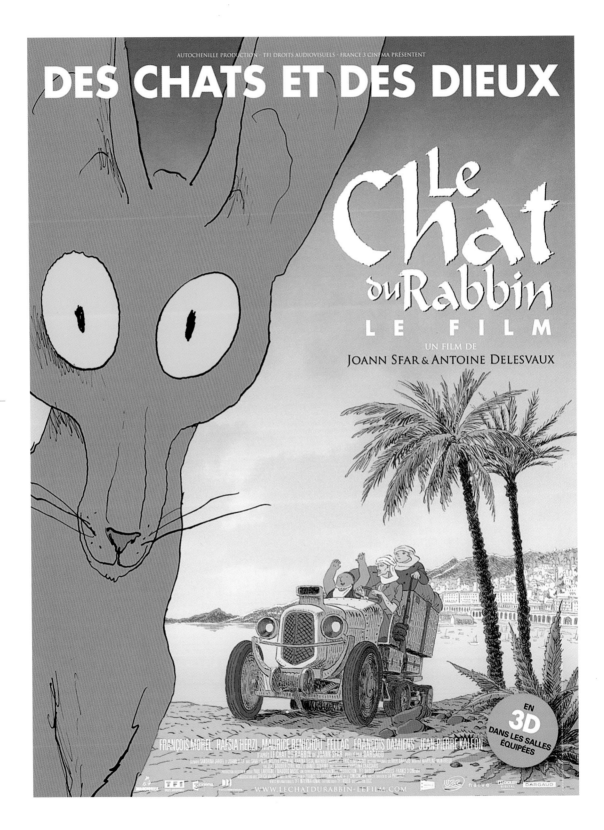

The Rabbi's Cat

In 2001, the then unknown Joann Sfar had the idea of creating a new comic strip hero.

He's a tomcat that lives with a rabbi, an honest, pious, benevolent, and modest rabbi, who lets all his cat's fooling around go unpunished, since he thinks—quite rightly—that the hand of man is too subtle a tool for hitting people or cats with. The cat lives more closely with the rabbi's daughter, the beautiful Zlabya, with whom he is in love.

Things become rather more complicated when the cat starts speaking. By what miracle is this? Quite simply because he cannot stomach the parrot, which is forever saying the first thing that comes into its head and deafening the entire household. Thus, one fine evening, our cat swallows him whole and starts to talk.

"And where's the parrot?" the worried rabbi asks the next morning.

As quick as a flash the cat replies: "He had to go out. Urgent business. He said you shouldn't wait up for him."

And how does the story go on? In a nutshell, our chatty tom wants to assume the majority of the privileges enjoyed by beings endowed with the gift of speech, and in particular that of having his bar mitzvah. The rabbi is suitably outraged—the cat's not even Jewish! But then, who's Jewish and who's not, the cat enquires? And then, what's the real difference between a human and a cat?

To resolve this quandary, our rabbi, accompanied by his cat, goes off to consult another rabbi, the rabbi's rabbi as it were, who answers that God made Man in His image. The cat is not moved by such a paltry objection, and demands to be shown an image of God. When the rabbi's rabbi refuses, because God is the Word, the cat retorts that if Man is like unto God because he can speak, then he is like unto Man, and therefore. . . .

Joann Sfar's irony is glorious. The misadventures of this Sephardic rabbi smuggle in an enjoyable and intelligent way of initiating us painlessly into the thousand-and-one twists and turns of Judaism and Jewish thinking. The great ideas of the Kabbalah are here; the intricacies of Jewish thought according to Talmudic approach are here, too, thanks to a cat that is the living illustration of them.

Facing page
"In 2001, the then unknown Joann Sfar came up with the idea of creating a new comic strip hero. And why not? It would be a cat. An excellent initiative." F. V. French poster for the 2011 movie adapted from the comic.

If a dog jumps into your lap, it is because he is fond of you;
but if a cat does the same thing, it is because your lap is warmer.

Alfred North Whitehead

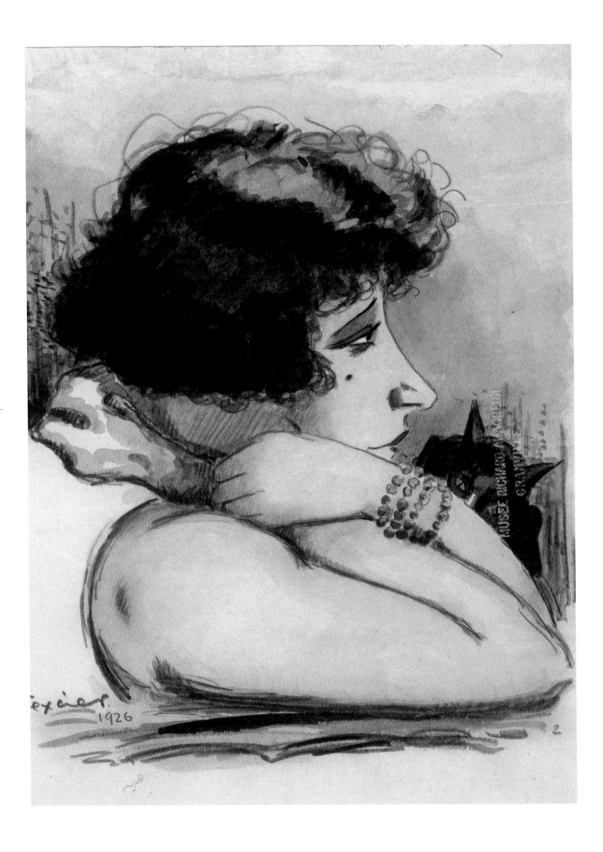

Colette

Thinking of the authoress Colette (1873–1954), we tend to remember the *Claudine* series of novels written in her youth, which her first husband, the "literary charlatan" Willy, had no hesitation in claiming as his own with a nerve that today leaves us open-mouthed—as does Colette's submissive acceptance. And then we picture in our mind's eye an extraordinary, unique old lady with a mass of curly hair, looking down from the windows of her apartment (to which she was confined by crippling arthritis) onto the gardens of the Palais Royal. In fact, Colette brings to mind a myriad of images, many immediately associated with the presence of cats: not only those that shared in her life, but also those she dreamed of, described, and lauded, in book after book, novels and confessions alike.

Perhaps there are two sides to Colette. Her mother's side first of all: the realm of Sido, a woman from whom happiness seemed to flow, and who taught Colette how to love nature and animals, down to their deepest feelings. And then Willy's side, the *"gai Paris"* side: gaudy, dazzling, with sentences chiseled in their beauty.

Under the gaze of Sido, Colette moves us by her ease, by her closeness to nature, and by a vision of cats that remains wholly devoid of corniness. On the other hand, when part of the Willy faction, she irritates us because she tries too hard, overplays her hand. In her youth she had appeared in variety shows in the flimsiest of garments, and, here again, bedecked in perfectly superfluous frills and flounces, she tends to overdo it.

Let me quote you one of her remarks, an admirable sentence that goes straight to the heart of the matter, written in a foreword to a volume anthologizing her most purple passages about cats:

"There are no ordinary cats."

That's it, in a nutshell.

In it, Sidonie-Gabrielle Colette shows herself a daughter worthy of her mother.

"There are no ordinary cats." A great deal of wisdom, a consummate elegance of expression, and an understanding soul is required to be able to state, without the least emphasis, this rather disconcerting truth.

Facing page
Colette adored her Chartreux. Watercolor by Jean Texcier, 1926.

Pages 70–71
Colette and her cat, posing in front of the galleries of the Palais Royal in Paris.

And then, very quickly, Colette, the "woman of letters," takes over. Putting her pen through the mangle, she wants to give her readers value for money, indulging in a resounding and glittering demonstration of high style of the kind not to be found lying about at home or in the newspapers, which attracts attention and earns its keep. Ah! *That*'s a writer! She gives you what you've paid for. Here's a person who knows how to spin out an adjective and strum on an exalted sensation!

In *La Chatte* (*The Cat*), for example, is the following nugget (there are thousands more): "He was talking to the cat who, with empty and golden eyes, had her eyes half-open almost overcome by the excessive odor of the heliotropes, her face had the look of almost sickened ecstasy animals assume when confronted with an overpowering smell."

Oh, come on! "Excessive odor of the heliotropes." "almost sickened ecstasy." Goodness, it's like a late Edwardian drawing room with velvety curtains and over-the top cushions, with sofas and kentia palms in china pots and a reek of tuberoses. It makes you feel dizzy, it's so airless.

All the same, one can forgive Colette a lot, precisely because of her cats. The real ones: the gorgeous yet gentle Chartreuse, Saha, Kiki-la-Doucette, Péronnelle, Krô, Kapok, Minione, Chatte Dernière—all those she knew or she dreamed of, which she praised and which inspired some wonderful pages, at once tender and empathetic (because Colette's love for her cats, wordy or no, was never affected or false). To say nothing of Bâ-Tou, which she was presented with one day, and which was not even a cat but a snow leopard, an affectionate and terrible pocket panther that she had to hand over rather rapidly to a zoo, unfortunately, leaving her inconsolable.

But when she tries to make her cats speak, inventing dialogues for them, she slips back into her old faults. Why give them the gift of language when they have no use for human speech? It's as if she had to disguise them or truss them up in fancy dress. It's all very awkward for them, for her, and for us her readers. But let's not dwell on it: often enough (after bidding farewell to Willy, to stylistic fireworks, and to the tittering of the drawing room), Colette reins herself in, and her observations become all her own work. Then her eye is quite something. Cats reduce her if not to silence, then at least to an exemplary economy of language. It is then that she bewitches us; it is then that we can admire her unreservedly.

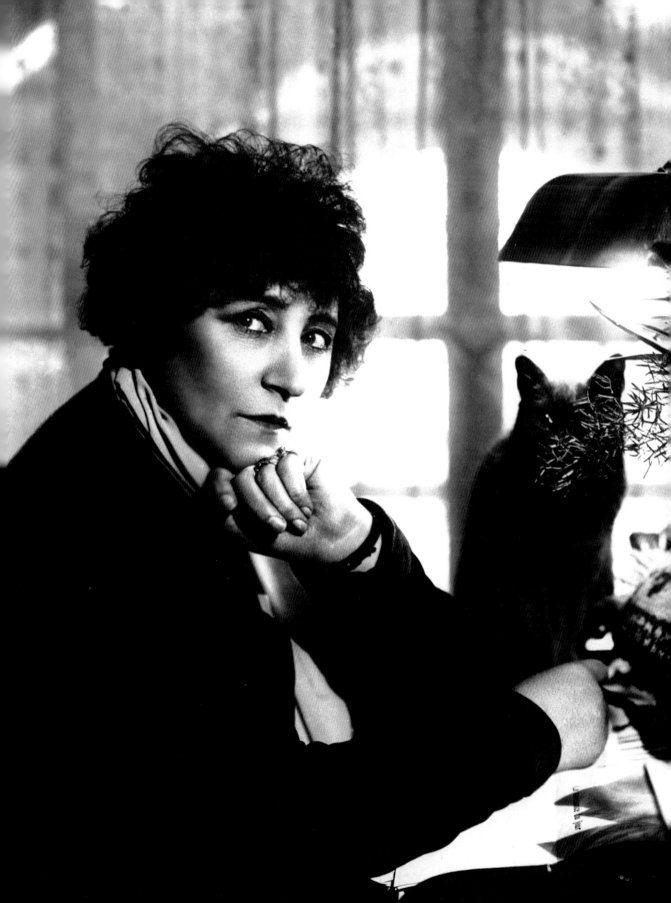

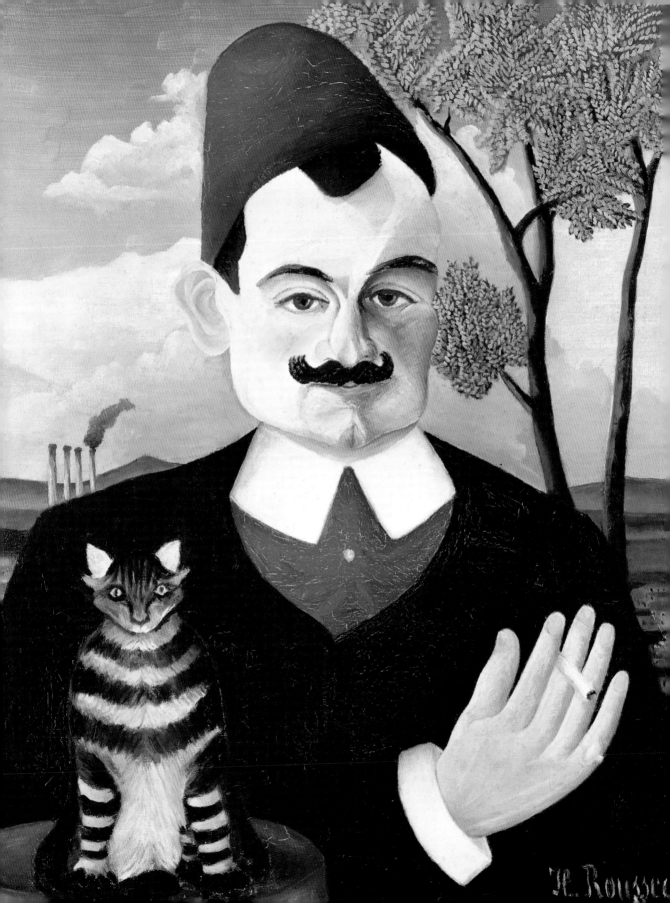

If man could
be crossed
with the cat,
it would improve
man but
deteriorate
the cat.

Mark Twain

In the Corner of a Painting

A cat is not one for striking a pose. It will not remain stock-still for hours on end in the painter's studio while he doodles away at his sketches, correcting expressions, capturing lifelike attitudes, and balancing light and shade. But, more than that, cats are rarely seen in genre scenes. They almost never take center stage in a painting.

Of course, there are many pictures *of* cats: cats invented, imagined, dreamed up by the artist; cats that suffice in themselves and that are the ultimate reason for the work. I'm not thinking of this type of piece. I'm talking more about cats that might form part of scenes featuring other figures: an episode from the Old or New Testament, for instance, or a family get-together, a village procession, a historical or mythological event, a battle, whatever.

Painters often find it amusing to place a cat in these sorts of scenes. Indeed, how could they resist the temptation or challenge of incorporating the dose of pure beauty, of brutality, mischievousness, humor, and life, brought by a cat? Such a feline resembles a snapshot frozen in a representation of eternity.

If ever a cat does appear in a canvas of this type, however, it is often scarcely visible: a tiny outline in a corner, and no more. This "scarcity" betrays an essential fact. Like a grain of sand, of genius, or of disorder in the great machine of the universe, this shadow of a cat, this soupçon of cat, belies everything.

In such paintings we are supposed to admire the hierarchical representation of the world. Discipline is enforced; a particular aesthetic triumphs. A political vision is applied. A faith or spiritual order expounded.

How could anyone refute the great, the admirable, the truly Venetian setting of *The Wedding Feast at Cana* (1562–63), as reinvented by Paolo Veronese, which today stands in the Louvre? Or *The Last Supper* (1592–94), celebrated in a climate of intensity verging on the overwrought by Tintoretto in San Giorgio Maggiore in Venice? It is impossible not to empathize with the intensely meditative peasants depicted by the Brothers Le Nain, or feel reassured by these Flemish dignitaries in their finest garb, by their tables weighed down with produce, by the bounty of the fish stalls on their street corners. And one cannot remain insensitive to the

Page 72
"Cats have skittish little souls, tiny souls full of affection, of pride and whimsy, not easily fathomed, which reveal themselves only to certain, special people, and which are put off by the least insult, sometimes even by the mildest disappointment," Pierre Loti averred. Here is Loti in a portrait by the Douanier Rousseau, 1891.

Facing page
The playful kitten in a detail from Veronese's *The Wedding Feast at Cana* (1562–63) is certainly in a corner of the painting but, front of stage, adds an intimate, luminous note that contrasts with the formality of the banquet.

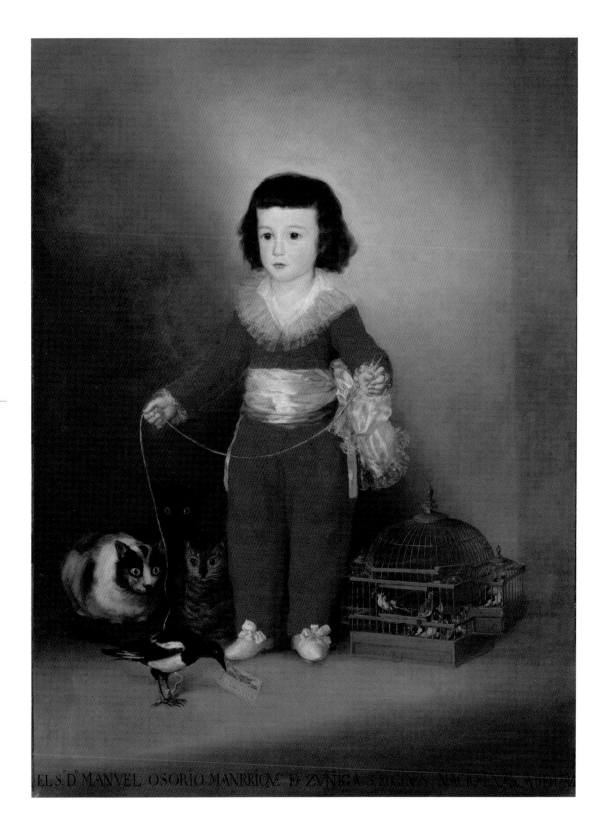

Facing page
In this strange scene painted by Goya of Don Manuel Osorio Manrique de Zuñiga in the late eighteenth century, the three cats seem all too ready to make short work of the bird that the child holds on a lead.

Page 78
This engraving by Édouard Manet illustrates the cover of a book by Champfleury entitled *Les Chats* (1869). At once scholarly, sophisticated, and entertaining, it's well worth discovering.

reverence shown by a woman of modest condition as she puts her hands together to say grace before eating her soup and breaking her bread, in a picture in the Rijksmuseum in Amsterdam that Nicolas Maes presents to us, in which he involves us. How can we not—with Goya—admire the wisdom of the tiny grandee, Don Manuel Osorio Manrique de Zuñiga (1784–92), who, in his desire for immortality, has put on his Sunday best? All these paintings remind us of the prosperity of La Serenissima, the immutability of the Flemish commercial empire, the social and religious order of seventeenth-century France, the Protestant piety of the North, the pride of the Spanish nobility.

And yet, there's a cat in the corner: a cat that doesn't seek to deny anything, for sure; indeed it simply says nothing, bearing witness for us. It acts as our representative in the corner of the picture, refusing to take part in this performance, as if it doesn't believe in it, or is not so easily deceived; the cat pulling at the tablecloth in order to get at the goodies on the table as quickly as possible without bothering to say grace; the cat ready to gobble up the magpie that Goya's boy holds on a leash; the cat rifling through a basket while Christ and his apostles share their last meal together—in short, this is the cat at play: distracted, palpitating, and aloof, the cat that doesn't give a hoot about the picture or about anything it is endeavoring to depict or celebrate.

That, then, is the grain of sand! The scurrilous dash of skepticism and distance that the cat brings. Your tall stories of water changed into wine, your Eucharist, your ostentation, your genteel illusions, your worthy Flemish finery, your idealized rural lives, your prayers, your boyhood sense of aristocracy—it's all very well, but don't ask *me* to put any store by it!

I am life, it seems to be saying. I am inquisitive, voracious, I thrill at every passing moment; I sleep, I hunt, I am very interested in mice, in birds, and in recently caught fish, but I do not believe in your constitutions, your miracles, your representatives, your comforts, your titles of nobility; I do not drape myself in honorary civic gowns, I am not so easily duped, I do not entrust my destiny to improbable gods, I do not worry about eternity—I pulsate with each instant, I wrap myself in the instant, and that instant is for me the only worthwhile absolute.

Manet

Cats were the gangsters of the animal world, living outside the law and often dying there. There were a great many of them who never grew old by the fire.

Stephen King, *Pet Sematary*

Water Babies

Although cats loathe and detest water, don't go thinking they are weak, feeble, card-carrying softies.

Their coat isolates them from the cold when the weather is dry, no question; but they do not have much of a protective fatty layer beneath the skin. So, when they are soaked and, even more so, when they are actually in water, their fur loses its thermal quality, sticking to the skin and cooling them even more.

More serious still, they seem to shake themselves dry much more laboriously and less effectively than a dog. So, even if all cats can instinctively swim, come summer, they are not especially keen to take a quick dip, like some banal holidaymaker. For them, this is the epitome of wisdom. In this sense, cats resemble those seamen who hate water, knowing that it represents a danger, an enemy that has to be overcome. Cats, moreover, have long shared sailors' lives. They too were press-ganged on board ships. At least one cat had to form part of the crew, otherwise the insurance company would refuse to pay out on goods damaged by rats.

Still, in this connection, there have been some bizarre exceptions. Cats that do not live up to the usual image.

My old Papageno liked to slip a paw under a running tap and even to drink the flowing water (no bowl required), his head a little to one side, and he appeared to be none the worse for wear if his muzzle got soaked. There are also records of fishing cats that dive for their prey, like otters.

In the 1950s, a breed known as the Turkish Van was discovered near Lake Van in Anatolia, eastern Turkey. All the members of this breed display the most immoderate taste for water, in spite of a long, silky coat (generally cream in color). Hence their nickname "swimming cat." Though if you share your life with such a cat, it's probably a good idea to give them a towel-down after their dip. To tell the truth, I find these Van cats a little frightening. Like all fairground phenomena, the bearded women and two-headed monsters exhibited in circuses, the shame is entirely on those who earn a living from showing them.

For my part, I prefer hydrophobic cats. I find them less disturbing.

Pages 80–81
A "swimming cat," one
of the rare members of
the species that is at
home in water.

Facing page
Let's hope this cat has
calculated his leap from
rock to rock correctly,
and won't end up with
wet paws.

In a burning building,
I would save a cat before a Rembrandt.

Alberto Giacometti

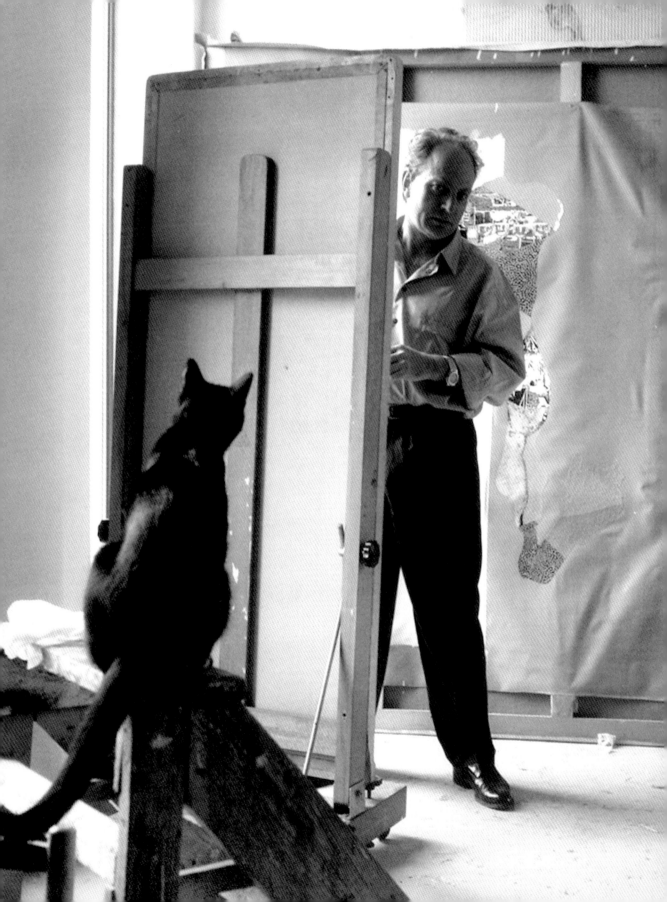

Writers and Their Cats

If ever one needed to compile an encyclopedia or a dictionary (or even a miscellany) with entries or articles on all the writers who have lived with cats, or who were interested in the creatures, such a doorstop would practically amount to a complete history of world literature. It would be easier to list the names of those great authors who appear to have been ailurophobic, if I dare venture the word. I can hardly think of any, except for an unhappy and asthmatic few, unrelentingly allergic to cat fur. They earn our commiserations, of course, but they don't count.

So why is there, in general, such complicity between men of letters and domestic cats? There are many and various reasons. To understand the phenomenon, perhaps one has first to recall Marcel Proust's famous remark in *In Search of Lost Time*: "Books are the offspring of solitude and the product of silence."

Only a cat can occupy the silence and solitude every author finds necessary and, as it were, accompany the slow toil of writing. Only a cat can be the accomplice or partner of one who cuts himself off from the world. For them, only a cat can play the indispensable role of watcher and critic.

A cat likes to remind the author: I don't write; I keep warm under the lamp or by your computer; I drowse over your papers, purring, and savoring each fleeting moment. I'm pondering, keeping my thoughts to myself, and not tiring myself out trying to convey or prove anything. I am the instant and I am eternity, all curled up in the pure delight of a moment truly lived.

A writer's cat will not disturb the author's solitude or silence; but it may do more, or worse, than that. It unsettles, it tempts, it puts the writer to the test. When it sleeps, it may invite the author to sleep too.

Are you totally convinced that a good siesta would not do you more good than writing these lines, these pages, so laboriously conceived and penned? Are you positive, I stress, that what you are writing will be of advantage to humanity? This is, in substance, what the cat whispers to the wordsmith.

When writers drown in the deep blue water of their cats' pupils, they are inevitably disquieted and can at last confront the essential questions: wouldn't I too be better off losing (or finding) myself

Facing page
Françoise Sagan photographed with her cat.

Pages 88–89
"Only a cat can occupy the silence and solitude every author finds necessary and, as it were, accompany the slow toil of writing. Only a cat can be the accomplice or partner of one who cuts himself off from the world." F. V. The English writer John Ruskin in his house at Brantwood, England, now open to the public.

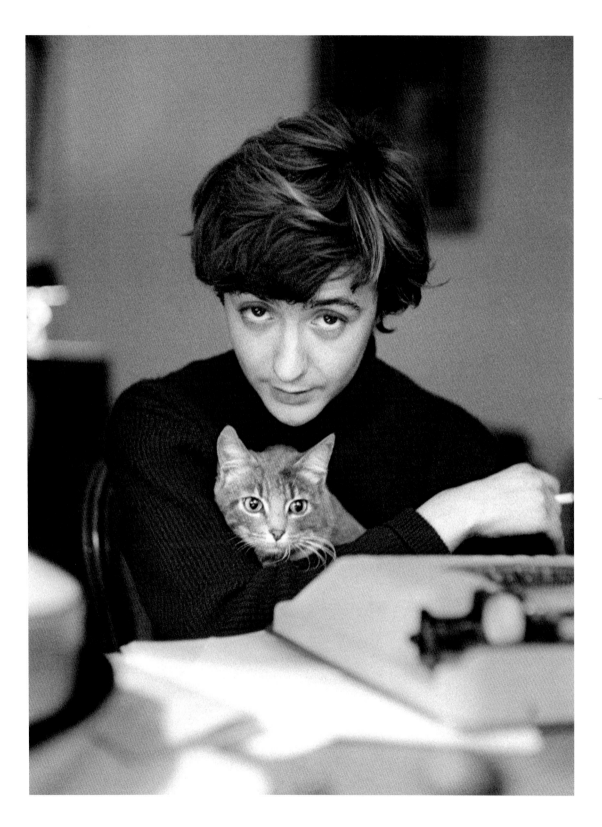

in the moment, rather than writing and projecting myself with such impudence and ludicrous self-importance into the future, dreaming of posterity and imagining for one second that what I've thought up and written down represents something at all original, worthy of diverting, comforting, or informing my peers?

What pride, really! What childishness! Posterity? What a joke! You'd have to be a lunatic to believe that a word, a sentence, even an idea could ever improve the lot of humankind!

The cat presents a living temptation to authors. It is the temptation of silence; or idleness, wisdom, resignation—whatever you want to call it. And this temptation is necessary. If writers can overcome it, if they can resist the delicious vertigo of idleness and that kind of skeptical hedonism or unspoken philosophy proffered by the silky incarnation of the cat, then, yes, perhaps what they write will be a little less trivial, a little more serious or genuinely joyous, a little less pedantic, a little lighter and more lucid, a little less constricted, as if cleansed of the noisome lies and illusions that cats are the first to dispel among us.

The cat is silent, secretive. It's embarrassing even to put down such an obvious statement. But it may well be that it is this secret (the infinite depth of its eyes, the spark of the sacred that flickers within it) which, as it were, drags a reaction out of the writer, forcing him or her to "come clean." It is impossible to be deceitful with a cat around. Impossible too—still more discouragingly—to become a cat; to be locked up in a cozy shell of intimacy.

What must it be like to have understood, like the cat, the most unknowable secrets of life and death, of the spirit and of passing time, of the conquest of happiness—and then, having reached such a stage of initiation (rather like those people who, because they are constantly traveling and going to far-flung places, never seem fazed), to choose to do nothing? Or else to do the only thing worth any sacrifice: to sleep, to wait, to screw up one's eyes, stretch, purr, arch one's back, and blithely ignore all the pointless goings-on around one?

There is an old Chinese legend that the American writer William Faulkner (1897–1962) was fond of telling. I quote it from memory. In former times, cats were the dominant species on earth. They had governments that appear to have been civilized. In other words, they were confronted with all the vexations inherent in the mortal condition: wars, famines, epidemics, injustice, stupidity, love of power, and greed. It had become intolerable. The wisest cats then

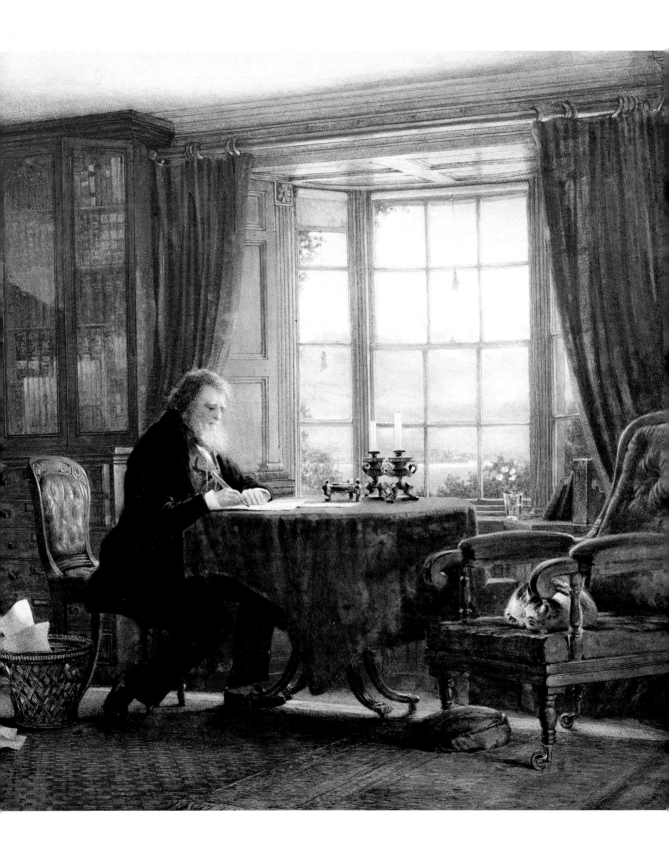

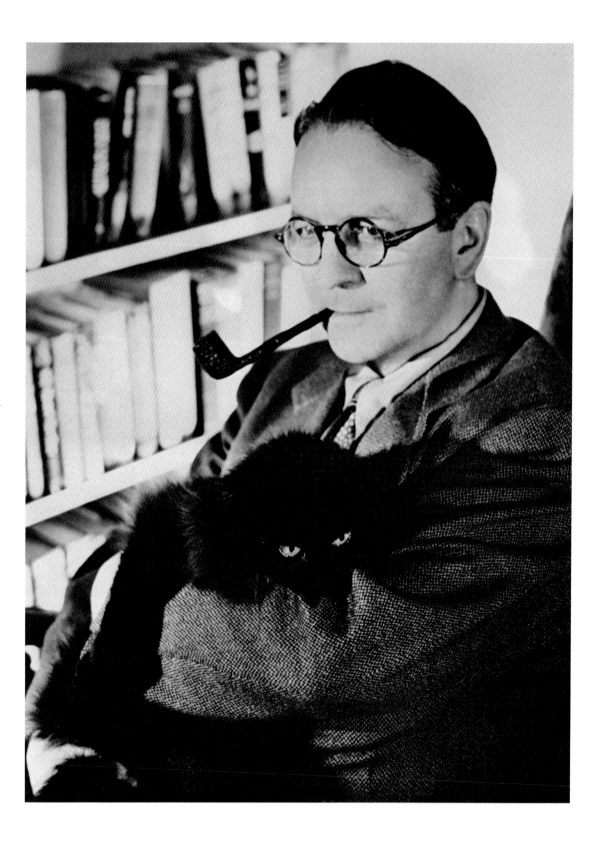

Facing page
"Raymond Chandler absolutely adored cats. Though this fact is hardly obvious in his work, it is blatantly and delightfully apparent in his letters." F. V.

Page 92
Cats are inordinately fond of lying down on books to stop you reading, as in *Woman with Cat* (1921), by Fernand Léger.

gathered into a great council to debate a solution. They deliberated at length. They argued. They thought up remedies whose inanity quickly struck them. There remained only one way out: to give up their responsibilities, to abdicate, to stop living as the dominant species, with all the burdens and miseries this implied. They still had to select, among the lower species, one capable of replacing them: one optimistic enough to think they might find solutions to their unhappy destiny as mortals, and yet ignorant enough never to be able to acquire their knowledge—their knowledge as cats. So they chose man and handed over to him. Humans snatched at the chance greedily, while the cats faded into the background, reveling in their newfound comfort and looking at humans with eyes that have forgotten nothing.

And this brings us back to writers, who are unable ever to truly know their cats, just as they cannot fathom all the secrets of knowledge, but who nevertheless try to come to grips with them. And it is the approach that's the important thing. For there can be no other reason to line up words, to compose sentences, to organize, in the last analysis, a little music with a little thought. In short, to cure oneself of not being a cat, of never reaching that inaccessible point in life where the greatest wisdom coincides with the most unredeemable indifference to wisdom, just as the knowledge of eternity is folded up in a single moment—a moment of life that contains everything, past and future alike. Then, an author can start to write, and this act is perhaps the only genuine consolation.

On the writer's desk, piled high with bundles of paper and on which a computer has recently begun to occupy a substantial place, the cat and the writer look at one another, face to face, as if from either side of a mirror.

It is a great error to believe that a reflected image presents the exact double of the original image. It is precisely the reverse. Everything on the right passes over to the left, etc. Writers are thus just the opposite of their cats. They look at them and envy them. Since they can't take the place of their cats, they write: there is no other solution.

Their cats gaze back at the writers. They feel sorry for them, though they might judge them, due to the solitude and silence they have chosen, as marginally more bearable than other humans. The cats may well be thinking back to the time when they were, in a way, in their place. Today, though, they are quite satisfied with their fate and they purr contentedly.

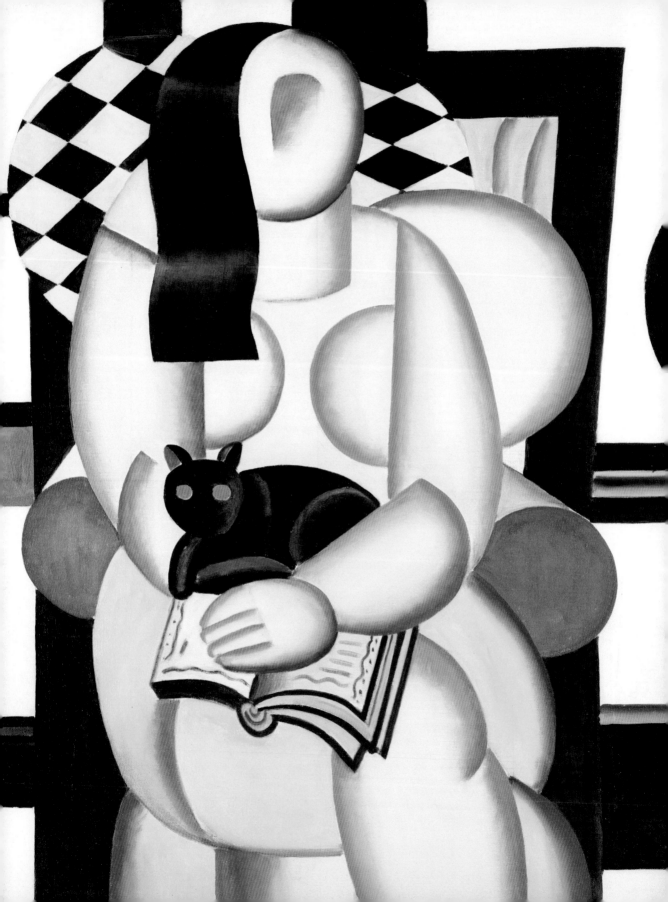

I write so much
because my cat sits
on my lap. She purrs
so I don't want to get up.

Joyce Carol Oates

Felix the Cat

It would be inconceivable not to pay homage here to a cat that in his time was the most celebrated feline in the world. Even if they are prone to hyperbole, American publicists were in this case correct to dub him "The World's Most Famous Cat." His name: Felix (the Cat). He appeared for the first time on the silver screen in 1919 in a short film entitled "Feline Follies." The success of this cartoon, which only lasted a few minutes, was such that Pat Sullivan, the producer, turned out more than one hundred and fifty more— the famous Pat Sullivan Cartoons. Animations starring Felix the Cat thus appeared as fillers in between innumerable feature films in every movie theater and on every screen all over the world. His career was assured: he had gone global.

Felix the Cat, superstar? Of course! Douglas Fairbanks, Mary Pickford, Ramón Novarro, Lillian Gish, Rudolph Valentino, and those other American stars of the silent screen could kindly leave the stage—Felix the Cat had upstaged the lot of them. But unfortunately, just like all too many cinema gods of the era, he found it hard to make the leap from silent films to talkies. Was it a question of vocal training? No, not that.

The truth is that another star was beginning to put his nose— and his big, round ears—into show business. And the height of irony was that this was no rebranded 1930s puss, but a mouse. What humiliation. The rest is history.

But Felix the Cat was a real celebrity at the time, an all-conquering hero of all five continents. For a start, there was no language barrier to hinder him. No social prejudices reduced his appeal among viewers. His antics, his rages, his escape acts spoke to all. He also had a late-blooming career in comic books. After all, the character had to be exploited in every possible medium. Certain historians claim he first hit the American newsstands in a comic in October 1917, so I take them at their word, but it's not that important.

It was on the screen, first and foremost, that he was unforgettable, and even today—when his escapades seem swathed in a kind of naivety, a freshness, an innocence, like that of primitive painting—he has his fans, his groupies, his collectors, his maniacs, and his nerds.

Facing page
With his funny-looking body and his cheeky temperament, Felix the Cat became one of the foremost "stars" of the twentieth century.

Blessed Felix the Cat, with his gently swinging gait, his amazement at the world, his audacity, and the ease with which he turns into a cowboy when he needs to get rid of some Arizona outlaw, or into a spaceman when he finds bad guys on the moon. It doesn't take him long to get over his fright. He's a cat with more than one trick up his sleeve. In fact, he has a bag full of them—a magic bag that turns into a boat or a plane and that contains an infinite stock of objects of all sizes, an entire room of props to assist him in his battles.

And our friend Felix has more than his fair share of adversaries. In particular, an evil professor and his sidekick, Rock Bottom, are ready to do anything to get their mitts on the famous bag (which is understandable). Luckily, Felix can count on some precious allies, like the young science whiz Poindexter—who is, in fact, none other than the professor's nephew.

Did I say Felix the Cat, superstar? Proof, if proof were needed: he really was the first star in the whole history of television. Literally. In 1928, as technicians and researchers at RCA were hard at work researching the best conditions for transmitting a TV picture (scanning sixty lines, if there are any connoisseurs of such matters among you), what deathless star did they use as a guinea pig? Felix the Cat, of course, a tiny, black-and-white statuette of our favorite hero, filmed revolving on his axis, while researchers tuned the picture on screens the size of a pocket handkerchief: Felix the unforgettable.

His name alone was a brainwave. Felix. How obvious, unarguable even, this name appears today. Felix, like feline; Felix like *felis*, the Latin word for cat; Felix, *felix*, happy, like felicity, and so on. There's no two ways about it: the name Felix says it all. And even today, decades and decades after the disappearance of our friend Felix from our screens, everyone knows his name, and everyone connects the name with a cat. Certain savvy manufacturers even took the name for a cat food. They're no fools.

Right
Felix the movie star as a giant balloon, flanked by other characters from the series, at a Thanksgiving parade in Manhattan.

He seems the incarnation
of everything soft
and silky and velvety
a dreamer whose
philosophy is sleep
and let sleep.

Saki

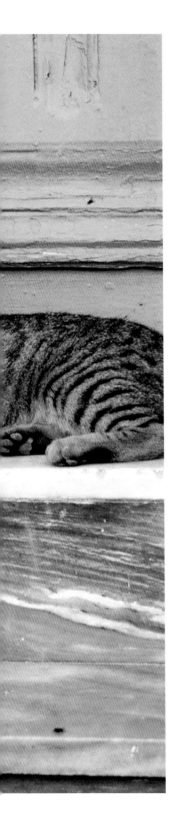

Origins

The domestic cat is a close cousin of the wildcat: the *Felis sylvestris* of Europe, the *Felis libyca* of Africa, and the *Felis ornata* of Asia. But, as every naturalist will tell you, and as the French naturalist Georges-Louis Leclerc, Count de Buffon, had already realized in the eighteenth century, there are important anatomical differences between these two and it is impossible for them to interbreed. So?

I rather like the fact that our ordinary cat, *Felis sylvestris catus*, has remained so mysterious for so long. Its exact genealogy, its geographical origin, is unknown. It has kept its secrets under wraps: its biological classification is far from simple. Even scientists are stumped. Recently, things have begun to become a little clearer.

Let's go back in time—fifty million years, in fact. That remote era, the beginning of the Tertiary Period, witnessed the arrival of the Miacidae, distant antecedents of cats, dogs, leopards, and other beasts. Skipping forward some ten million years, we meet *Proailurus*, halfway between a cat and a civet. In the Neocene, a mere fifteen million years back, flourished *Pseudaelurus*, with a head of fully developed, razor-sharp canines, comparable to that of the cat, and digitigrade as well (meaning it walked on tiptoe).

This genealogy is getting irritating. Let's speed up a bit.

Making its way from Asia to Europe, Africa, and North America, *Pseudaelurus* spawned a number of families, such as the *Smilodons*. This was a mere twelve million years before our time. Briskly enough (well, some seven million years later), the Felidae family split into two subfamilies: the Felinae (smaller felines, including the cougar, the lynxes, and the cat) and the Pantherinae (the big cats, including the tiger, the lion, and the leopard).

And that's that.

So, these are the Felinae, carnivorous mammals like their predecessors, one genus of which—Felis—developed (but how and when?) into the wildcat and then into the animal heinously dubbed the "domestic" cat, some ten thousand years ago.

Does this get us very far? Perhaps.

In any case, it should, if anything, increase our respect for the ordinary cat, which has such a lengthy history behind it, and which attained its anatomical perfection, suppleness, elegance,

energy, distinction, and wisdom, even, while our forefathers were still huddled up in damp caves, communicating with grunts, desperately knapping flints, and altogether in a lamentable ignorance of the safety razor.

Perhaps the cat was instrumental in civilizing, in humanizing humankind; that is, in inculcating us with a sense for beauty.

In a once-inhabited site near Jericho, vestiges of cat bone have been discovered interred beside human remains. Both date back some nine thousand years. The coexistence of cats and humans is therefore an ancient story. Though fiercely independent, each felt a need for the other, and they seem to have been prepared to repose like brothers in the same tomb. It's an old story, but, more than that, it's a beautiful one.

Let us recap.

The cat is there, standing before us. Immutable, it seems. Its origins date back to the dawn of time. I love that expression: "the dawn of time." The cat, a nocturnal animal, is at home in the dark. There it crouches. There it can hide away from the impertinent investigations of scientists, of tomb-robbers, and of the plain nosy. And then, come dawn, it emerges, as if by magic, from that dark night, and blesses us with its presence.

Perhaps it has nothing to do with the *Felis sylvestris libyca* that biologists today believe was its ancestor; nor even with the improbably named *Pseudaelurus*.

Perhaps it was conjured up one fine day by a wizard or created by a god in his image, to make our lives a little less ugly, a little less drab.

Who knows?

Pages 100–101
"These cats, the result of haphazard crosses and one-night stands, these cats of no breed." F. V. Soaking up the sunshine, they lounge on a front step where Hans Silvester photographed them.

Facing page
A head for heights: Marie Babey's photographs explore the life of the cats living in and around old houses near the Canal Saint-Martin in Paris.

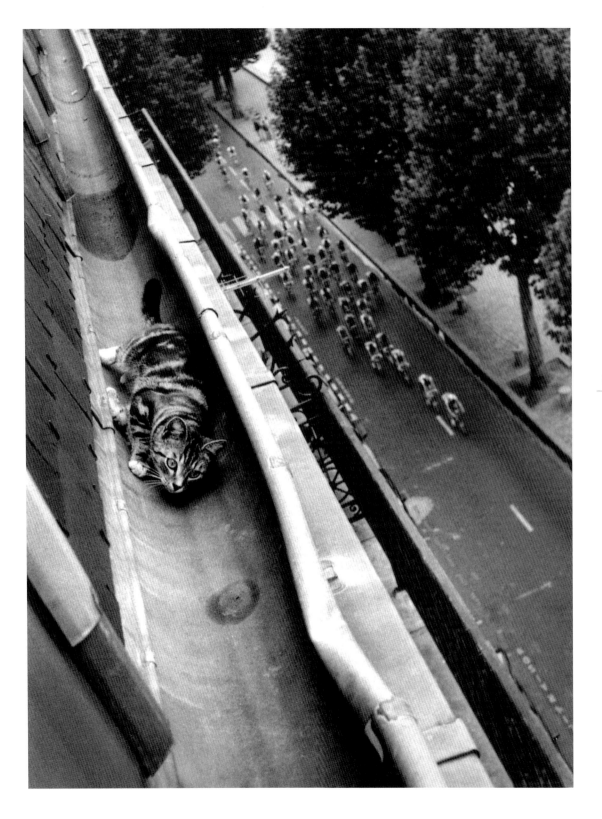

Tweety and Sylvester

The cat/mouse combination has inspired some really memorable cartoons. One thinks immediately of *Tom and Jerry*—that goes without saying. But the cat/bird twosome is not far behind. This time top of the bill is awarded to the series *Tweety and Sylvester*, two unforgettable characters to which I would like to offer a heartfelt tribute here.

Firstly, for our present purpose, we should consult their ID cards. Give honor where it's due, and allow us to commence with the cat:

— Name: Sylvester.

— Date of birth: 1945, in "Life with Feathers."

Note first that at this juncture he has not yet crossed swords with Tweety.

— Type of animal: feline.

— Species: *Felis domestica*, or, more familiarly, domestic house cat.

— Distinguishing features: large, thin, innocent look, rather clown-like nose.

— Infirmity: afflicted by a perceptible lisp, unlucky to the core.

— Notable characteristics: congenial, gullible, never discouraged.

— Favorite food: Tweety the canary.

— Favorite occupation: chasing said Tweety, who constantly teases him from behind the bars of his cage or from the branches of a nearby tree.

— Father: Fritz Freleng, born Kansas City, 1906, died California, 1995, an animator, cartoonist, director, and producer. In the course of his career he won four Academy Awards.

And now let us come to his opponent:

— Name: Tweety (Bird).

— Name at birth: Orson.

— Date of birth: 1942, in "A Tale of Two Kitties," the cartoon in which he appears for the first time.

— Type of animal: bird.

— Species: *Serinus canaria* or, less scientifically, (yellow) canary.

— Sex: male (though some researchers contest this point).

Facing page
Tweety and Sylvester: one of the most famous animal duos in the history of the cartoon.

Pages 106–7
Tweety, the death-defying canary, always escapes from the jaws of his "frenemy."

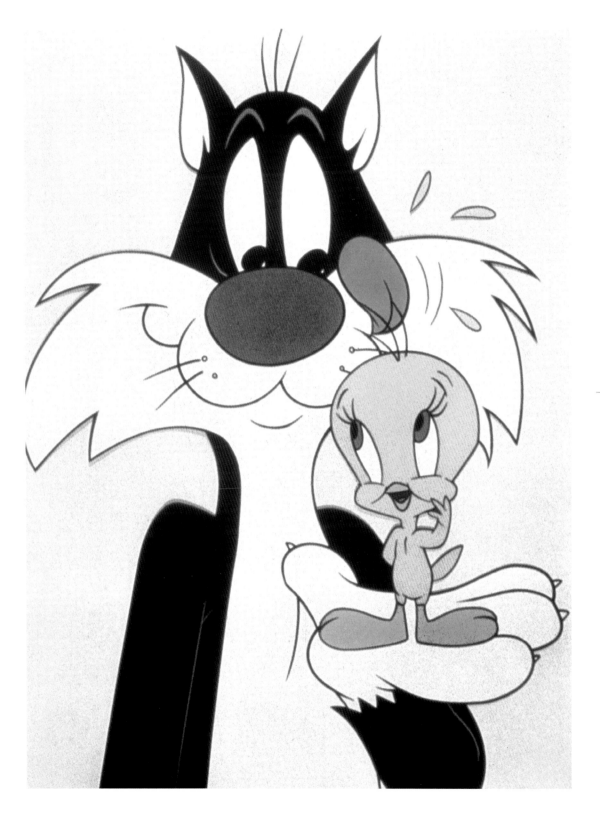

— Eyes: blue.

— Distinguishing features: an enormous head.

— Infirmity: a speech defect by which he pronounces the letter "s" as a "t" or "d," for example.

— Notable characteristics: crafty, quick to anger when his feathers are ruffled, fearless, generally enjoys life, and quite sociable when nothing threatens him.

— Most important encounter: with Sylvester, in 1947, in "Tweety Pie," a cartoon produced by Warner and awarded an Oscar. Consequently, the lives of the canary and the cat would be inextricably entwined in dozens and dozens of animations, until 1964. (Arranged by Fritz Freleng, this marriage would prove to be one of the most remarkable and fertile in the whole history of American animated film.)

— Memorable utterances: "I tawt I taw a puddy tat" (in the vernacular, "I thought I saw a pussy cat"); "Poor old puddy tat."

— Father: Robert Clampett (1913–84), one of the outstanding figures in US animation, who began his career as a collaborator with Walt Disney, joining the Tex Avery team before working on Warner's *Looney Tunes*.

The cat, in general, does not have it all his own way in these historic cartoons that served as the staple fare of our childhood.

Given how devoid of critical spirit one is at an early age, how could one fail to be on the side of Tweety the canary—who clearly seems more fragile, more vulnerable—just as easily as one tends to root for Jerry against the frightening Tom? But, actually, how can one not sympathize with Sylvester? Blundering, sensitive, determined, badgered by this bird of ill-omen. He puts into action every single imaginable plan, dreaming up the most unlikely schemes to attain his ends. He never does attain them. But hope springs eternal—though not much hope, actually. That's the great contradiction. The cat chases the mouse, the cat chases the bird. But it's no good, it's old hat.

Having parodied this age-old antagonism for so long, perhaps cartoonists themselves made it seem a thing of the past. And about time, too. In the end, the cat joins forces with the mouse and the canary becomes the cat's buddy. The fighting's all a sham. There is a difference of opinion. But it's all just for laughs.

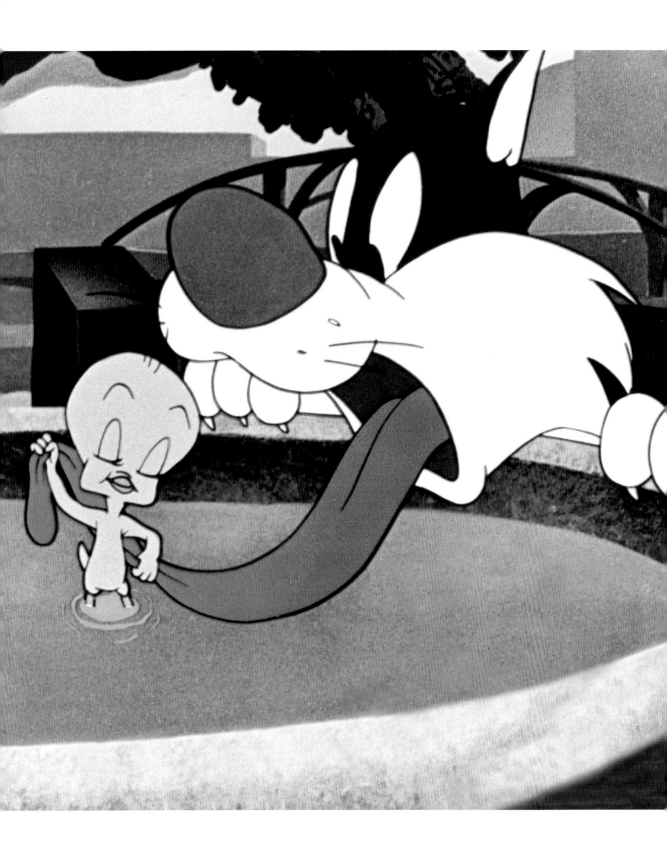

Who can
believe that
there is no soul
behind those
luminous eyes!

Théophile Gautier

Hemingway

It was in the Luxembourg Gardens that Ernest Hemingway first encountered Gertrude Stein. "I cannot remember whether she was walking her dog or not, nor whether she had a dog then. I know that I was walking myself, because we couldn't afford a dog nor even a cat then, and the only cats I knew were in the cafés or small restaurants, or the great cats I admired in *conciergeries*." (*A Moveable Feast*)

Is this an irrefutable sign of Hemingway's poverty, that he couldn't even afford a cat? The passage shows at the same time his interest in the animals and the destitution in which he then lived. After a certain amount of traveling and the birth of his son, "Bumby," in October 1923, Hemingway and Hadley, his wife at that time, returned to settle in Paris. From then on, they shared their life with a cat: "Alone there was no problem when you got used to it. I could always go to a café to write, and work all morning over a *café crème* while the waiters cleaned and swept out the café and it gradually grew warmer. My wife could go to work at the piano in a cold place and with enough sweaters to keep warm playing, and come home to nurse Bumby. It was wrong to take a baby to a café in the winter, though; even a baby that never cried and watched everything that happened and was never bored. There were no babysitters then, and Bumby would stay happy in his tall cage bed with his big loving cat named F. Puss. There were people who said it would be dangerous to leave a cat with a baby. The most ignorant and prejudiced said that a cat would suck a baby's breath and would kill him. Others said that the cat would lie on the baby and the cat's weight would smother him. F. Puss lay down beside Bumby in the tall cage bed and watched the door with his big yellow eyes, and would let no one come near him when we were out and Marie, the *femme de ménage*, had to be away. There was no need for babysitters. F. Puss was the babysitter."

How can a cat—an animal notorious as being underhand, spiky, unpredictable, egoistical, wary, solitary—how could a cat be left to look after a child? You need to be Hemingway to invent that. To dare to. To turn Paris into a feast and a big tom into an irreproachable nanny.

Facing page
From Paris to Cuba, there was always a cat in Hemingway's life. The photograph here shows him with his wife, Mary, and their cat, in the garden of their house in Cuba in 1954.

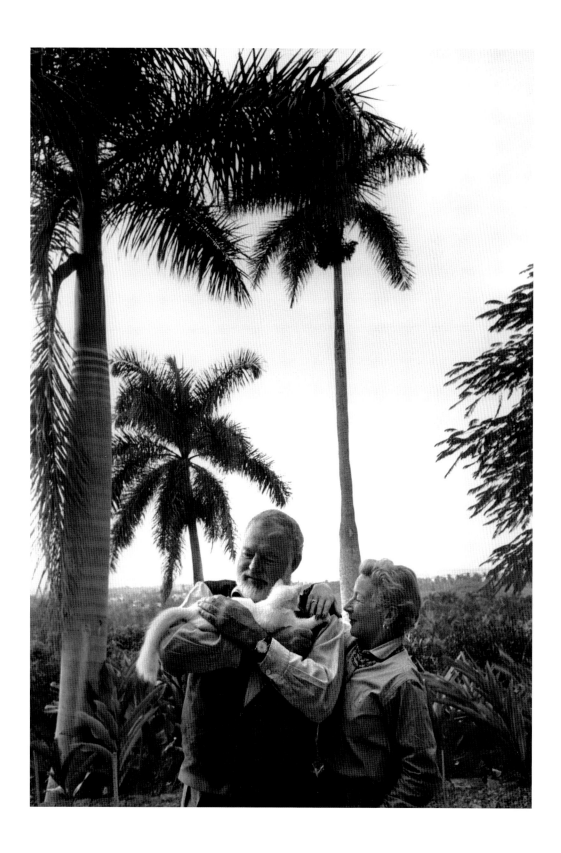

A cat makes a home a home;
a writer is not alone with a cat,
yet is enough alone to work.
More than this, a cat is a walking,
sleeping, ever-changing work of art.

Patricia Highsmith

Pages 114-15 Throughout her life, Patricia Highsmith lived with cats—more precisely with Siamese cats. This is a 1985 photograph by Gérard Rondeau.

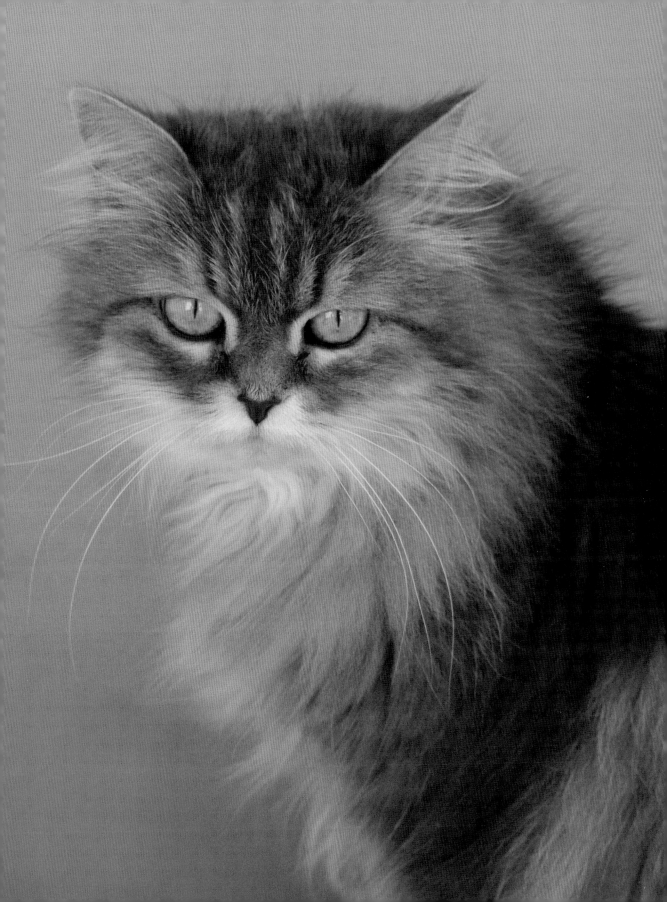

Highsmith

I remember seeing Patricia Highsmith (1921–95). It was at the end of the 1960s. I spotted her at the Café des Sports, on the corner of rue Saint-Louis and rue des Deux-Ponts in Paris. She was a regular. Sitting at a formica table, thoughtful; benumbed, perhaps, by alcohol vapor. She was probably dreaming up macabre stories, diabolic novels, perverse characters, innocent assassins, guilty victims—who knows? Perhaps she was thinking of her cats? But I couldn't know that, as I was unaware then that she loved cats.

She explained this simply and compellingly in a short piece originally published under the title "On Cats and Lifestyle" in the journal *Murder Ink* in 1979.

This is what she wrote: "A cat makes a home a home; a writer is not alone with a cat, yet is enough alone to work. More than this, a cat is a walking, sleeping, ever-changing work of art."

Patricia Highsmith, however, could not prevent herself from slipping the odd cat, if not into a novel, then at least into a short story or two, where they could play a starring role (or almost) without it sounding false or artificial, as she justifiably feared it might in more extensive fiction. It is diverting to learn that the "something" in the tale *Something the Cat Dragged In*, set in a manor house in the English countryside, is several human fingers. In *Ming's Biggest Prey*, set in Acapulco, the feline justifiably cannot bear the string of lovers his young owner brings back to the house; just as one of them is preparing to purloin the woman's necklace and vanish into thin air, the cat manages to eliminate this unscrupulous wretch without a trace.

Though Patricia Highsmith certainly "invents" a glorious collection of characters (unhinged, bloodthirsty, or simply terribly good at crime), she never overplays her hand when it comes to describing cats and their ways. In short, in Patricia Highsmith's eyes, a cat is just too *cat*, too marvelously and naturally *cat*, for her to feel the need to embellish it.

For this single but simple and decisive notion, the great novelist Patricia Highsmith deserves our respect.

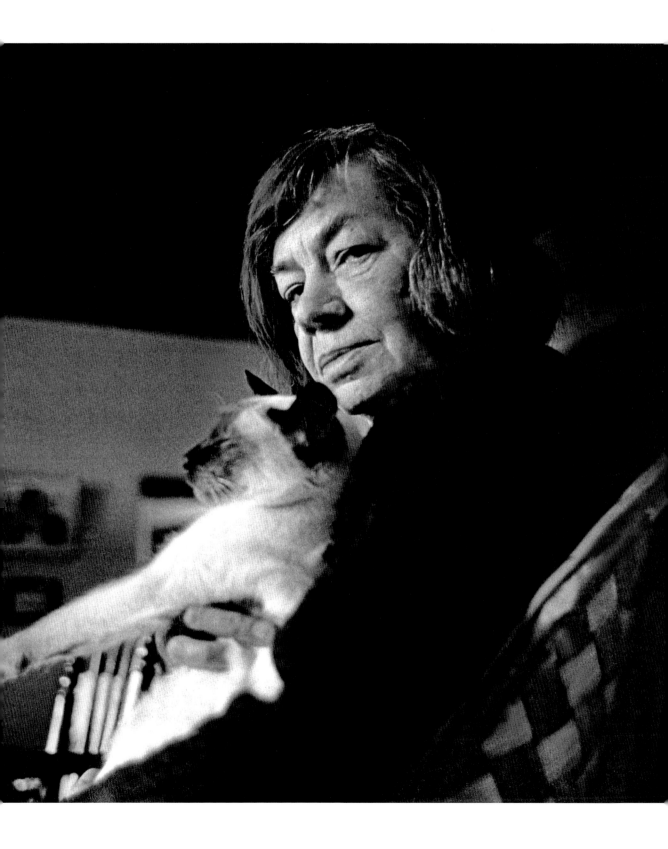

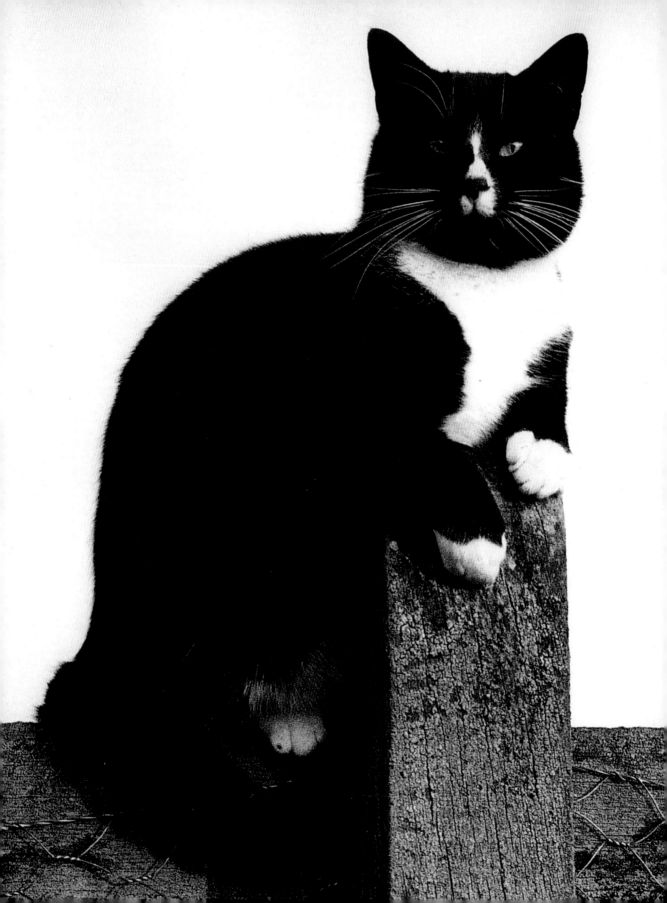

Dogs look up to us.
Cats look down on us.

Winston Churchill

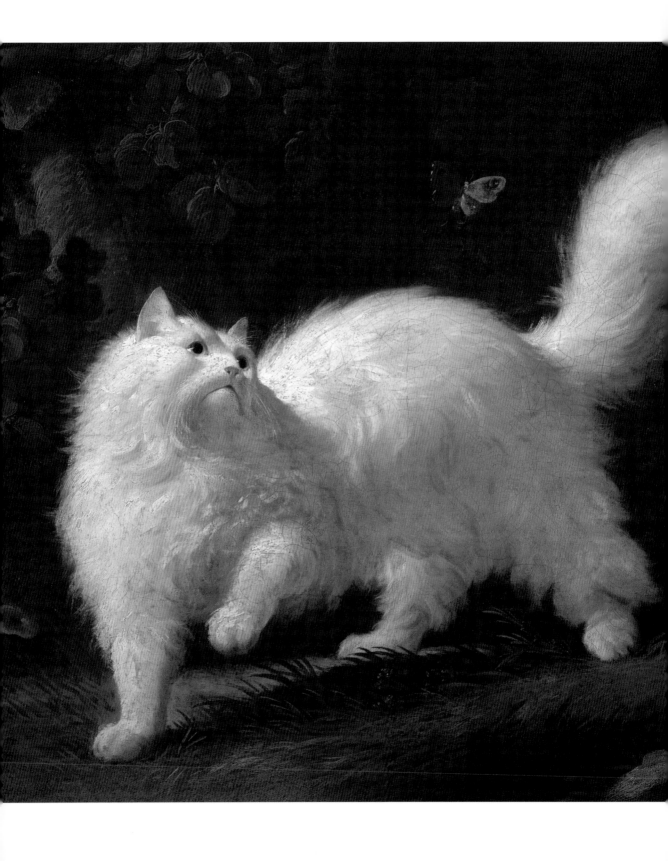

Purveyors of Pedigrees

Some men make a fortune (or at least dream of striking it rich) by importing a rare and valuable product that they think they might be the first to have discovered, something that will delight their compatriots. These wily wheeler-dealers cannot speak too highly of their new-found treasure. They burst with pride. And they're right to—especially if they manage to make their future customers as happy as they themselves seem.

At the dawn of the seventeenth century, two remarkable individuals, an Italian aristocrat, Pietro della Valle, born in Rome in 1586, and a French notable named Claude Fabri de Peiresc, born six years earlier and councilor at the Parliament of Aix, were very much of that ilk. And what did they bring to the notice of their compatriots?

Cats. Not ordinary cats; not those that already more or less thrived in Europe, short-haired and a long way from being pedigree, but exceptional, exotic, refined, gorgeous, silky-coated cats from the mysterious East. Cats that were, in their eyes, wonders of the world; cats without a price (that is, cats at a price), and, better still, pet cats (pasha cats, as it were), much-vaunted felines of unadulterated sensuality; cats one would certainly never pack off to the pantry with orders to eliminate mice, absolutely not. So, it was thanks to Pietro della Valle and Claude Fabri de Peiresc that the West first encountered not just other breeds of cat, but the beauty of the cat for itself: the cat as companion and work of art, the cat as delight and grace.

The Italian painter Alberto Savinio (brother of painter Giorgio De Chirico), who was one of the most witty and subtle writers of the twentieth century, observed that the quintessence of civilization is the triumph of superfluity over necessity. And indeed, one may well say that the new types of cat brought back by our two gentlemen testify precisely to this hard-fought victory. These were superfluous cats. Or, alternatively, indispensable cats. Luxury cats. Cats of high culture.

Pietro della Valle was an inveterate traveler. After working in the service of the Pope, he went to Venice, then a great commercial capital. From there he set off for Egypt, reached the Holy Land, and then Syria and Persia, where he acted as a mediator between the Shah and the Christian communities of the country.

Pages 118–19
Toying with a butterfly,
this white Angora
with a feathery tail
was painted by Jean-
Jacques Bachelier in the
eighteenth century.

Facing page
With its timid
expression, this white
Angora seems almost
embarrassed to be so
pretty.

He then made his way—or rather a ship did—to India. Through-out his journey, he corresponded with a professor of medicine in Naples, Mario Schipardi. Their letters were published, translated, and publicized all over Europe as early as the middle of the seven-teenth century. In one of these missives, sent from Isfahan on June 20, 1620, he announced his first discovery (I quote from Laurence Bobis's invaluable *Histoire du chat* [History of the Cat]):

Having seen here a very beautiful breed of cat, originally from the province of the Khorasan, and of a grace and quality quite different from that of the Syrian type (which, however, we hold in great regard, but that beside those of Khorassan are as noth-ing), I was seized by the desire to bring the breed back to Rome. In size and shape, they look like everyday cats: their beauty consists in their color and their fur. They are of a gray color, without stripes or spots, but plain all over the body; some areas are lighter or darker, however: the back and head are darker, while the breast and belly are lighter, sometimes to the point of being almost white.... Moreover, the fur is very fine, light, shiny, and as soft as silk; and so long that, although it is not really curly, in certain places nevertheless it forms waves, espe-cially at the throat and breast, and on the paws. In sum, the cats of the Khorasan are to other cats as what we call barbet spaniels are to other dogs. Their most beautiful feature is the tail: rather long, it is tufted with hairs so full that their span is a good half-palm, and they look like those of a squirrel: so much so that, like squirrels, they fold them up over their backs with the tip forming a plume, to most graceful effect.... I've put together four couples of males and females to reproduce them and bring some of good pedigree back to Rome: I intend to take them along on the journey in cages, in the way the Por-tuguese have taken some of them as far as India.

What exactly happened to these Khorasan cats (today one would call them Persian), no one actually knows. Probably several made it to the Eternal City, but there are no reliable historical docu-ments to tell us how they acclimatized to the banks of the Tiber, or of the impression they might have made on the Pope's loyal subalterns.

Peiresc was on the road much less than della Valle. He thought it was enough to get his cats sent in from Asia by merchants

and correspondents. Some originated in "Ancyre" or "Angoury" (ancient names for Ankara), and, as their source suggests, were of the angora type. In his eyes, no gift could be as precious as this rare, beautiful, and inestimable cat.

He was soon informed about another breed of cats, however: the famous Persians unearthed by Pietro della Valle. This is how Laurence Bobis relates the events:

> In Damascus, Father Théophile, his emissary in the Orient, had spotted a man carrying a couple of very white cats, with long hair like water spaniels, which hailed "from the land of the Mongol" and were intended for the "Great Lord of Constantinople." His curiosity whetted, initially Peiresc doubted the very existence of such a cat, thinking that Father Théophile might have confused it with an ounce. Then it dawned on him that the rank of the personage for whom they were destined did indeed suggest that the species was likely to be a rare one. Not long afterward, a merchant from Marseilles assured him that he too had once caught sight of one of these white cats with a feathery tail, more beautiful than that of a barbet.

Peiresc's correspondence shows us how he managed thereafter to acquire and breed a number of these novel cats, mating them and producing a thriving community. They were then used as an alluring and universal form of currency, with Peiresc creating a demand that he only satisfied frugally, so as to make their value rise. If he had his eye on purchasing some ancient vase, for example, he would inform a middleman that, as a bonus, he would promise the seller two or three of his cats, with the proviso that no one should "boast of this promise, because other dignitaries of the most eminent condition were pleading him for them."

In spite of Pietro della Valle and Claude Fabri de Peiresc, their first importers, the rarity of both Persian and angora cats was to persist for some time—as if Europe was not yet ready for such refinement, or such luxury. Or for such a level of civilization.

Purveyors of Pedigrees

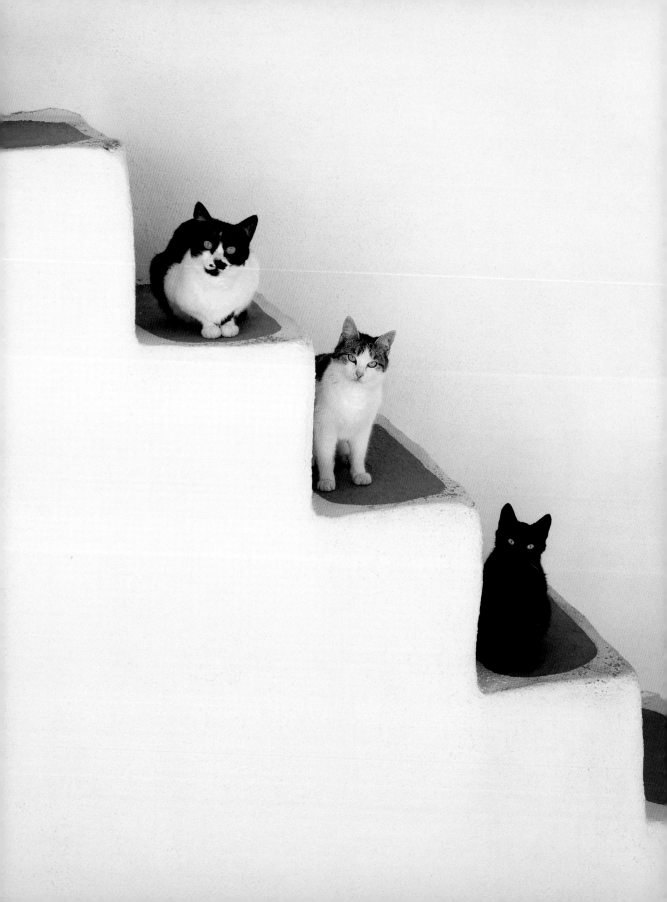

No matter how much
cats fight, there
always seem to
be plenty of kittens.

Abraham Lincoln

Kipling

Kipling, the great Rudyard Kipling (1865–1936), is an immense writer, whom today too many intellectuals and readers persist in neglecting, seeing him only as a children's author, or—more unforgivably stupid still—as the spokesman for British colonialism and imperialism in the Victorian and Edwardian era. Kipling had little to say about cats.

His bestiary is otherwise extensive. His two *Jungle Books* swarm with monkeys, panthers, tigers, and wolves, to mention but a few. Dogs are ever-present in his fiction. As are elephants, horses, camels, and the fish of the North Atlantic. He observed them all, wherever he lived, in Asia and in Africa, in America, and in the oceans around him.

But cats?

An animal does bear the name of "Cat" in one of his short stories, but the word designates a polo horse. In a collection of his early short stories, which he subsequently put to one side and didn't wish to see anthologized, *Abaft the Funnel*, there appears another rather ragged (if very dignified) cat named Erastasius, boatswain to the captain of a leaky tub, *The Whanghoa*. It is the cat that, one dark night, saves the crew and the cargo by mewing in terror in the captain's cabin and thus raising the alarm.

But such lip service hardly amounts to much, and Kipling would in all likelihood have simply been absent from this miscellany had he not written a short but brilliant tale called "The Cat That Walked By Himself," published in 1902 in his *Just So Stories*.

In a matter of a few pages, it tells a beautiful, poetical, picturesque, marvelous story—and one would like to become a child again just to be read it at bedtime. More than this, Kipling shows a remarkably intuitive understanding of the cat in this story, of its uniqueness, its independence, and its love of creature comforts. Perhaps, if it one day becomes necessary to inform a foreigner, an extraterrestrial, even, what exactly the animal we call a cat is—the character it embodies and the temperament it manifests—well, one could do worse than hand them these dozen or so pages by Kipling.

So let's read them once again.

In the beginning, the world was a wild place, the animals were wild, and Man was wild too. Then Woman came forth. Man

Facing page
"The Cat That Walked By Himself," illustrated by Hervé Le Goff, for a children's book.

"didn't even begin to be tame till he met the Woman, and she told him that she did not like living in his wild ways."

She took up residence in a cave she kept neat and clean, and demanded that her companion now wipe his feet before entering the abode.

Then they had to tame the animals. This posed little problem for Woman. First came Wild Dog. Woman threw him a mutton bone. Dog tucked in. Woman told him: "'Wild Thing out of the Wild Woods, help my Man to hunt through the day and guard this Cave at night, and I will give you as many roast bones as you need.'" Of course, Dog obeyed and became tame. The listening Cat, however, laughed and exclaimed: "'That is a very foolish Dog.'"

Woman operated in the same fashion with Wild Horse, thanks to the "good grass" she was drying in front of the fire. The Horse also bent to her will. But the Cat—after observing that "This is a very wise Woman, but she is not so wise as I am"—resisted, declaring: "'I am the Cat who walks by himself, and all places are alike to me. I will not come.'"

After Horse, Wild Cow was captured, or captivated, by Woman. The Cat felt sorry for her. But one day he made his way back to the cave, watching as Woman milked the Cow, seeing the bright fire in the cave, and breathing in the smell of the white, lukewarm milk. When Woman saw him, she tried to drive him away: "'You are the Cat who walks by himself, and all places are alike to you. You are neither a friend nor a servant. You have said it yourself. Go away and walk by yourself in all places alike.'"

The Cat stood his ground. But then, imprudently, Woman made him a promise: if she let out but one word in his praise, he could enter the cave; another, and he'd be permitted to sit down close to the fire; a third, and he could lap at the white, tepid milk three times a day. But Woman was sure that this time would never come.

As evening fell and Man, Horse, and Dog returned from hunting, she said nothing about the arrangement she had made with the Cat, for fear of displeasing them.

One morning several months later, Bat said to Cat: "'There is a Baby in the Cave. He is new and pink and fat and small, and the Woman is very fond of him.' 'Then my time has come,'" thought Cat.

Woman was busy cooking and Baby cried and cried. Cat advanced his nose. "Then the Cat put out his paddy paw and patted the Baby on the cheek, and it cooed." Then the "little

Below
A French edition
of Kipling's tale.

upside-down bat" informed the Woman that "'a Wild Thing from the Wild Woods is most beautifully playing with your Baby.' 'A blessing on that Wild Thing whoever he may be,'" said the busy Woman. "'O my Enemy and Wife of my Enemy and Mother of my Enemy,' said the Cat, 'it is I.'" And so he entered the cave.

The Woman was angry, but a promise is a promise.

Later, when the Cat went away, the child bawled again. So the Cat returned to keep him amused, playing with a ball of string. And so Baby fell asleep to the animal's soft purr. Again the Woman voiced her gratitude and Cat sat down next to the fire.

Then a mouse ran past. The Woman was terrified; the Cat jumped on it, ate it, and Woman thanked the Cat a third time. And so now he could drink the milk.

End of story? Not quite.

The Woman warned the Cat that their bargain did not extend to the Man or the Dog. What would they make of such goings-on when they returned?

In the end, Man and Dog seemed ready to conclude the same bargain, provided the Cat caught all the mice and remained kind to the Baby. But the Cat's boasting and independence, the fact that he was always reminding them: "I am the Cat that walks by himself, and all places are alike to me," got on their nerves. So the Dog told him that he would continue running after him and chasing him up trees, and the Man said he'd still throw his boots at him.

The end of Kipling's story is rich and complex. It captures the dual nature of the cat, a dual nature that is his very essence—his liking for warmth and food, for all that's cozy, soft, and homely, and his love of solitude and independence, his refusal to be dominated—as it does the dual nature of men (and dogs), who want to make use of the cat, but who can at times be mercilessly cruel to him.

"Three proper Men out of five will always throw things at a Cat whenever they meet him, and all proper Dogs will chase him up a tree. But the Cat keeps his side of the bargain too. He will kill mice and he will be kind to Babies when he is in the house, just as long as they do not pull his tail too hard. But when he has done that, and between times, and when the moon gets up and night comes, he is the Cat that walks by himself, and all places are alike to him. Then he goes out to the Wet Wild Woods or up the Wet Wild Trees or on the Wet Wild Roofs, waving his wild tail and walking by his wild lone."

Prowling his own quiet backyard or asleep by the fire,
he is only a whisker away from the wilds.

Jean Burden

Facing page "I just adore Chartreux, why should I hide it?
They are my favorite (pedigree) cats." F. V.

Pages 132–33 There are two ways of forgetting the troubles of this life: music and cats,
wrote Albert Schweitzer. The photo is by Édouard Boubat.

"Kitten on the Keys"

Have you ever caught your cat shamelessly marching over your typewriter, or, more likely these days, your computer keyboard, without worrying whatsoever about the damage being caused and the work that has just been blithely sabotaged?

I remember my cat Nessie leaping onto my first Mac one day; her unwelcome intervention locked up the computer irretrievably and scuppered the document on which I was working, seemingly forever. The computer repairman I called to my rescue could not understand by what magic, by what amazing programming skill, I had managed to obtain a result that even he could never have dreamed of. Nessie, whose paws had performed the operation, looked at the fellow gravely, but offered no further enlightenment.

But back to our subject. In 1921, the American Zeg Onfrey (1895–1971) composed an absolutely irresistible piece for piano with all the funky beat, playful transitions, and spicy key-changes of ragtime.

Entitled "Kitten on the Keys," Onfrey's inspiration was (he informs us) his grandmother's cat, who (the cat, not the grandmother) used to wander over the keys of the piano that stood in the living room and elicit surprising sequences of notes in rather unusual rhythms.

I applaud musical cats and kittens, unlike the wretched Nessie on my computer keyboard. Ah, if only she'd typed out the feline equivalent of a poem by Rimbaud (as long as I could correct the spelling mistakes, of course): that would have been worthwhile.

He was a funny guy, Zeg Onfrey. He's rather forgotten today. Benefiting from a solid classical music education, and having absorbed Debussy and Ravel, at an early age he was lucky—or unlucky—enough to earn a good living as an arranger for variety orchestras and a composer of many jazz hits. He headed a band of his own for a time, and was a rising star of the Roaring Twenties.

But, today, who can even remember his name?

And yet, in its way, "Kitten on the Keys" remains a standard of the repertoire.

A cat's got her own
 opinion of human beings.
She don't say much,
 but you can tell enough
 to make you anxious
 not to hear the whole
 of it.

Jerome K. Jerome

Fabulous La Fontaine

Can we say that Jean de La Fontaine (1621–95), admirable author of the *Fables*; La Fontaine, the noble-hearted man and not the court gentleman, who always rated loyalty above honors, who never denied his friendship with the disgraced minister Fouquet (even if this meant displeasing Louis XIV); La Fontaine, one of France's greatest writers of prose and poetry, whose verse is so limpid, rich, rhythmical, and of such sublime simplicity; La Fontaine, who is perhaps studied to death in French schools—to the point that adults can't bear to read him (which is a sad state of affairs since it deprives us of such delight); can we say that La Fontaine, whom we all love and admire unreservedly, was a great friend of the cat?

Actually, no.

In his anthology on cats published in the late 1860s, Champfleury records one of La Fontaine's contemporaries and friends—suffering a rush of blood to the head, perhaps—writing: "La Fontaine portrayed the cat as he studied him, from every side, and as a master. La Fontaine is the Homer of cats." I've certainly read more nuanced praise. And more justified, too. Why not go further and tell us how La Fontaine is the Homer of crows, ants, lions, foxes, frogs, monkeys, tortoises, grasshoppers, hares, and the rest of the zoo? For, in all honesty, cats do not take a starring role in La Fontaine's bestiary. Indeed, the animal first appears as late as the fifth fable in Book VI, in the company of a cockerel and a "young mouse."

From the outset, the cat plays the villain. A scatterbrained young mouse is terrified of the young rooster, who beats his wings, and whose voice is piercing, whereas, "benign and gracious," the cat has no trouble in winning him over. "This animal who seemed to me so gentle… with such a modest glance and yet a shining eye" has soon inveigled the silly mouse.

For of course the cat's hypocritical wiles are entirely for show. And the moral of the story? It has almost become a proverb: *Guard against, for as long as you live / To judge others by the face they give.*

Things hardly improve for our favorite animal in "The Cat, the Weasel, and the Young Rabbit." Again, it is the cat's hypocrisy

Facing page
La Fontaine's *Fables*, as revisited by Robert Wilson for the Comédie-Française in 2004, in a spectacularly triumphant show.

that comes to the fore, a predominant characteristic that La Fontaine ascribes to him as the essence of his personality. A weasel and a young rabbit are arguing over an obscure affair of overdue rent or illegal occupation. In no time they decide to appeal to the cat as witness to—and even as judge over—the case, which seems most unwise:

This person was a hermit cat, / A cat that played the hypocrite, / A saintly mouser, sleek and fat, / An arbiter of keenest wit.

And here he is, the one La Fontaine calls Grippeminaud, complaining of his deafness and his great age and requesting that the plaintiffs approach the bench... closer... until:

[He] laid on each a well-armed paw, / And both to an agreement brought, / By virtue of his tusked jaw.

An even more ungenerous view of the cat is to be found in "The Cat and the Fox":

The cat and fox, when saints were all the rage, / Together went on pilgrimage. / Arch hypocrites and swindlers, they, / By sleight of face and sleight of paw, / Regardless both of right and law, / Contrived expenses to repay, / By eating many a fowl and cheese.

Still, the cat is even wilier than the fox. He has perhaps only one trick up his sleeve, while the fox has a range of stratagems, but, when a pack of hunting dogs tracks them down, the cat just leaps up to the top of a tree, while the fox runs round and round the trunk and is torn to pieces.

But let's draw a veil over that.

Hypocritical, duplicitous, thieving, merciless, crafty, cruel: just a few of the derogatory adjectives that rain down on dear puss. Had La Fontaine, as a boy in Château-Thierry, once received a painful scratch from a cat? Another reason—less incriminating—might be advanced for our fabulist. First and foremost, each of his stories had to be readily comprehensible, and the diverting situations he describes needed to be boiled down to the unambiguous, understandable moral at the end. So La Fontaine had to be prepared to rely on a zoological typology and stereotyped images readily understandable by the youthful (and less youthful) readership of the time.

La Fontaine had to zero in on the then generally accepted ideas about cats, however unjust they might be. It was from such stereotypes that he composed his incomparable fables, thus giving French literature some of its finest pages.

Strays

Hemingway famously said, "One cat just leads to another," and, in some countries, it seems as though stray cats outnumber the local residents. But are strays a dying breed? Ordinary housecats were commonly underfoot throughout the nineteenth and early twentieth century. A penniless student or bohemian artist who lived in a garret pursued his nocturnal love interest with the servant girls to the accompaniment of searing meows on the rooftops, with a crescent moon hanging from the chimney, the whole scene drenched in an overwrought romanticism. The felines in the rafters were immortalized by artists like Toulouse-Lautrec, serenaded by cabaret singers, and painstakingly delineated in the novels of Émile Zola. To me, these images all flow into one.

Stray cats, those roof-haunting mousecatchers, have all but disappeared; not least because the passageways in which they used to traipse from building to building are no more. Instead of rain gutters or zinc along the rooftops, modern buildings are now tower blocks made of concrete, steel, and glass. Lugubrious. And generally with individual terraces that are difficult for strays to access. The days of squeezing through dormers or attics into a maid's room at the top of the house when the weather turned nasty went out the window along with the maids and servants themselves. So the tender and melancholic urban landscape that the old tomcats inhabited is dying, and their freedom to roam along with it.

These disappearing cityscapes were the beloved backdrop for French author Paul Léautaud (1872–1956), stalwart urbanite who was known to crisscross Paris chasing after abandoned cats and dogs. Renowned for his animal obsession, he bequeathed the copyrights to his works to the local animal protection agency. "I must have had at least three hundred cats and 150 dogs. Not all at the same time, but the average was about thirty cats and a dozen dogs," he informed Robert Mallet in one of his celebrated radio interviews. "Each time a mistress leaves me, I adopt a stray cat: when one animal makes off, another turns up," he wisecracked. Hard to imagine how he'd manage today.

Facing page
Writer Paul Léautaud spent his entire life surrounded by dozens of cats. For him their company was the best of all.

It is a very inconvenient habit of kittens
(Alice had once made the remark) that,
whatever you say to them, they always purr.

Lewis Carroll, *Through the Looking-Glass, and What Alice Found There*

———————

Facing page Renoir's famous picture *Woman with Cat* (c. 1875)
seems to echo Champfleury's observation that cats are "like all creatures that invite caresses,
that give and receive them, like women."

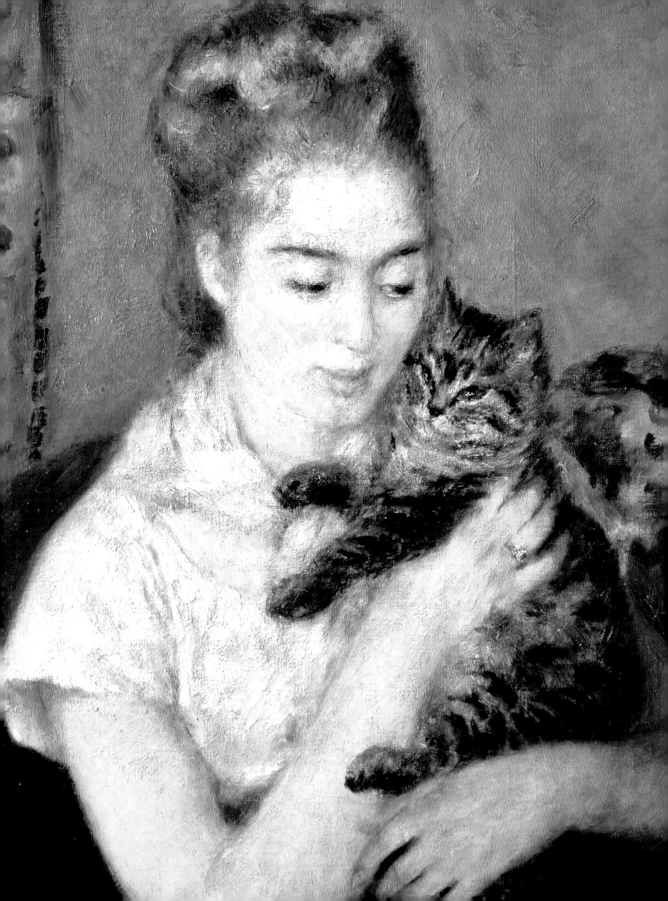

King Cat: Louis XIV

The subject of the following paragraphs is not some obscure king of France who reigned over Versailles and the seventeenth century, but a world-famous cat that lived in the middle of the twentieth century and answered, perhaps, to the name of Louis XIV.

He was the companion of Sanford H. Roth, an American photographer who was born in Brooklyn in 1906 and who died in 1962, and who throughout his career was constantly on the move, taking portraits of the celebrities of his era. He lived in France for years after the war, though he often stayed in Hollywood, where he was for a long time a staff photographer for *Life* magazine.

But let us return to Louis XIV, the vagrant, who was a beautiful Siamese—slender, moody, and intrepid, with proudly erect ears, as if not to miss a note of the music of the world. Roth had the simple idea of photographing his famous models, not in the company of any pet of their own, but posing each time with *his* cat.

And so who was Roth actually taking his photographs of? The movie star, the much-vaunted writer, the master of painting? Or, really, of Louis XIV, still and always Louis XIV? We are inclined to go for the second option.

In 1950, in Colette's apartment in the Palais Royal, we surprise Louis XIV turning his back and preferring to gaze out the window, while in the foreground the authoress, plunged into half-light, seems to be reading a letter. Then, that same year, there's Louis XIV again, perched on the shoulders of the poet Blaise Cendrars, viewed through a half-open carriage door, while the writer strokes its neck; then Louis XIV in Giorgio De Chirico's studio, rather unwilling to stay too long on the painter's lap; Louis XIV on Georges Braque's drawing table, trying not to get his paws dirty in the painting cups, and relatively indifferent to the artist's efforts to stroke him; Louis XIV sauntering along in front of Igor Stravinsky (we are still in 1950), or Louis XIV, now—in 1955—back in the United States, on a glossy table, alongside James Dean as they both lean toward the lens (it's hard to tell which one is the more brooding and seductive of the two), or, finally, Louis XIV in a zoo in 1957, curled up on Paul Newman's shoulders in front of some wire netting.

Who could do better than that?

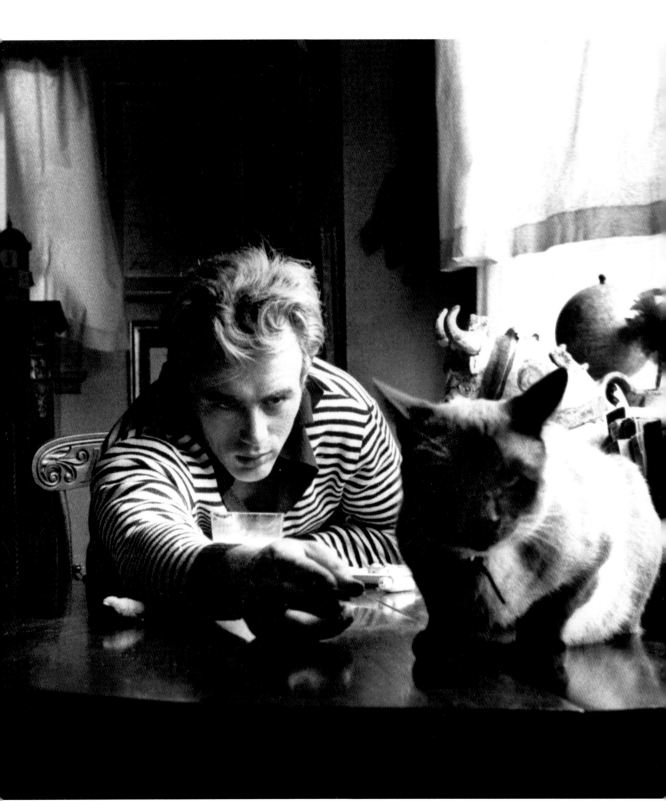

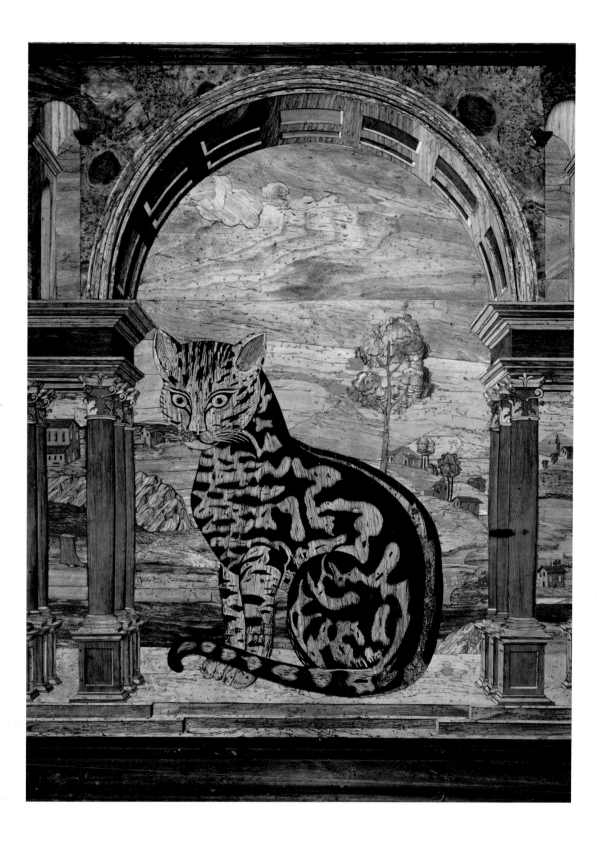

The Cat Lectern

I'd like to talk briefly to you about an extraordinary lectern that stands in the abbey church of Monte Oliveto Maggiore, to the south of Siena in Tuscany, Italy. The site is breathtaking. Undulating all around the green rise on which the Benedictine monastery stands are desiccated, ocher hills, like those Simone Martini painted in the background of his famous condottiere on the walls of the Palazzo Pubblico in Siena.

It is almost nightmarish, a set for some wild and dramatic Western. But it's not the landscape that interests me now. Nor the architecture of the monastery, built at the very end of the fourteenth century on the foundations of an ancient medieval abbey. Nor even its sublime cloister, in which Luca Signorelli (in 1495) and Giovanni Antonio Bazzi—better known by his moniker of "Il Sodoma" (in 1505)—painted a fresco, depicting episodes from the life of St. Benedict, which is universally hailed as one of the greatest masterpieces of Italian Renaissance painting.

No, I want to tell you about the abbey church and, more precisely, the carved, inlaid wood lectern that stands at the entrance to the choir. What does it represent? You've guessed it. A cat, of course!

I find two things especially touching about this. First, to see a cat enthroned in a church, in a place of honor, close to the consecrated altar, in the choir in which the monks would gather prior to a service. Clearly, there were good men in the Renaissance who dared to contradict the more dubious—not to say satanic—image of the cat they had inherited from the medieval period. But, most of all, it's the fact that the cat is represented on a lectern. A lectern is not just any old piece of church furniture. It is the desk on which Holy Writ or hymn books are placed during Mass or for readings. It is thus an object intimately related to knowledge: as it were, it bears the sacred word, the printed text, knowledge in general. Well, the fact that a cat is depicted on such an object, on this intermediary between man and book, fills me with delight.

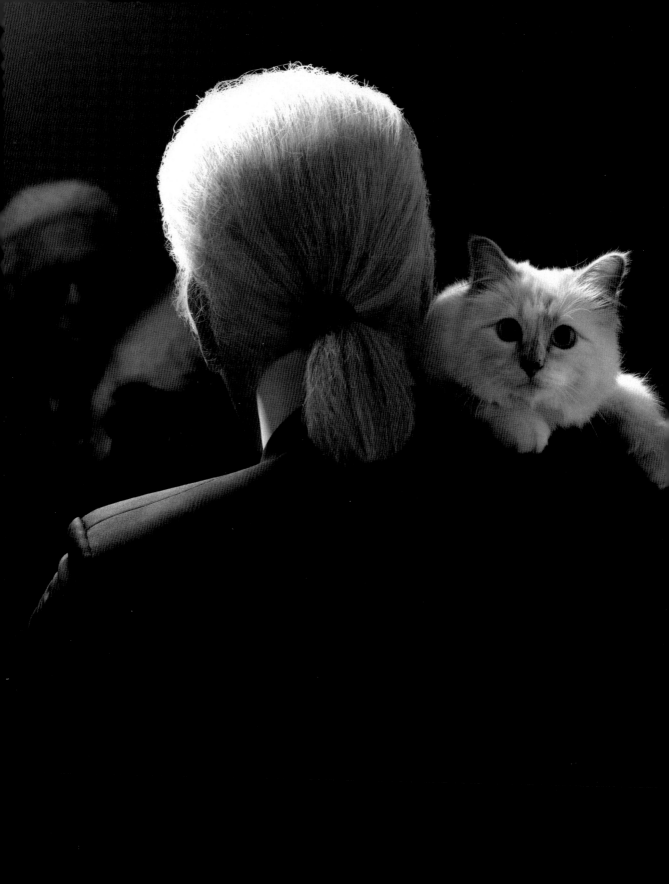

The smallest
feline is
a masterpiece.

Leonardo da Vinci

Maine Coon

I'm not an aficionado of the Maine Coon, so I won't drown you in science. It's a breed that's impressed me by its majesty, its sturdy, imposing presence, its strength, its brawler's chic. With its mid-length fur, it gives the impression of wearing pantaloons or cowboy chaps. Just don't rile him. It looks like a cat that can take care of itself. Quick on the draw.

This cat doesn't have the air of a recent concoction. No, this American cat, as its name implies, originating from the State of Maine, seems to have strolled straight out of the primeval forest.

Meeting a Maine Coon is like bumping into the Last of the Mohicans. Or the first trapper. In any case, it's one hell of a bruiser. And there's none better for getting rid of rats and mice. As to scalping its enemies, I can't be sure.

With its rather broad chest, powerful legs, relatively square head, large, expressive eyes, mid-length, low-maintenance fur, unencumbered by a woolly undercoat, there's no denying it, it oozes star quality. In the John Wayne—rather than the Audrey Hepburn—vein, of course.

And where does the word *coon* come from, you might ask? An abbreviation of raccoon, it would seem. It's possible, even though it's hard to see what raccoons might have to do with the Maine, with its haughty bearing, arresting presence, and adventurer's panache.

But don't get me wrong, the Maine Coon's no hard-bitten killer. It's no Billy the Kid. It's more of a gentle giant. A good, clean fighter. Quietly spoken, like John Wayne again, which takes its time growing up (only reaching adulthood at around three years, not before), and which can bear the harshest winters (and enjoy the warm glow of a wood fire) in a Canadian hut.

That's as may be, but the Maine Coon I became closest to, and which answered to the plain vanilla name of "Charlie," spent the summer months in a vast property in the hills of the Maures, near the Gulf of Saint-Tropez. The mild climate suited him to a T. With all the cork oaks and chestnut trees, he might have been a logger or a forester. He was perfectly content living calmly and lazily in the company of the humans he had adopted, Claudia and Serge Lentz.

Facing page
"Meeting a Maine Coon is like bumping into the Last of the Mohicans. Or the first trapper." F. V.

Pages 152–53
Gisèle Freund's photograph of André Malraux seems to show the writer and politician engaged in a conversation with his cat.

Pages 154–55
The famous Japanese waving cat, the *maneki neko*, is supposed to have been born in the Gotokuji Temple in Tokyo, where this photograph was taken.

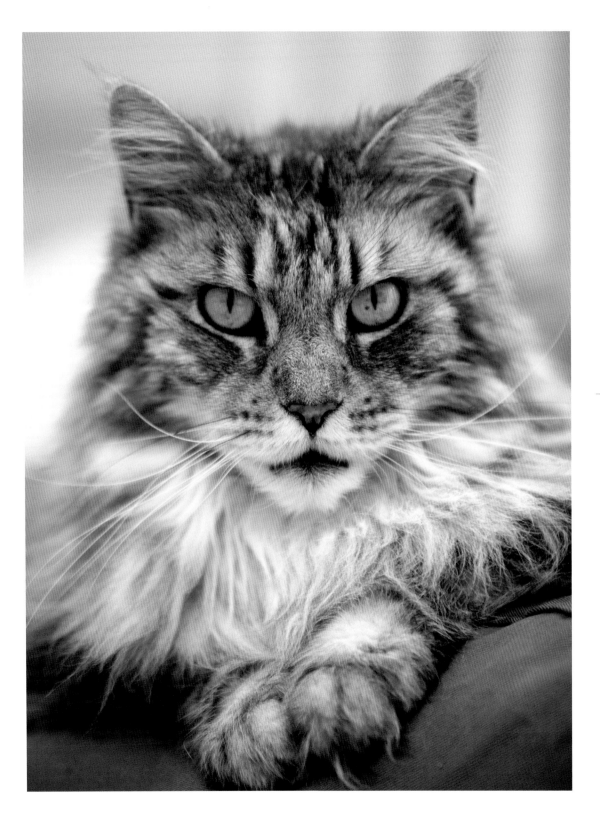

Malraux

Novelist and politician André Malraux loved cats and lived with them. With Lustrée, a green-eyed, pitch-black she-cat. With Fourrure, a tabby with a gaze of washed gold. With Essuie-Plume, immortalized in his *Anti-Mémoires*.

Toward the end of his life, Malraux—immovable as General de Gaulle's Minister for Culture from 1958, and thus responsible for the conservation, embellishment even, of the French architectural heritage, and, more exactly, for the classification and safeguard of historic buildings—lived in the Château of Verrières-le-Buisson as the guest of author Louise de Vilmorin. One day, in his host's absence, he busied himself sawing cat-flaps in Verrières' historical and listed doors to make it easier for his beloved pets to move from room to room. Louise de Vilmorin's fury when she discovered the damage had to be seen to be believed! But it was too late. The crime had been committed. But was it really such a crime?

Malraux only seems to have started to know—and thus started to love—cats when he was getting on a bit. They hardly appear at all in his early novels and writings. It's as if Malraux the adventurer, the Spanish Civil War volunteer, and the late-coming Resistant leader of the Alsace-Lorraine brigade, hardly had time to bother himself with keeping a cat.

However, in 1928, when Gallimard brought out *Royaume farfelu*, he already referred to cats, as the amusing dedication addressed to the Flemish painter James Ensor testifies: *"Royaume farfelu,"* it runs, "is a story written to amuse the cats and masks who while away the evening before the fire." As if he already knew, at the onset of his literary career, everything that cats know and all the qualities that they hold for us in safekeeping. Especially those pertaining to reading. Still, he only began really to adore felines after World War II, when he reverted to a more sedentary lifestyle. Then cats were able to settle down with him at home. But it went further than that, for Malraux's stories and anecdotes teem with references to them, and in some they even play a starring role.

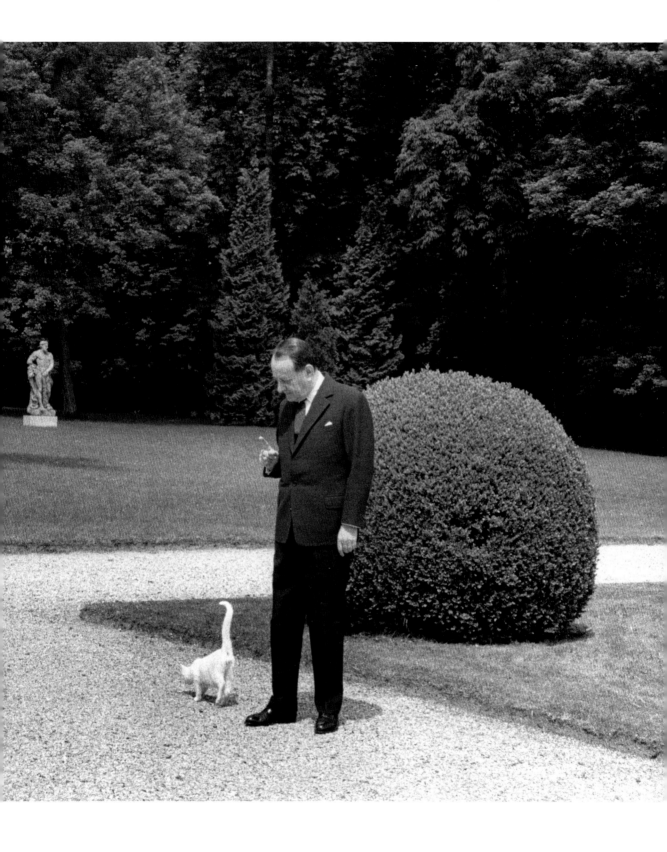

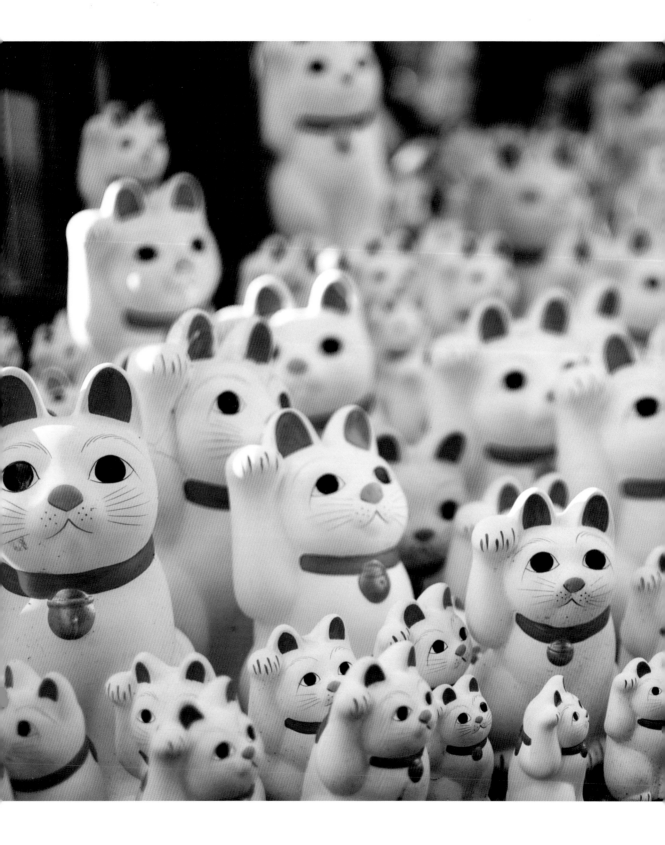

Maneki Neko

In Paris, tourist vendors deal in repro Eiffel Towers. In Venice, there are more plastic gondolas than you can shake a stick at. In London, it's miniature Horse Guards; in Moscow, nests of babushkas. In Brussels, little versions of the "Manneken Pis." In Disneyland, Mickey Mouses of all sizes.

And in Japan? *Maneki neko* (the "beckoning cat").

In other words, those tubby, smiley-faced porcelain kittens sitting on their behinds with a paw raised in salutation.

But where does the *maneki neko* come from?

It is said that, centuries ago, certain samurai were passing in front of a temple and spotted a cat lounging on the bottom steps. On seeing them, the cat got up, sat on its behind and lifted a paw up to its ear, as if in greeting. Amused and intrigued, they approached the animal. Suddenly, there was a flash, and a bolt of lightning struck the ground at the very spot on which they had been standing—so the cat had saved them from certain death. Later on, having become rich, our samurai endowed the same temple with huge donations.

A crucial question arises: did the cat raise his left or right paw? For the Japanese, when a cat lifts its left paw, it means happiness, so the majority of *maneki neko* raise a left limb.

Maneki neko lifting the right paw do exist, however, which is supposed to signify wealth and material prosperity. Today's tireless Japanese businessmen and industrialists, whose electronic devices, TVs, computers, and motorcycles continue to command a fair share of world markets, have proved receptive to this variant, so it should come as no surprise to learn of the growing number of *maneki neko* with their right paw in the air. Now nearly thirty percent, I am reliably informed.

Tell me which paw your cat lifts, and I'll tell you who you are.

To the Japanese (and to tourists), color is an important factor too. Invariably sporting a red collar with a bell round his neck, the rarer and more precious examples are tricolor. These china cats generally tend to be white, symbol of purity; black, a talisman against evil spirits; red, to ward off disease; gilded, to bring good fortune; or—last but not least—pink, as a love charm.

I want to have in my home:
A reasonable wife
A cat among the books
Friends in every season
Without whom I cannot live.

Guillaume Apollinaire

Facing page In this painting by Cecilia Beaux, the American portraitist (1855–1942),
the cat and the young woman, Sarah, seem to have the same mysterious look.
Perhaps the young woman only has ears for the cat's purr?

Manx

Manx designates a breed of cats originating on the Isle of Man in the Irish Sea: a curious race whose principal characteristic is to be deprived of a tail.

Let us gloss over the legends this anomaly has inspired, such as the one that tells how the cat, last into the Ark, had its tail sliced off as Noah slammed shut the door or hatchway.... *Et après moi le déluge!* In truth, it originates in a bizarre genetic mutation.

Specialists distinguish two types of Manx: the rumpy Manx, which bear no trace of the appendage at all, and the stumpy Manx, which still has a remnant of it. I spoke of a mutation. In fact, in the long term, had man not intervened, this lack would have proved fatal. It is impossible to obtain more than a few generations of "real" rumpy Manx, one after the other. By the third, the kittens die off. For the breed to remain viable, one has to cross the completely "tailless" ones, either with a stumpy or with a regular cat.

Thinking about this breed which, if not actually created by man (the presence of these cats has been attested on the island for centuries), then at least preserved and nurtured by his action, I feel rather uneasy. Poor cats without a tail. Poor cats, manhandled by sinister characters, who interfere with what is none of their business.

The cat from the Isle of Man is a touching beast, whereas its breeder, reproducing and crossing it, is far less so, because one cannot celebrate the glories of a cat's tail too often. Its aesthetic value goes without saying; its anatomical advantages too. The cat's tail, this excrescence, this almost ironic extension of its spinal column is, of course, employed for balance. Like a sinuous and graceful pole. But the cat also uses it to communicate. With a tail, it can speak an entire language. Does it want to show satisfaction? It carries it proudly, vertically erect. Does it wish show clearly how angry it is? It shakes its tail in disturbingly wide sweeps. Almost cracking it like a whip.

Thus, not only is the Manx an amputated cat, it is a cat that cannot speak. Doubly disabled, he demands compassion.

The cat from the Isle of Man is a curiosity, but no more. Am I being unfair? Perhaps.

Facing page
"The cat without a tail from the Isle of Man, a bizarre genetic mutation." F. V.

Pages 160–61
"Cats are shrewd and they know they are." Tomi Ungerer, who adores cats, has featured them in many amusing or poetical drawings.

Pages 162–63
"A cat's whiskers serve to make it still more beautiful, splendid, and majestic." F. V.

Whiskers

What are a cat's whiskers actually for?

One remark before addressing this delicate question: it is more scientific, and classier too, I daresay, to speak not of a cat's whiskers, but of her *vibrissae*. This is the correct anatomical term, appearing in Latin in this sense during the seventeenth century. The ninth edition of the *Dictionary of the French Academy* concurs with the *Oxford English Dictionary* that the term designates the long stiff hairs that certain mammals have around the mouth, and refers explicitly to the cat, the seal, and the otter.

So, let's try again: what is the purpose of a cat's vibrissae? Several answers come to mind.

Obviously, the one I prefer is of an aesthetic nature. Its whiskers serve to make a cat still more beautiful, splendid, and majestic. How can one imagine for a single moment a cat without whiskers (i.e., without vibrissae)?

In this connection, I would like to share with you a subject of singular perplexity. I have often witnessed my cats losing their whiskers. Sometimes I come across—with a kind of melting, emotional (and I grant you perfectly dumb) tenderness—one of those interminable, silky, bright hairs that one of them had jettisoned on a cushion, the couch, a table, without, apparently, feeling any great sadness.

I am the one who feels dismayed. After all, a cat does not have that many vibrissae around its muzzle. One can almost count them on the fingers of two hands. Yet, just like that, Fafnie, Nessie, and Papageno jettisoned several of them every year. I feared that at this rate they'd soon have none left, because not one vibrissa ever seemed to grow back. By some miracle, though, they kept the majority of their whiskers until they got really ancient.

Veterinary surgeons inform us that vibrissae are to all intents and purposes organs of touch, like antennae, which transmit sensations from the external world to the nerves, and thus from the face to the brain.

Some even say that the span of a cat's whiskers equates very precisely to the maximum diameter of his body and that in this way he knows if he can squeeze through some particularly narrow passage

without ending up ignominiously wedged. Between you and me, this appears a flight of the utmost fancy. It's like when Bernardin de Saint-Pierre alleged that a melon's skin is split into divisions so it can be shared out between the family. But let's move on.

At night, in any case, a cat's vibrissae allow it to sense obstacles in front of it and all around. It's rather as if they enable it "to see," in the absence of light, acting like extra short-range radar.

Nothing is as expressive as a cat's whiskers, though. When it's happy, they point up into the air. Feeling on the defensive, it flips them backward and flattens its ears to its skull. Aggressive, they stiffen, as if aiming dead ahead.

But perhaps the finest appeal in favor of the cat's whiskers, as well as the most convincing explanation of their existence, was penned by Theodore de Banville in his famous eulogy to the animal, written in 1882, at a time when the majority of gentlemen were proud to parade a trim (if full) beard and whiskers of the most diverse shapes.

Hence Banville risks a comparison between man and beast. This is an extensive extract from the Parnassian poet's panegyric:

Perhaps there are aspects by which the Cat is inferior to us; in all events, it is certainly not by dint of its charming, fine, subtle, and sensitive whiskers, which decorate its pretty face so well, and which, provided with exquisite receptivity, protect, pilot, and inform it as to obstacles, and guard against it falling into traps. Compare this luxury adornment, this tool of defense, this appendix that seems to be made of beams of light, with our whiskers, hard, inflexible, coarse, which crush and kill the kiss, and erect a material barrier between us and our beloved. Unlike the delicate whiskers of the Cat, which never hide or block up its pretty pink snout, a man's whiskers, and more so if they belong to a leader, to a chief among men, so full and warlike, render life impossible; thus it is that one of the finest of modern whiskers, those belonging to King Victor-Emmanuel, which split his face into two like some heroic gash, prevented him from eating in public; and, when dining alone behind tightly shut doors, it was necessary to tie them up with a scarf, the ends of which were attached behind his head. How he then must have envied the whiskers of the Cat, which lift up under their own steam and which would in no way impede the pageantry of ceremonial feasting!

Cats are mysterious
kind of folk. There
is more passing in
their minds than
we are aware of.

Sir Walter Scott

Birds

Most often, animals go in pairs: because they resemble, complement, or conflict with one another. La Fontaine was well aware of this. The grasshopper and the ant, the hare and the tortoise, the crow and the fox, and so on.

Generally, the wolf turns on the lamb, and the falcon falls on the dove, making clear the difference between predator and pacifist, warmonger and peace lover. The Gospels immortalized the pairing of the ass and the ox in the stable. In French, to say that a couple, or an idea, is like "a marriage between a carp and a rabbit," indicates that one thinks the couple incompatible, or the idea absurd. And there are countless similar examples of animal pairs.

And the cat? Of course, its counterpart is the dog, the more common pet; and they are forever at loggerheads. To fight like cat and dog: that says it all. The cat is even closer to the mouse or the rat, its prey since way back. This was, after all, the main clause in the contract that felines signed with man in that remote era, when, in exchange for protection, for the warmth of the hearth, and for human affection even, it agreed to do all it could to exterminate these harmful rodents. The cat and the mouse: there are many expressions and proverbs about this antagonistic tandem, too.

There is perhaps one other twosome, even older in our imagination than that of the cat and the mouse: that is, the cat and the bird.

Humans must have long watched other small carnivores, like weasels and stoats, kill rodents. On the other hand, to associate the cat with its favorite dish, the bird, which it kills without a second thought, has been a cultural practice, a reflex, a commonplace for humankind, for millennia. Look, for instance, at the earliest known artistic representations of the cat—on molded reliefs on the island of Crete dating to 1800–1700 BCE, or on the frescos discovered there at Knossos, dating to the same period, which show, for example, a cat seizing a duck, or even sneaking up on a pheasant.

The theme is a frequent one in pictorial representations from Egypt, too. One of the most beautiful, as well as the most striking, that I know goes back to the time of the New Kingdom and the Eighteenth Dynasty, c. 1350 BCE. This is the painting from the tomb of Nebamon, today in the British Museum. What does it

Page 164
Ernst Ludwig Kirchner's cat looks angst-ridden. This German Expressionist often painted cats in strident colors.

Facing page
"A bird is all grace, innocence, beauty. As for the cat, it embodies concupiscence." F. V.

show with admirably evocative elegance? A hunting scene among the marshes of the Nile. Hunters, standing on a boat, make their way through the reeds. They are accompanied (or should one say assisted?) by a cat—a fine, big russet-red cat with stripes. It throws itself on a bird, jaws snapping shut over the bird's left wing. Front paws grab another one by the neck. One has to salute this superb animal with cordial and respectful affection; it looks so like today's pets, and hunted in an age when our European ancestors, uncouth and backward, were still desperately rubbing flints together to light a fire.

Originally, then, it was the opposition between cat and bird that was the key one, and it was this that humans first strove to represent. Whoever has been lucky enough to visit the National Archaeological Museum in Naples will never forget the sublime mosaic—prized off a wall in the House of the Faun in Pompeii— that hangs there. It must date from the second century BCE. A sturdy tabby with large, wide-open eyes, its tail bristling and with a wild and childish expression—inquisitive, touching, innocent, and pitiless all at the same time—leans, smacking its lips, over an unfortunate partridge, which is destined to become lunch before too long. This is only one example, though it is among the most admirable and expressive of the Roman era. Elsewhere, on other mosaics, the theme of the cat is recurrent, not as a hunter of mice but as a predator of birds.

Is this one of the reasons why the cat has found it so hard to be accepted, let alone loved, by humans? This is more than probable. The majority of authors of Antiquity, from Aristotle to Petronius, from Callimachus to Seneca, note the culpable inclination of cats to kill birds. They observe how all birds, down to the most vulnerable nestling, are instinctively wary of them. To creep up on a bird, especially a little garden bird, and kill it, is surely a dreadful crime—and cowardly to boot? Man feels he must avenge such an offense, and, if he can't succor every widow and orphan, at least he can protect the warbler and nightingale from dastardly attack. In the sixth century CE, a certain Agathias the Scholastic thus roundly condemned the murderer: "Does the house cat that ate my favorite partridge think it's going to remain alive in my house? Dear partridge, I will not allow you to die dishonorably; but, on your corpse, I will immolate whatever took your life."

The cat's unforgivable behavior ("unforgivable," for those who cannot resist a naively anthropomorphic reading of its actions)

is in addition reinforced by powerful symbolic dimension. A bird is all grace, innocence, beauty, and sweetness; as for the cat, it embodies concupiscence, violence, abduction. Does it remind you of anything? The sexual connotations are patent. The cat, in other words, is obviously the corrupter, the seducer, a being with uncontrollable urges, one that "sullies" the bird—that is, purity, fragility, virginity, even. It is to the excellent Philippe de Wailly, veterinary surgeon, writer, and friend, that I owe an anecdote that may serve as a conclusion to the present section. It is a little story that, though admittedly extremely unusual, might well prove of inestimable worth to a PR officer employed to rebrand the image of the cat.

One of his elderly clients had for a long time kept a favorite tame bird in a cage. One day, a stray cat found refuge in her house. She took him in readily—on one condition, she told him: that he would never touch the bird, not even a single feather. The cat seemed to understand this stipulation. He never so much as threw a covetous glance at the little cageling and remained dutifully seated on his cushion a few meters away.

Alas, one day the bird passed away. It was a natural death, I hasten to add. Its mistress, who was all too visibly upset, removed its tiny, inanimate body from the cage and showed it to the cat, as if saying to him: look, my dear old cat, you've lost your little companion! The cat stared at the deceased fowl, and then walked off.

A few days later, after one of his customary escapades in the district, the cat returned home and sat down in front of the empty cage with a bird in his mouth. Wretch! exclaimed his mistress. But then she noticed that the bird it was grasping between its jaws was alive and kicking. Freeing it from its toothy prison, she placed it gingerly in the cage. The cat purred with pleasure and sauntered off to take a well-earned rest on its favorite cushion.

"And the strangest thing," Philippe de Wailly said, "was that the bird was of the same species as the one that had just died!"

I could hardly believe this detail. Canaries and parakeets do not grow on trees, or on every street corner.

"Of the same species, really?"

Philippe de Wailly broke into a smile.

"Well, perhaps not *exactly* the same," he conceded. "It might in fact have been a sparrow. Still, the resemblance was striking."

There are two
means of refuge
from the misery
of life—music
and cats.

Albert Schweitzer

Heartbreaks of an English She-Cat

Honoré de Balzac's series of interlinked novels *The Human Comedy* is a wonderful, admirable creation, unquestionably one of the monuments of French literature. But it is not impossible to conceive that Balzac occasionally felt, as he toiled away at this vast and immensely ambitious saga, a certain lassitude, even discouragement. So it is understandable that, on at least one occasion, Balzac took solace in collaborating—and with good grace—on *Scenes from the Public and Private Life of Animals*, a series published by Pierre-Jules Stahl in two volumes in 1842. This very same Stahl, already busy bringing out the ongoing *Human Comedy*, was to become famous afterward under the pseudonym of Hetzel, the publisher's name appearing on, among others, each volume of Jules Verne's extraordinary voyages.

Of course, the *Heartbreaks of an English She-Cat*, which Balzac penned for the Stahl collection, cannot be listed among his major works. One would hardly swap these tales for *Lost Illusions* or *Splendors and Miseries of the Courtesans*. The fact remains, though, that they are delicious, and one further element contributes to our enchantment: they are accompanied by drawings by Grandville, the great illustrator; for this publication he produced works of great tenderness, telling elegance, virtuosic satire, and meticulous and inventive firmness of line. Thanks to Grandville, then, we see—in her London interior and in all her finery—the attractive and spotless Beauty, who every now and again might risk a wander out on the roofs to lend a shell-like ear to the blarney of that irresistible French lothario and errant poppycock, Brisquet, while the swollen-headed Puff, as a perfect representative of the English gentry, unwisely thinks of her as a fiancée and already his property. Balzac's text is always associated in readers' minds today with Grandville's engravings. Together, they add to our delight.

To be honest, though, in his novel *The Human Comedy*, Balzac does not demonstrate a perceptive or especially profound knowledge of the feline soul. Still, that's not what it's about. Of course, Balzac's observations hit home. He would not have been such an eagle-eyed witness of the society of his time, such an intrepid

Pages 174–75
Beauty, the she-cat from
Balzac's novel, and star
of the show staged by
Alfredo Arias at the
Montparnasse Theater
in 1978.

Facing page
"Thanks to the drawings
of J. J. Grandville (1803–
47), we can see, in all her
finery, the attractive and
spotless Beauty." F. V.

speleologist of the potholes of the human condition, of the mind and of the soul of his characters, were he not able to show the same perspicacity in recording the moods and attitudes of the cat. But they manifestly interest him less than his fellow man. So in fact this animal fantasy presents an opportunity for Balzac to indulge in a wonderful satire on social life on the other side of the Channel. This is its true subject.

Its heroine would surely have been drowned at birth, like dozens of her brothers and sisters, had not Nature blessed her with such irreproachably snow-white fur. While still young, she would on occasion "forget herself" in some far corner of her abode: this was severely punished. She should wash and answer nature's call only where nobody can see her: that's the rule. "Thereby demonstrating the perfection of English morality, in that it deals exclusively with outward appearances, the world being, alas! only surface and deception," as our puss observes. Typical British hypocrisy.

"I acknowledge," Beauty again informs us, "that my animal common sense recoiled from such duplicity; but, after a few beatings, I ended up realizing that the entire virtue of the English she-cat resides solely in external cleanliness. From that point on, I grew accustomed to hiding the delicacies I liked under the bed. Never did a soul see me eating, drinking, or giving myself a cat-lick. I was thus looked on as a pearl among pussies." She indulges Brisquet, a French charmer as self-confident as he is impoverished, though his boasting and insolence are plain for all to see.

Beauty is expected to take off with him? Love without capital is a nonsense! She tells him: "While you'll be rushing right, left, and center looking for something to eat, you'll soon neglect me, my dear."

Suffice it to say that, when it comes to Beauty, we all have the eyes of Brisquet, that Britain is perhaps not, in spite of its low social security deductions and liberal tax laws, a country one should think of emigrating to, and that English young ladies (cat and non-cat alike) are the most beautiful, the boldest, and the most desirable on the planet, whatever their hygiene.

Grandville was clearly convinced of the fact, as his drawings attest.

And, in the final analysis, it is surely a great comfort to know that, for at least once in his life, this most eminent of all French novelists deigned to associate his name, his effort, and his talent with an animal we admire no less than we do him.

What female heart can gold despise?
What cat's averse to fish?

**Thomas Gray, "Ode on the Death of a Favorite Cat,
Drowned in a Tub of Gold Fishes"**

Facing page A foodie cat. A *New Yorker* cover from 1973 by the great British
cartoonist Ronald Searle, who devoted several albums to cats.

Persian

The Persian cat is a deluxe cat. A hyperbolically luxury cat. One would be hard pressed to think of something more downright luxurious than a Persian cat. It's so gorgeous it's almost touching. One hardly dares to take it up in one's arms, to stroke it, to look at it, even.

A Chagall hangs over the mantelpiece. A Persian drowses on the sofa. Which is easier to damage? And watch out with that feather duster: let's hope they're adequately insured.

Yes, a Persian makes us melt because it looks so fragile. And isn't fragility one of the chief characteristics of luxury?

Persians require—what am I saying?—Persians *demand* ceaseless care. You can't release one into some natural habitat or allow them the run of the garden. Unlike some out-of-towner, or even its distant ancestors, it's certainly not one for stalking the undergrowth, clambering up drainpipes, or fighting with ill-mannered tomcats over a rotting rat or shrew! With its long, silky hair, its great, amazed, or constantly tired eyes, it needs its beauty sleep, its repose. Or else a store window. In short, it needs to be waited on hand and foot.

There are (at least there were at one time) high-society women and demimondaines of this type, with chambermaids to dress and undress them, and corset and powder them, as well as doing and undoing their hair, or giving them a helping hand in the bath. Persian cats are a similar breed.

Washing? What? Themselves! Have you taken leave of your senses? There are servants for that. That is, humans. We are all the servants of Persian cats.

And they leave their fur all over the place. And we sweep, do the vacuuming, put everything back shipshape. If, by some error, or prey to a strange democratic atavism, they suddenly start licking their coat, sprucing themselves up like any normal cat (or like you and me indeed), watch out! They are likely to swallow too many hairs, and fur balls will form in their digestive system. They'll get the vapors. They'll suffocate. Perhaps it's the height of chic for a society lady or a Persian cat to suffer from the vapors. Still, better safe than sorry.

"Persian cats have squat
bodies, broad, shortish
paws, small round ears
and, of course, a wide,
squashed nose that I
find, forgive me, rather
ridiculous." F. V.

Facing page
Luxurious and
expensive, Persian cats
come in an incredible
variety. This one is a
Golden Shaded.

And it's much the same rigmarole with food. The Persian cat disdains fast-food menus, absolutely. On the contrary, it requires a varied diet of vegetable, meat, and fish. And a Michelin-starred chef, if possible. And, like all stars, it turns up its nose, makes scenes, and sometimes plays the anorexic. What? You think I'm going to eat *that!* Waiter, get me the manager, *now*.

I've been talking about Persian cats generally. I was getting carried away. In truth there exists an incredible variety of Persian cats—like *appellations contrôlées* or *grands crus* in France, if you want. There are Persian whites. There are Persian-blue Persians, like the one that lived with Queen Victoria—and which was the more majestic, the more autocratic of the two, one wonders? Then there are Persians with blue eyes (almost always deaf, as if they couldn't bear all the compliments dropped into their ears, the poor dears!), plain Persians and silver Persians, stripy Persians, the colorpoint and the exotic shorthair, a distant cousin, and more.

All have squat bodies, broad, shortish paws, small round ears, and, of course, a wide, squashed nose that I find, forgive me, rather ridiculous. It looks as if their proboscis, like that of a punch-drunk boxer, has been whacked and thwacked by too many straights and uppercuts during an unsuccessful career in the ring.

A bit ridiculous, and a bit pathetic too, the Persian (I'm digging myself a hole here), so striking is the contrast between its self-assurance, pensive otherness, certainty of belonging to an elite (and it's no good asking it for a cuddle as a bonus; once and for all, we owe him everything and he owes us nothing), and the bloated bruiser's mug that it assumes with such haughty disregard.

Like all stars, divas, kept women, and crowned heads, Persians are delicate beasts. Like retired welterweights too, perhaps. Their famous squashed nose causes respiratory problems. Sometimes the narrowness of the lachrymal duct elicits chronic sneezing fits. All very *La Traviata*, in short.

As you may well have deduced, I'm not a fan of the Persian. I prefer sporting beauties to consumptive young ladies. But I bow before their splendid allure. And more still before their certainty of being gorgeous and therefore deserving of our homage.

For my part, I will never be the adoring slave of any Persian cat, but I like to think of them looking down on us as their valets. They certainly don't lack cheek. And it's that cheek that I find so charming.

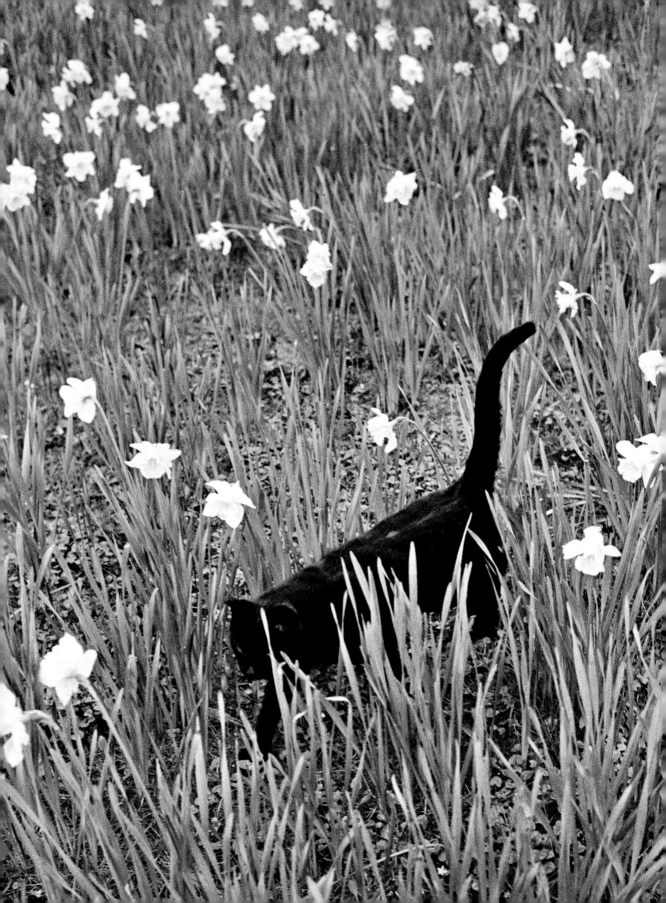

There is no more
intrepid explorer
than a kitten.

Jules Champfleury

Siamese

Have you ever heard of Sir Owen Gould?

It was this quintessential Englishman, his country's consul-general at the court of King Prajadhipok of Siam, who, in 1884, first had the idea of bringing a pair of Siamese cats to London. For a long time, rumors had been getting back to Europe of a breed of cats, little felines of peerless beauty, who thrived in those parts, where they were as jealously guarded as a national treasure.

It was only natural that the first appearance of Siamese cats on the banks of the Thames proved a sensation: the magic of their porcelain blue eyes, so deep, so strange; their sinuous form, their slender, triangular head, their supple movements, their distinction and delicacy, their short hair—so fine, almost shiny—in understated hues from cream to dark maroon.

At night, they say, all cats are gray. But did you know that all Siamese are white at birth and that their coat only takes on its splendid colors and iridescence gradually as they age?

Alas, initial efforts to reproduce them were not crowned with success. Of delicate health, Siamese kittens found it hard to acclimatize. It was not before the beginning of the twentieth century that these South Asian cats finally began to feel at home in Europe.

As you've probably gathered by now, I like Siamese cats. Rather, I admire them. But, above all, they intimidate me. There's always something intimidating about beauty.

But (luckily, one might say), there's something in this type of cat that is far from distinguished, something that renders them less off-putting. Almost the opposite. Siamese cats are, as a general rule, talkative. They are, in fact, incorrigible chatterboxes, veritable windbags. A Siamese has the looks of Ava Gardner or Grace Kelly mingled with the gift of the gab of Whoopi Goldberg or Joan Rivers. Siamese mew at the drop of a hat. They whine and opine, they mimic and haggle, until your head spins. Seen and not heard? Chance would be a fine thing. No, they're decorative *and* loud.

In the end, because they talk *so* much, one begins to wonder whether they might not be the only cats that don't actually know how to communicate.

Page 184
"He can be spotted sniffing away at a spot of ground where there's nothing's to see, as if he were a great sleuth on the brink of some capital discovery." Bernard Frank writing about his cat, Médor.

Facing page
The owner of these five Siamese has just won a prize at the International Cat Show in Paris in 1930.

Pages 188–89
"The adorable ginger cat belonging to Audrey Hepburn, the no less adorable heroine of Blake Edwards's 1961 *Breakfast at Tiffany's*." F. V.

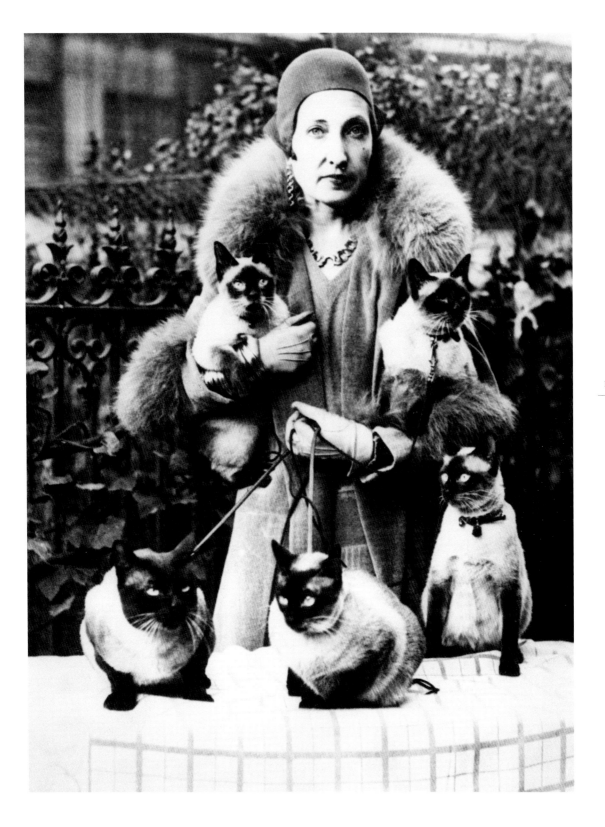

Lights, Camera, Action!

As directors—all directors—will tell you, there are only two things on set that really fill them with dread: a take that needs a kid and a take that needs an animal. In other words, completely unpredictable creatures, unable to control their movements, to do two shots in quite the same manner, or to carry over the same expression from one moment to the next.

Of course, there are children who can be persuaded—more or less—to act. There are even a few who are remarkable hams, smirking, simpering circus animals. Dogs, too, are trainable. Just like seals, sea lions, tigers, horses, elephants, and mynah birds.

But a cat? Is it even possible to direct a cat?

Does anyone imagine for a single moment that it would be enough to shout: *"Lights, camera, action!"* to make such an animal perform a particular action? It's more likely that the only action would come from the director jumping up and down on the spot in frustration at his fruitless efforts to metamorphose a cat into a star of the silver screen.

François Truffaut, in his 1973 movie *Day for Night*, illustrates the phenomenon of cats on set with great humor and a tinge of tender melancholy. It can't be that hard to get a black kitten to lap from a saucer of milk in front of a camera, can it? Puss had other ideas. He walked off stage left, stage right, out of shot; he wasn't thirsty, wasn't hungry, and totally ignored the flattery and orders of a posse of assistants. It was hilarious. In this sequence, Truffaut is in fact making a reference to one of his early films, *Silken Skin*, made in 1964. In that, a cat appeared furtively one morning, in the country hotel to which Jean Desailly had taken his young mistress, Françoise Dorléac; it contentedly licked up the milk on the breakfast tray that had been left outside the door of their room. Had Truffaut found it so difficult then? Anyhow, ten years later, it remained etched on his memory of the scene.

However tough producing motion pictures with cats may be, I do recall some famous specimens and movies in which their appearance is an inextricable part of my delight when I watch them. It goes without saying that I don't mean cats in cartoons or goofy, Walt Disney-like confections in which a cat plays the lead,

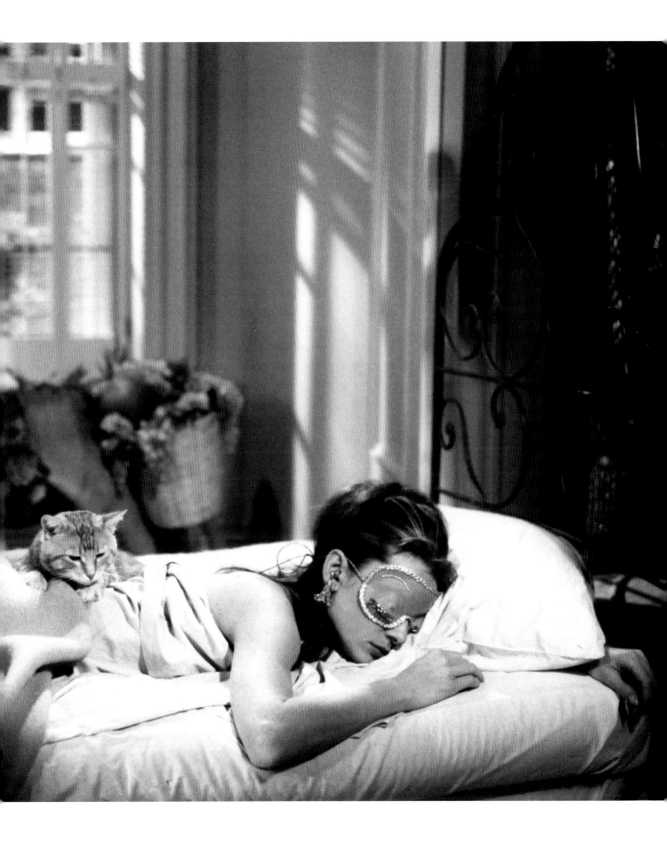

though they do at least testify to admirable technical expertise on the part of the film crew (as, for example, in Robert Stevenson's 1965 *That Darn Cat!*).

No, first up, I'd like to hail the sublime Siamese cat belonging to the no less sublime Kim Novak, with whom I was head over heels in love as a teenager, before realizing a few years later that she was a rather poor actress (but let's keep that quiet; and anyhow, all is forgiven, since Novak was immortal in Hitchcock's iconic *Vertigo*). So, Kim's Siamese makes its intervention in a delightful comedy by Richard Quine entitled *Bell, Book, and Candle*, released in 1958. In it, opposite James Stewart, the actress plays a bewitching and—apparently, anyhow—most respectable and plausible witch, willing to abandon her privileges for the love of her partner.

From shot to shot, she is shown tenderly holding her Siamese cat, her accomplice in witchcraft, to her breast. I would have then (and in fact would today, too) given everything I owned to be in the place of the cat. In the script the animal was called "Pyewacket" and was even awarded a Patsy Award (a bit like an Oscar for animals). And quite rightly, too.

From out of the disorder of my cinephile memory, I can also add to this random and far from exhaustive list the adorable ginger cat belonging to Audrey Hepburn, the no less adorable heroine of Blake Edwards's 1961 *Breakfast at Tiffany's*, based on Truman Capote's masterpiece.

It's well worth seeing that big tom (called, in real life, "Orangey," but which in the film answered to the extremely plain name of "The Cat"). It was a twenty-pound A-list feline, famous in Hollywood, and had also pocketed a Patsy Award. It is he that, to wake up his sleeping mistress who is struggling with an appalling hangover, decides to jump on her. And he is no more mindful when he leaps on George Peppard's shoulders. Good old Orangey. Later on, our heroine wants to get rid of him. Thank God, she finds him again in the pouring rain, soaked to the skin, in downtown Manhattan, between two trash cans, so there's a happy ending.

In which James Bond movie does a white Persian, at once placid and terrifying, lounge on the lap of the mysterious head of a crime syndicate who dreams of dominating the world? The cat is the only thing we see: his master's face remains out of shot. Perhaps he features in *You Only Live Twice*, in *Goldfinger*, or in *Thunderball*, but I wouldn't swear to it. Or perhaps it's *Diamonds Are Forever*, and a film-buff friend thinks he remembers he was called "Solomon."

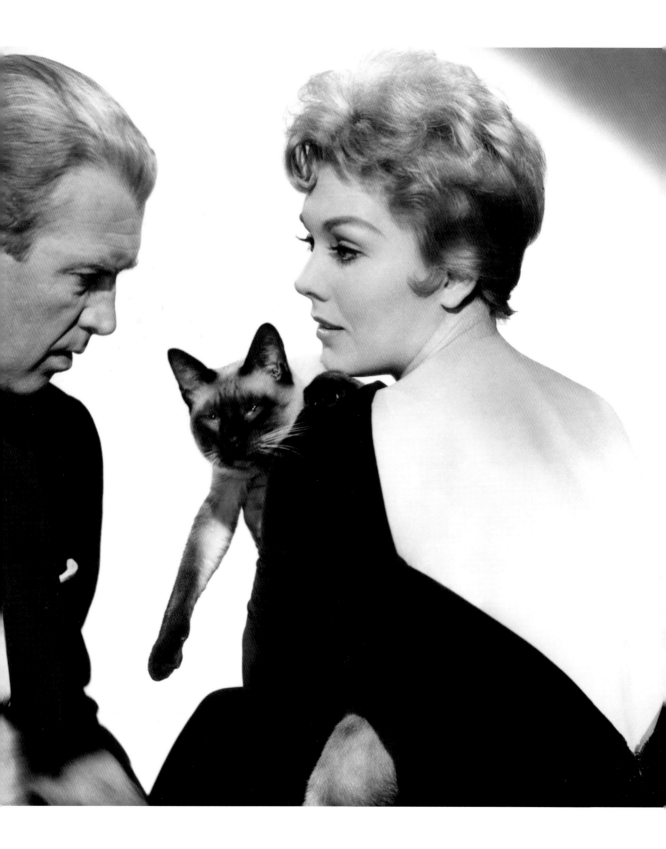

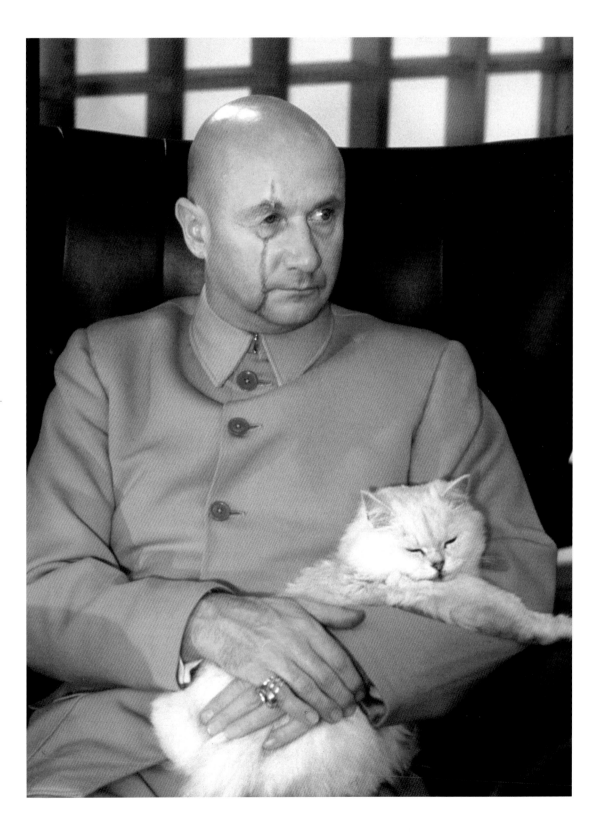

Pages 190–91
"The sublime Siamese cat Pyewacket, belonging to the no less sublime Kim Novak in Richard Quine's 1958 comedy *Bell, Book, and Candle.*" F. V.

Facing page
The placid but disturbing white Persian in the lap of Ernst Stavro Blofeld, the criminal mastermind in several James Bond movies.

As for Marlon Brando, in the first part of Francis Ford Coppola's *Godfather*, he too has a cat on his knees, in the half-light of the drawing room, from which he controls his mafia organization. And when Bourvil, the cop in Jean-Pierre Melville's *Red Circle*, gets back home to place Maubert in Paris, he too returns to a cat.

There was another cat I have never forgotten: that survivor, the orange tabby, the only space traveler to escape the rage of the extraterrestrial monster (apart from Sigourney Weaver herself) in Ridley Scott's famous *Alien* of 1979. There was also Elliott Gould's cat in Robert Altman's 1973 movie *The Long Goodbye*, based on a story by Raymond Chandler. It wasn't wise to take the mickey out of him. He was very fussy about what cat food he ate.

In the end, cats that play an active, dramatic role in a film are often absent from it: they are cat ghosts, ideas of cats. Though this did not prevent Carol Reed, in his legendary *Third Man* of 1949 (from the story by Graham Greene), fleetingly showing a cat on screen in the decisive episode of the film, when the hero, played by Joseph Cotten, reaches Vienna, where he finally catches up with a friend whom he thought was dead—the criminal trafficker, Orson Welles. This cat is not a *deus ex machina* but a *cattus ex machina*. It is the cat that, one night in the streets of the Austrian capital, unmasks Welles, its former master, as he hides under a gateway, by mewing round his legs and thus attracting the attention of the hero. Carol Reed has described—amusingly—the difficulty he had trying to get the take, which is not hard to imagine.

One could probably write an extremely erudite thesis on cats in the movies—sensual cats, homely cats, reassuring cats, evil cats, avenging cats, kleptomaniac cats, fantastical cats, disappearing cats, murdered cats. But I for one will not draw any hasty conclusions about the occasional, delicate appearances of cats on the silver screen. I simply relish them as brief miracles, moments of intense belonging, and that's enough.

It's difficult to catch a black cat in a dark room,
especially when it's not there.

Chinese proverb

———————

Facing page Portrait of a Cat (c. 1900)
by Julius Adam II.

Sleeping and Dreaming

The cat is asleep. It's always asleep. One might say that this is its philosophy, its very reason for living. Its motto, perhaps. We wretched humans, whose quest for rest is sometimes in vain, we seem pathetic and grotesque in comparison. Laughable.

In the grip of insomnia, our life becomes miserable. We swallow sleeping pills that make us feel groggy. And the cat sleeps away and says no to drugs. I have never met a cat that finds it hard to drop off. The daze of sleeplessness is the sole prerogative of man.

The cat sleeps. Preparing for it is quite a business. It looks high and low for a suitable place, which might change from day to day or week to week. A cushion, a pillow, the top of a cupboard, the armchair you're sitting in at the moment and from which it would like to dislodge you. Who cares? It occupies the place. Pads it down with its paws. Rotates once or twice on its axis. And yawns.

The yawn of the cat is a remarkable affair too. Utterly free of shame and scruple, it never raises a paw to his mouth. It has no sense of decency. It just yawns like there's no tomorrow, right in front of us—provocatively, almost. I'm yawning. I'm off for a sleep. I've had enough of your company, it seems to be saying. I'm yawning and I offer you the spectacle of my wide-open mouth, my gaping jaws, my canines, just in case you might entertain the fatal idea of disturbing me. Forewarned is forearmed.

Then it stretches out, squats, curls up. It screws its eyes, half opens the slits, then shuts them again. Sleep is about to engulf it. It's imminent. It lets itself be absorbed by sleep. It's a tide that it lets wash over it. A pleasure into which it subsides; blissful and dauntless. The cat, that unrivaled predator, finally abandons itself, without transition, to sleep.

You need unheard-of courage to do that. It's a fact not adequately appreciated. It's cowards and defeatists who can't sleep. They're afraid of being attacked, wary of the tiniest adversary. And so they remain on their guard. All eyes. They tremble, all aquiver. Is that a creak, an unusual shadow over there? Is someone trying to do away with them? Or, worse still, perhaps, with their wallet? They can't relax, the wretches. They don't trust anyone. They doze, but with one eye open. They don't ever

actually sleep. Their soul is not sufficiently at peace for that. If you like, they don't really have a soul at all. To put it another way, they have no valor, no *virtù*.

The man of courage and the cat, on the other hand, sleep the sleep of the just. Even in daylight. Especially in daylight, one might be tempted to add. This attitude formulates a challenge. When you come to think of it, such boldness is remarkably provocative. Look, they seem to say: My enemies can maraud about me, traitors can sharpen their knives, and pit bulls their canines; I couldn't care less. The sun is high in the sky and I'm slumbering. I fear nothing, nobody, naught. By my sleep, I'm telling you that I am stronger than you. Or else that, when I wake, it will be terrible. Beware the sleeping cat. Give it a wide berth. Pass by on tiptoe.

To comprehend the—length of the—sleep of the cat, one probably has to go back quite a few years. To remotest Antiquity, and even before. To a few tens of thousands of years BCE, prior to the domestication of the cat (in so far as it ever *was* domesticated, but that's another story), when it lived alone as a feline predator, a territorial animal.

Could anyone have spoken then about the cat being idle? Do we call tigers and leopards lazy? Animal ethologists readily explain the sleep patterns of felines, and in so doing cast a light on the quite reasonable languor of the cat, which belongs to the same family.

Let us start with the example of the lion. Hunting alone, experts inform us, a lion succeeds in capturing approximately one prey in six, not more. Leonine productivity, in short, is not up to much. Just think of the incredible amount of energy such a large animal has to expend to feed itself: the mad pursuit, all the jumping and running it has to do to crunch its jaws into just one solitary and unfortunate gazelle out of six. For the lion, as for the big cats in general (and remember once again, the cat is a member of this group, its entire genetic memory speaks of the fact and this determines its behavior), food is scarce and precious. There can be long periods of famine between two feasts. They can't be running themselves into the ground for nothing. On the contrary, they have to accumulate maximum strength for the next hunt, where physical weakness is out of the question. Hence the lengthy periods of rest, of sleep, and thus of low energy expenditure. So now you understand: all talk of the cat's being lazy is nonsense. It's been "programmed" to alternate periods of rest, sleep, and hunting.

Pages 196–97
"Nothing is more sensual, more relaxing, more calming than a cat yielding to sleep. And does it dream? A vast, abstruse subject!" F. V.

Facing page
A cat burrows into sleep as if into the softest eiderdown. How wonderful to be able to do that!

Pages 200–201
"A cat is mysterious enough. A sleeping cat is a mystery even more unaccountable." F. V.

You may well point out that cats today, fortunate enough to enjoy food and lodging at our expense, eat as much as they like all the time without a blinking an eyelid. No point *them* saving up for the occasional explosive burst. They live the life of Riley, from morning to evening, and their plate and bowl is full. They can just watch the world go by.

This is all too true. Still, the cat can't know that. It remains a predator, genetically speaking. In substance, its genes keep saying: OK, you're eating a lot at the moment, you're pigging out, even! You are not the unhappiest of cats, but who knows how long this abundance will last? You need to save up and think of a rainy day and nights of shortage.

So a cat sleeps. Look, it burrows into sleep as if into the softest eiderdown. Watching a cat falling asleep is a real joy. One would so much like to be in its place. Nothing is more sensual, more relaxing, more calming than a cat yielding to sleep. Night all.

And does it dream? That is a vast, abstruse subject.

Pursued, hunted, vulnerable, tracked animals, creatures devoured by larger ones, almost never dream. For dreaming is a luxury that leaves an animal totally open, since it exchanges the real world for the realm of the dream. When you dream, you're defenseless, and helpless animals can't afford to be in that position. A cat, on the other hand, can serve itself great hunks of dream.

But what does it actually dream about? It's a thorny question.

A cat is unlikely to take to the couch and ruinously expose his dream life to a psychoanalyst. All the same—according to a number of researchers who have analyzed the areas of the cat's brain excited by dreaming—it seems that it is not about sexual activity. And there is the implication, in passing, that psycho-analysis, with its overriding sexual instincts, is bunkum (or that man is a wholly different being from the cat), but never mind that for the moment. The most frequent dreams seem linked to hunting, fighting, and personal hygiene. But there's something more disconcerting. The kitten that has just opened its eyes, and that knows—as yet—nothing of life or the world, already dreams. About what? That's an unfathomable secret. Does it pursue phantasmagorical mice, etched into its brain by its genetic code? Are its imaginings based on experiences bequeathed to it by its parents, on the fears, desires, and expectations they once had?

A cat is mysterious enough.

A sleeping cat is a mystery even more unaccountable.

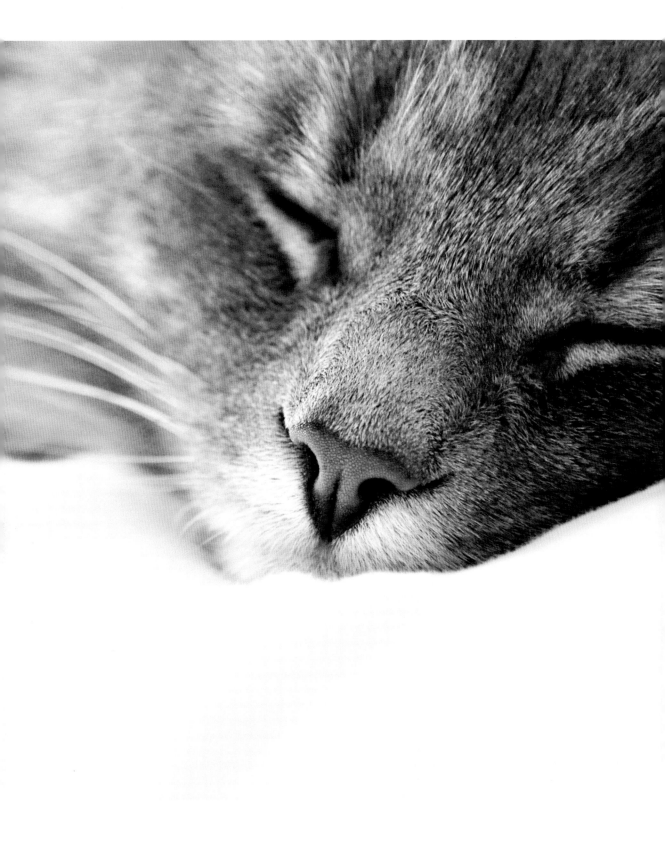

I believe cats to be spirits come to earth.
A cat, I am sure, could walk on a cloud
without coming through.

Jules Verne

Facing page There's something carefree
and sublime in this wood engraving
by Frans Masereel (1928).

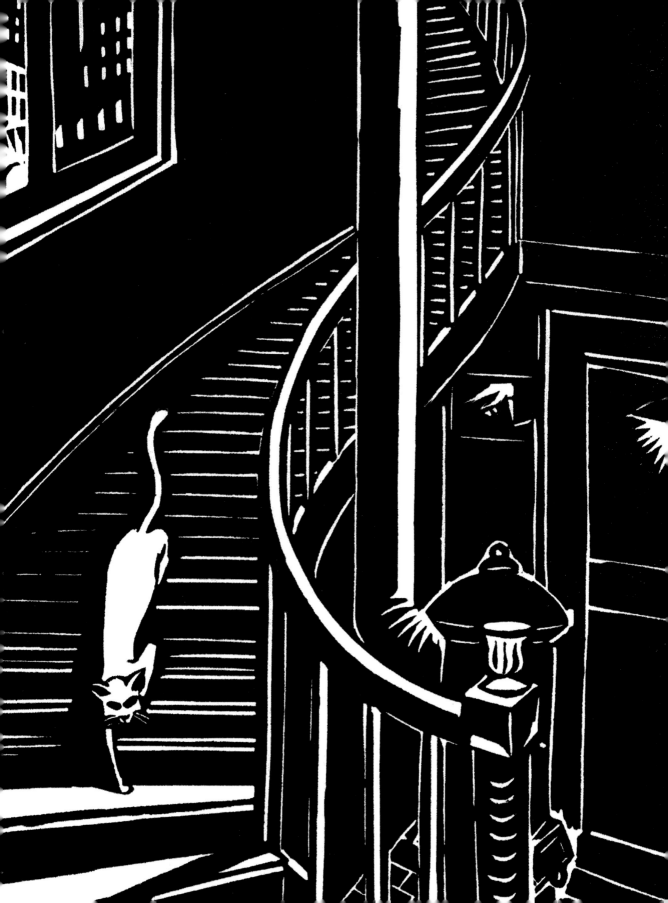

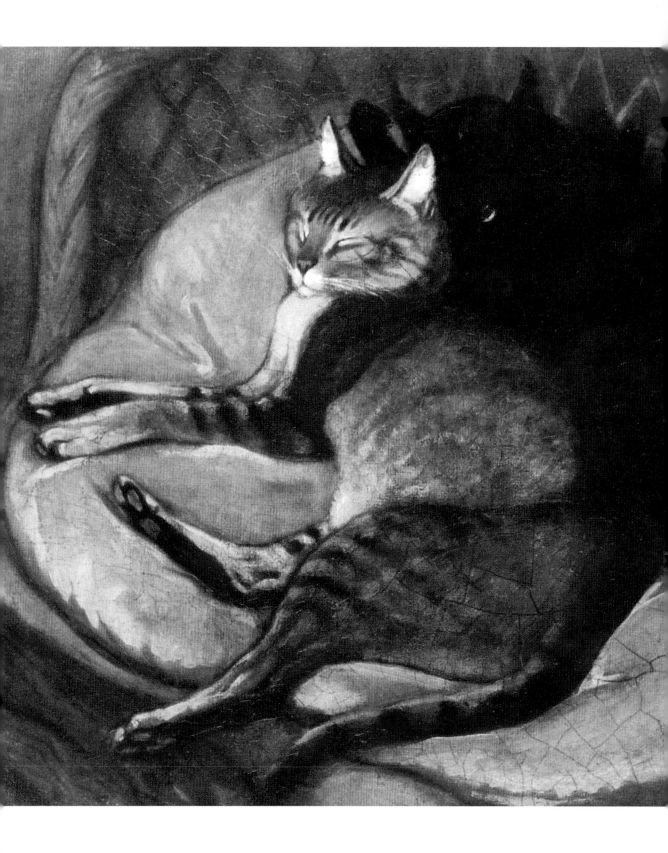

Steinlen: Chronicler of Cats

Of course, Théophile-Alexandre Steinlen (1859–1923) was not just a painter of cats. He would have thrown up his hands at such a label, just as the prolific Moncrif could not bear being characterized solely as the author of the *Histoire des chats* (History of Cats) of 1727. The fact remains, though, that this is how he will forever be characterized. Steinlen, you say? Ah, yes, cats! He did other things? Really? What other things?

Of Swiss origin, Steinlen began his career in Mulhouse as a draftsman, before making his way to Paris. There he was primarily a chronicler; an acerbic and trenchant observer, an uncompromising painter of the society of his time, with all this implies in terms of political and social commitment, of compassionate generosity for the starving, for beggars, and for the workmen in the city's fringes. There's something Zola-like about his depictions of capitalists and industrialists, of strikebreakers and the unemployed. Daumier-like too; the great Honoré Daumier (1808–79), from whose unfailing sense of caricature he had learned so much. By a strange paradox of the age, it should be mentioned that the more political, "leftist" artists, those who concerned themselves with the misery of the lowly, with vagrants and the downtrodden of Paris, were realists (some stigmatize them with a contempt they don't deserve as *"pompier"* artists; that is, artists bound by the conservative tastes of the Salon), as well as Steinlen and his like. On the other hand, the *grands bourgeois*, the "reactionaries," the pure aesthetes, obsessed by form and the play of light, ignored the living conditions of the peasants and the proletarians: these were the impressionists, or Caillebotte, or Manet. They are rightly celebrated today because they revolutionized painting (though they didn't revolutionize anything else), whereas a parallel pictorial tradition of the age is quite—and quite unjustly—forgotten.

So, Steinlen is left with his cats. And, with the cats, the offbeat, provocative, endlessly chirpy, and Bohemian atmosphere of Montmartre in the latter years of the nineteenth century, with which Steinlen is irredeemably associated. He is known for having produced a large number of illustrations for the revue *Le Chat noir* (The Black Cat) and for having carried out for Rodolphe Salis an *Apothéose des chats* (Apotheosis of the Cat) for the (second)

cabaret of the same name, as well as a poster for one of its tours in 1896.

His graphic output includes some of his finest and most famous pieces. It is impossible to forget the splendidly skinny black feline, with slightly bushy fur and wide-open eyes, seen in profile, but turning toward us, standing out against an orange background with a filigree red halo behind its head. The mystery, the vehemence tempered with irony, the incisive, shimmering elegance, the pithy economy of means, the unequaled suggestive power; all make this poster into a classic piece.

Another sumptuous work of painting is the touching *Cat on an Armchair* (now in the Musée d'Orsay). It has such fleetness of form and straightforwardness, with such an acute sense of observation. It is (almost) as fine as a Manet. It's a cat that is just a cat—just as *Olympia* is just a reclining naked woman, and certainly not an allegory of sensuality, a goddess, a symbol, or anything else. It is a cat that Steinlen has just woken up and that might soon fall asleep again—and not a god, a mystery, a pretext to some discourse. A cat, just a cat (in so far as a cat can ever be "just" a cat—but that's another story), in which it is the painting that matters.

But still, essentially, Steinlen remains a brilliant portrayer of cats in drawings, without recourse to color, oil, or canvas. He draws the cats of Paris: cats on roofs, cats against a plain background, whose attitudes—dapper poses, infinite twists and turns, and impalpable movements, shifting the lines and reorganizing them unceasingly—he never wearied of studying. Not prosperous cats, plump middle-class cats, or pedigree aristocrats, but thin-as-a-rake proletarian cats, moggies that know how tough it can be to make ends meet and which roofs are safe and which not, and whose nobility—that nobility that comes from deep within and that one earns, the only nobility worth having—is translated by indifferent, haughty, and hushed attitude.

A profound melancholy reigns in Steinlen: in his drawings, washes, watercolors, engravings, and sketches. The grayness of solitude.

His cats are waiting for something, but it's not clear what. A quest for the absolute or a little compassion; a reason for living or a well-filled bowl—no one knows. And Steinlen observes them all so closely, so fraternally. As if he too possessed something of their independence. Of their rebellious spirit. Of their loathing of pretence.

Pages 204–5
Two cats intertwined on a sofa by Théophile-Alexandre Steinlen, who "never wearied of studying the indifferent attitudes, the elegant poses of cats." F. V.

Facing page
This portrait of two cats by Théophile-Alexandre Steinlen was painted in 1894.

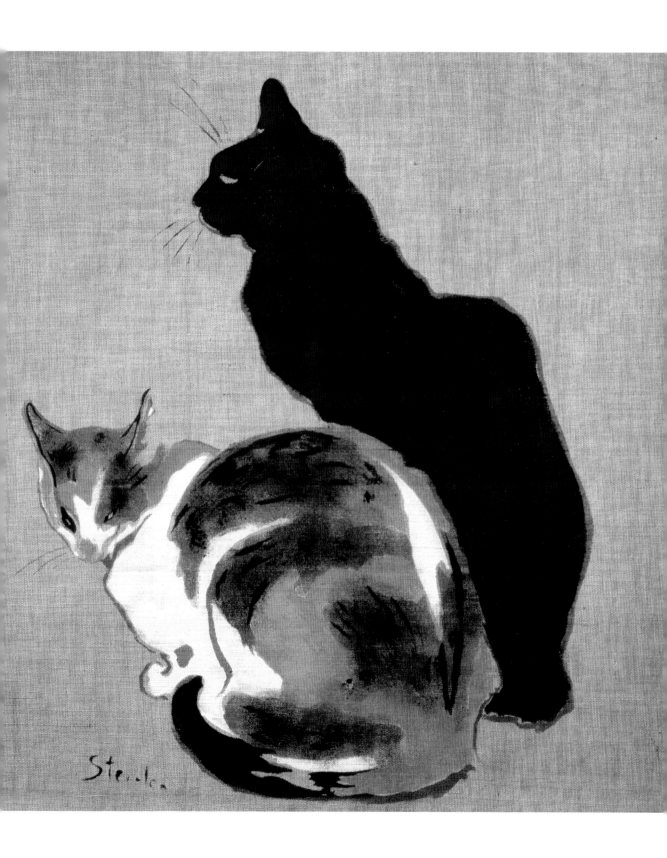

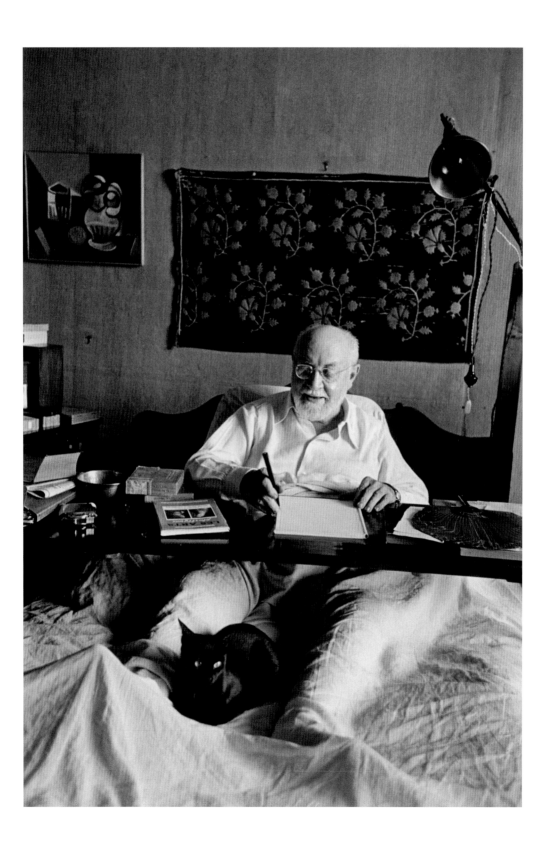

Cosseted Companions

On laps, in arms, grasped tightly against the chest: there they are, so well behaved, so gentle, so pretty, so disarming; those cats that strike a pose, and that painters strive to capture on their canvases—in the company of their masters or mistresses, with children, or with come-hither young ladies.

It's become a fashion—a mania, almost. It all started more or less in the eighteenth century. By then, the cat had jettisoned its diabolic reputation. Now, on the contrary, it had become the embodiment of softness, tenderness, and mischievousness; of beauty and sensuality. As you see, its symbolic range continues to expand.

To give a few examples, among hundreds—among thousands, perhaps? A delicate pastel by Perronneau (1715–83) in the Louvre, where a girl, Miss Huquier, delicately tickles the head of a pretty cat snuggling up against her bosom. An effeminate-looking, young boy, by Greuze (1725–1805), lounging and holding a black kitten on his knees in the museum at Troyes. The work by François-Hubert Drouais (1727–75) of a little girl, playing with a tabby as she waits for other entertainments that will surely not be long in coming (private collection). To say nothing, obviously, of the splendid ginger cat, astonished to find himself on the lap of the young Gabrielle Arnault, a girl some five or six years old, who seems no less perplexed to be sitting in front of Louis-Léopold Boilly's delightful easel, again in the Louvre (1815). Nor of the portrait of Louise Vernet as a child, painted by Géricault (1791–1824), in the same museum, holding—or rather doing her best to hold down long enough for the pose—a large tomcat on her lap.

More paintings? There's no end to them.

Let's see. There's that ambiguous picture by Renoir, painted in 1868, now in the Musée d'Orsay, which represents a standing adolescent boy, nude, seen from the rear, and snuggling up to an adorable cat perched high on a table. Or, from the very beginning of the twentieth century, a family portrait by Mary Cassatt (1844–1926), with a well-behaved tom on the knees of a girl wearing a green dress (the picture hangs in the John Suroveck Gallery in Palm Beach, Florida, should you wish to see it). And, to conclude with Renoir (1841–1919) again, a painter who adored cats, the famous portrait in the Musée d'Orsay of Julie Manet seated

Cosseted Companions

Facing page
"Those cats that strike a pose and that painters strive to capture on their canvases." F. V. Matisse draws while the cat keeps an eye on the photographer. Robert Capa, in Nice in 1949.

with a lovely tabby comfortably nuzzling against her in a kind of somnolent bliss.

And what is happening, as a rule, in these pictures? Nothing particularly metaphysical; nothing sulfurous, disturbing, or magical. All that was mysterious, ambivalent, and savage about the cat in earlier centuries finally seems to have deserted it. No longer does it appear indefinable. The cat, literally and metaphorically, can now be "grasped." By the painter. By the sitter. It is a luxury article, beautiful and coveted. A toy. On occasion, an erotic curio.

How gentle, tender, happy, comfy, and heartwarming it all seems. How the trusting glance of the child, woman, or splendid young man is attuned to the soft purr of the pussycat. Can you feel the shiver of the divine or the infinite anywhere? Or see the shade of Lucifer or anything remotely like sorcery; something untoward, mysterious, dark? No, all that's old hat—the Dark Ages.

This is the post-Enlightenment era. The triumph of reason. The apotheosis of the bourgeoisie. The sole subject of these pictures is the tenderness, warmth, and the kind of peace with a whiff of beeswax that reigns among fragile creatures in whose mouth butter would be in no danger of melting.

Well, perhaps, perhaps, but all the same, can we be so sure?

The innocence of children is relative; this has been accepted at least since St. Augustine (and Freud does not contradict him on this point). As to the innocence of the young woman, the married lady, or unclothed and languorous youths—let's not even go there. The innocence of the cat, meanwhile, is solely a transitory attitude, and we'd have to wait a long time before seeing it refuse the cream.

No, in fact it is the fragility, not to say deception or perversity of these charmingly trite paintings and drawings, that so delights me. All life seems suspended, as if in an improbable, and fugitive, moment of grace. The little girl has stopped sniveling. The young man is no longer dreaming of wealthy protectors. Are they prey to impure thoughts? On the contrary, they are trying to persuade us that the very idea of impurity could never enter their heads, the hypocrites! In short, they'd like to have us believe that all is for the best in the best (or at least the most comfortable) of all possible worlds, while Pop calculates his revenue in his study and Mom receives her friends for tea in the drawing room. Of course, they're having us on. Pop is a merciless moneyman, Mom is vain and insipid, the young man a real thug. The cat will soon get its claws out, and the little girl will begin whining again, while the

Facing page
This 1881 portrait by Renoir in the Musée d'Orsay shows Julie Manet, Berthe Morisot's daughter, with a favorite tabby.

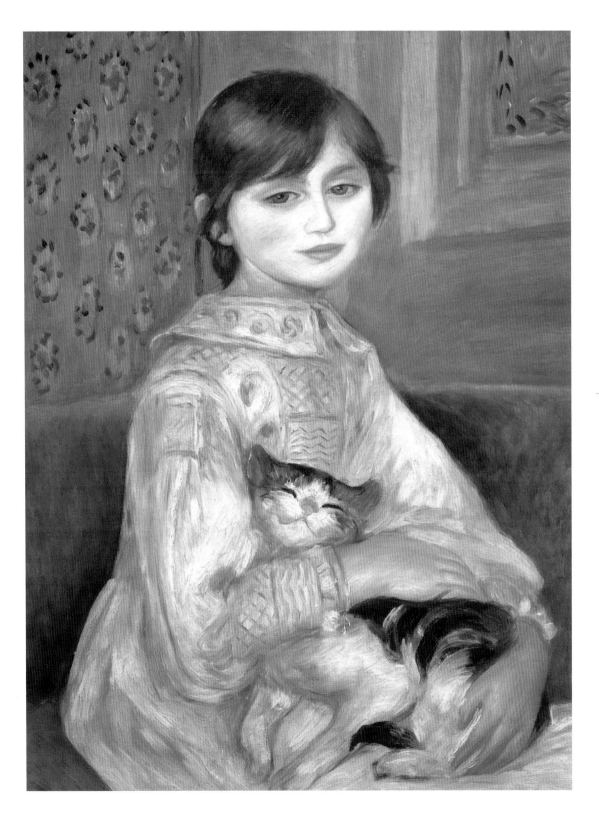

Facing page
The Boy with the Cat (1868) is the only male nude Renoir ever painted.

Pages 214–15
The main protagonist in *Mr and Mrs Clark and Percy* (1970–71), by David Hockney, is Percy the white cat. Forgetting the two fashionable figures of the 1960s gazing out at us, we wonder what has attracted the cat's attention outside the window.

young woman, who grasps the creature to her bosom so sensually, is only trying to compensate for the absence of her lover, whom she is waiting for expectantly, but who will never actually come.

In short, all this is just theater—delectable theater at that, the theater of appearances, where the cat is king. There's just one thing that does not deceive in the kind of pictures I've just referred to, however. That thing is the cat. Not the cat in eternity—in what would be quite wrongly seen as the animal's unique truth, but the cat in the moment: in the thousandths of a second, in the tenuous slice of life the artist was trying to portray; in the fugitive state of grace and repose, which is, for him, irrefutable.

The fact bears repeating: the middle-class world, the world that more or less all these pictures reflect, depends on a series of certainties (and thus illusions): the immutability of its values, the eternity of its comforts, the profitability of its investments.

But isn't this true of every society and of every political system? No, not to the same extent, and for one simple reason. By this point, the bourgeois world was one of Reason. And Reason, once the outrage of tyranny and the religious and superstitious vestiges of power have been swept away, does not change. The Revolution has triumphed, hasn't it? We've read Voltaire and Diderot. The issue has been decided. Human rights and universal values are enshrined.

Now, if a cat claimed to confirm all this, of course, it would be having us on. But, in truth, it's the painter who's trying to deceive us, knowingly or not, and not the cat he represents. Puss does not lie. It never lies. It was genuinely happy to be there, at that precise moment, on the knees of Boilly's little lady, or being stroked by Perronneau's girl, or dozing off against Renoir's delicious Julie Manet.

But, I insist, all this lasted but an instant. It is not a representation for all eternity, for eternal glory, the panegyric of a fixed society or other nonexistent certainties.

In these often admirable pictures, the cat, teasing and sensual, purring and cuddlesome, does therefore exist. It affirms its presence. Asserts it. It steals the show from the model. But it doesn't cheat. Better than that, perhaps, for slightly more perspicacious viewers, it calls us to order. It speaks of the transience of time, of the fragility of political regimes, of flickering states of the heart, of the to-and-fro of passions, of the risks of the Stock Exchange, of the whims of temper that are our destiny.

The cat, solely by its presence, dispenses a lesson in philosophy.

It is a professor of disquiet.

What greater gift than
the love of a cat?

Charles Dickens

Tom and Jerry

How does one recognize a legendary figure? In two ways, at least.

First, they affirm a characteristic or an attitude in the face of life or death that encapsulates something definitive and final, as if the embodiment of a model, a benchmark. In addition, mythical characters are always more famous than the writer who dreamed them up, sometimes to the point of eclipsing them completely.

Everyone knows Robinson Crusoe. Not everyone knows Daniel Defoe. The name Don Juan is on everybody's lips. But how many people know that he was invented by the Spanish playwright Tirso de Molina, before being taken up and embroidered by Molière, Mozart, and the rest? Don Quixote is immortal, even overshadowing the more indistinct figure of Miguel de Cervantes.

Would one dare to say that Tom and Jerry are legends? I can't be sure their posterity will be as enduring or as productive as that of the aforementioned heroes. But we can leave that up to the future to decide. The fact remains that, from the 1940s onward, in the hundreds of animated drawings in which they starred, and which enchanted generations of children, they were the incarnation of something fundamental: of the eternal struggle between the strong and the weak, between the blunderer and the crafty, between force and cold calculation.

On one side is Tom, a homely gray cat, who does not ask much of the world, but whose tail should not be pulled; and on the other is Jerry, an impertinent little brown mouse who spends his time doing just that, riling Tom to the highest pitch of anger.

Tom and Jerry, it bears repeating, are two wonders of the world. And yet it was amid the most perfect indifference that Joseph Roland Barbera died at home, in Los Angeles, on October 18, 2006, aged ninety-five, while his faithful collaborator and accomplice, William Hanna, passed away just as discreetly in 2001, at the no less respectable age of ninety.

Children, of course, always root for Jerry. They're on the side of the mouse—weaker, smaller, more sly, more impertinent. Are children right? Not at all. They're perverse, cruel, and violent, and have no empathy or identification with the suffering of others, as has been well known since Freud and St. Augustine. This, incidentally, is how we realize that we've aged. When we recognize that

Page 216
If he whips my cats there's a ghost / That'll come to haunt him. Georges Brassens, in his valedictory song "Le Testament," pictured here with his cat.

Facing page
The book Jerry is reading seems ideally suited to the situation.

Pages 220–21
A famous still from the cartoon's credits.

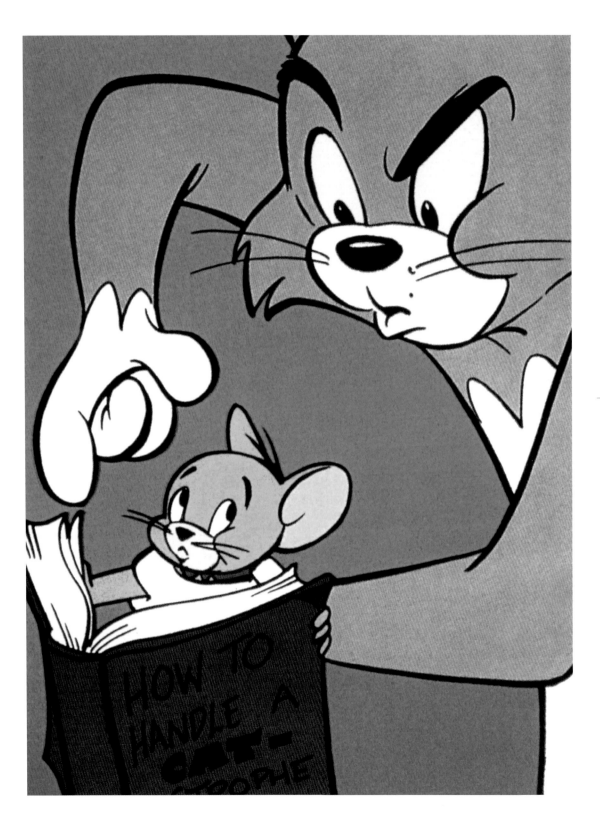

we've become a little less ferocious and a little more able to put ourselves in somebody else's shoes. When our judgment with respect to such mythical characters changes or evolves. In a nutshell, when we start cheering for Tom, who deserves our compassion, and not Jerry, that unbearable pest you wouldn't give houseroom to.

But, I can hear you saying, Tom is a cat, and that's why he gets your vote. Of course, but there's more to it, actually. There's my constant irritation at the commonplace assumption that "the little one is always right." All too many elder children of large families suffer from this, with their parents inevitably finding against them when, beside themselves, they finally lash out at the provocations of the younger ones, who equally inevitably know they'll benefit from impunity thanks to their supposed weakness (this is not personal rancor, honestly: I was the youngest in a family of three children). Jerry tries every trick in the book, with everything cunningly arranged so the blame falls squarely on Tom.

Who dares to disturb Tom's afternoon snooze? Jerry, of course, blithely ignoring the fact that one should *never* wake a sleeping cat. Doesn't he know that one day the Prophet Muhammad preferred to leave his coat where it lay rather than wake up a cat that had fallen asleep on it? Jerry certainly has no such scruples. Any pretext is good enough, in his eyes, to create disorder. Or better still, utter chaos. Anything to turn the house upside-down. And then his allies are among the most vicious possible, like the abominable Spike (a.k.a. Killer), the neighbor's bulldog.

And so, it can hardly be any surprise, after that, to see Tom mobilize for his defense (or attack) every possible weapon: rolling pin, ax, rifle, dynamite, or, the very worst, the electric toaster. Or join forces with some precious allies of his own, such as Butch, a black house cat whose feelings toward Jerry are understandably pretty ungenerous.

And so apocalypse ensues—in the house, in the garden, and in the great outdoors. Everything shakes, explodes, and collapses. Sixteen-ton weights fall on Tom. Happy birthday! And he ends up looking pathetic, pitiful, ridiculous.

His fur is pulled off him. Squashed by a steamroller, he's as flat as a pancake. And there's more before he slips back into his coat. But we love him. Jerry can strut about in triumph, sniggering, underhand. We hate him.

It took me some time to begin to hate him. To understand, in other words, that I was getting old.

Man is civilized
to the degree that
he understands the cat.

George Bernard Shaw

The Cats of Venice

Among its many merits and innovative enterprises, Venice has established an exceptional form of peaceful coexistence between cats and humans. As if a kind of *patto segreto*, a secret pact, binds the citizens of La Serenissima to the feline community.

Of course, other animals thrive in Venice. Jean Cocteau said it was the only city in the world where pigeons walk and lions fly. But let us leave in peace these marble or Istrian-stone winged lions, attributes of St. Mark and thus symbols of the Republic of Venice, perched on top of columns and on the pediments of the public buildings. And let's leave the pigeons to their own collective devices on the *campi*, in front of the Doges' Palace and on the Piazzetta, as if begging a pittance from the hordes of tourists, with no thought for cats. And they're right too. Here cats mean the birds no harm. They've been coexisting peacefully for ages. Cats do not compete with pigeons. They do not beg. They just take what they want: that's not the same thing at all.

The peace that has broken out in Venice between pigeons and cats is revealing of the city itself, the most tolerant in the world. If you think about it, from the sixth to the eighteenth century, the Most Serene Republic never expelled an ethnic or religious community, never condemned or executed anybody for heresy, and never gave the courts of the Inquisition a free hand. No witch was ever delivered up to the stake in Venice. Nor was any cat ever considered as a diabolical figure. During some of the most tragic of Europe's convulsions, Armenians, Turks, Jews all found refuge there, in quarters specially reserved for them.

But were the Venetians great philanthropists? Not at all! Rather, the Venetians are great merchants. And that means simply that violence and pogrom, religious dispute and mutual stigmatization, disorder and insecurity, as well as claptrap about the satanic or accursed nature of cats, are all deplorable for business and discourage custom. It's always better to negotiate—always, and with everyone.

Which brings us inevitably back to the cats that the Venetians protect... because cats protected Venice. These animals did not belong to some city aristocrat; they did not expect to sleep beneath

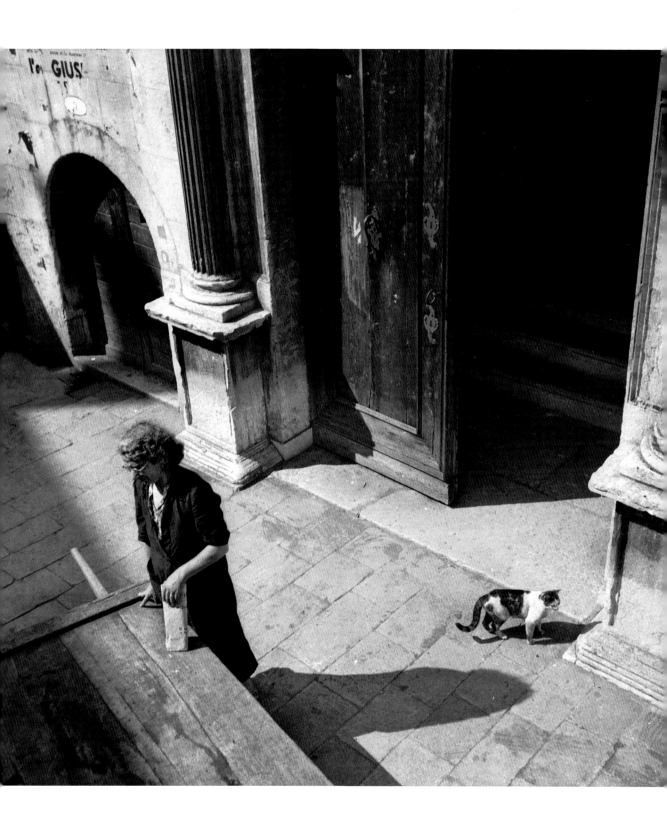

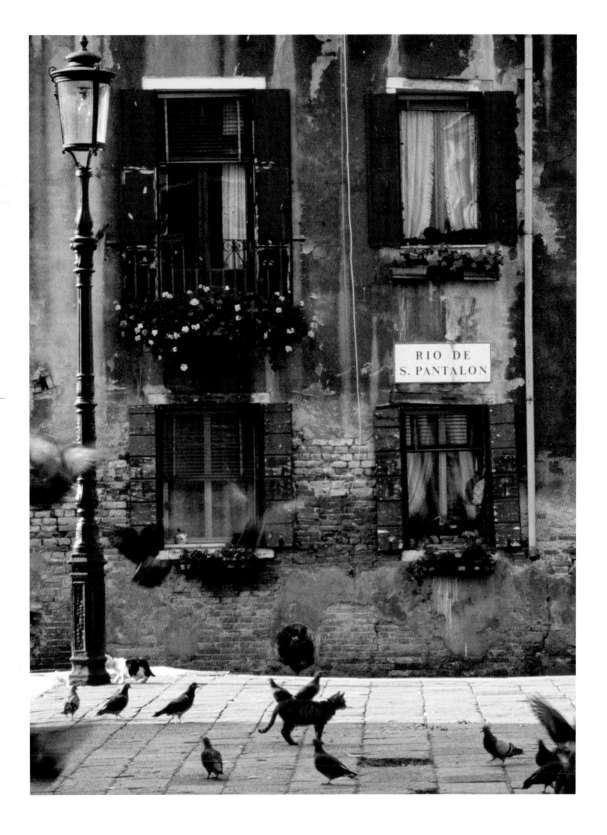

one of Tiepolo's ceilings, dream to an aria by Vivaldi, or flounce at the bottom of their master's gondola. Strays, they belonged to no one. They were, in their own way, free citizens of the Republic. They did not leave it. They never even thought of doing so. And how could they have escaped anyhow, since the City of the Doges is cut off by its Lagoon, protected by a maze of canals, making Venice, in effect, an impregnable city.

So what, more precisely, were the clauses of this *patto segreto* between cats and the Venetians? Well, cats assisted them in the fight against the plague, by hunting down the rats that carried the disease. In return, the Venetians gave them shelter, feeding them on occasion, letting them stroll about in peace in the shadow of churches erected by Palladio—not the most unpleasant or most unreasonable way of killing time and of meditating on the human, or feline, condition.

At one time, alas, long ago, back in the Middle Ages, black rats, the most harmful, started multiplying. The Venetians promptly sought feline reinforcements. From the Near East, they brought back a more muscular race with a stripy coat, called in Venetian the *suriàn* (*soriano*, in Italian), the etymology of which has roots in "Syria," and whose descendants still stroll down canals today.

The years, the centuries passed. The plague receded and soon vanished from Europe. No one complained about that. The rats became scarcer, less of a threat. But, in consequence, cats, those freeborn Venetian citizens, also appeared less of a necessity. For La Serenissima, they became a luxury, ennobling the city, and enhancing its secrets, sensuality, and silence. But was this enough? The absorption of Venice into the Kingdom of Italy in 1866, and the two world wars of the twentieth century, did little to improve their situation. By the early 1960s, there were approximately seventy thousand cats in Venice, often mangy, scabby, and starving. Wretched.

Moved by their fate, a woman took charge. She deserves to be recorded and indeed honored in this volume: Helena Sanders. Born in 1912, this Englishwoman first devoted her energies to helping the Jews who had escaped from Nazi Germany, and the French who had taken refuge in London in 1940. Her battle in Venice on behalf of the local cats initially sparked sarcasm and condescension. What business was it of this foreigner? She stood fast and soon found allies for her crusade from within the city itself. She had the cats looked after, controlling and reducing their birthrate. After twenty years of unstinting effort, the results were obvious: the feline

population, prosperous and thriving, had stabilized at around six thousand. In 1985, the City of Venice awarded her its highest honor: Helena Sanders was named a Knight of the Order of St. Mark.

An association, "Dingo," has since taken over where she left off, attending to the health, subsistence, and comfort of the cats of Venice. After this new *patto segreto*, the cats of Venice continue to honor the city by their presence, their elegance, their wisdom, their beauty, and their nobility. In every district, in every *sestiere*, from the Dorsoduro to Cannaregio, one loses count of these invaluable *mamme dei gatti* (literally "cats' moms"), whom Venetians call more familiarly "*gattere*," who contribute discreetly to the sum of feline happiness.

Perhaps today these animals are the last remaining true aristocrats in Venice, a city that was for so long, and from its very constitution, a noble Republic. I for one think they may well be. But there are fewer and fewer feline aristocrats, alas, over latter years. Has the appalling onrushing wave of tourism scared them off? Have they (almost) all been sterilized?

For many years, when I would visit Venice, I used to meet philosophical, gastronomic, hedonistic, playful, impatient, and epicurean cats. At the Lido (in the gardens of the Albergo dei Quattro Fontane, known only to connoisseurs and lovers of Venice), Red, an antediluvian and by then blind stripy ginger tom would chat to Bijou, a mischievous and ravishing little black she-cat.

I have also known some highly placed cats. By which I mean cats that lived exclusively at a certain height—on the city's roofs, terraces, balconies, and architraves, or on that unique form of belvedere, that ideal spot for repose and *dolce far niente*, dubbed in Venice, the *altana*.

One of my friends used to do her bit to feed them. For this elevated breed of tom, her *altana* was a gastronomical mecca. One day, she decided to carry one of these moggies down to the ground, probably in the belief that it had lost its way. Wrong call! Hardly had the animal perceived the noise, the hustle and bustle, the touristy crassness of the alleyways and the thumping of the water taxis along the canals, than it made it its business to regain its aerial haunt as fast as its legs would carry it. Zooming up the stairs, it demanded that every impeding door and window be opened until it was able once again to gaze down in peace on the city below.

Is Venice the only city in the world where the cats look down on pigeons from above?

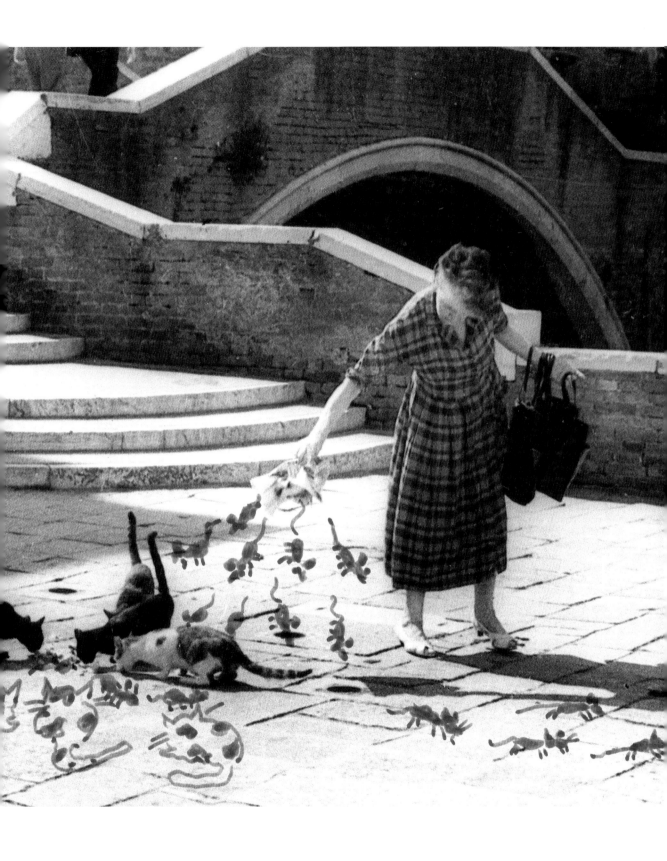

When a cat adopts you there is nothing to be done
about it except put up with it until the wind changes.

T. S. Eliot

Facing page In this unfinished painting by Manet (c. 1880–82),
the family cat, Zizi, snoozes on Suzanne Manet's lap.

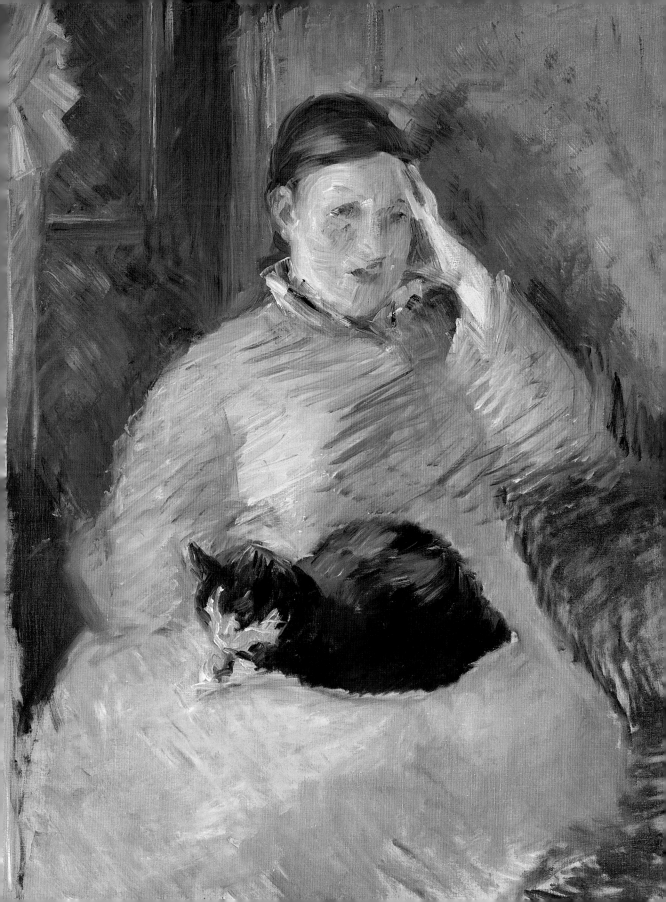

My Life in Cats

For a long time I used to go to bed early, without a cat near me, without even regret for a cat, hope for a cat—without the notion, the thought even, that a cat might share my life and that of my family. My parents saw nothing wrong with cats in general. Nothing right, either. My mother reckoned she already had enough on her plate with her three children, without being encumbered with a domestic animal.

My father was more wary. A cat was unpredictable. A source of mayhem. My father saw himself as a man of order, in the traditional or conservative sense of the term. The unexpected disturbed him. Cats made him feel uncomfortable. He didn't understand them. For him, beauty was a question of immobility, of balance. My father was, by temperament, a classicist. He distrusted the movement that shifts the lines. He liked what he could grab hold of and comprehend. It was difficult for him to understand cats; more difficult still to get a grip on them.

The first cat I met in any real sense was called Mouchette. Inevitably, it was a she-cat. An exceptional personality, too. Something I didn't expect.

One day, we meet a girl, find her nice, and we're soon tying closer, more tender bonds with her, and we convince ourselves that it's a private matter between her and us. Well, we're wrong. We ought to look at things more attentively, examine what lies hidden behind the young lady, who her close friends are, her confidantes, those she can't live without. We need get the measure of this escort before going on, because, sooner or later, this escort will quite possibly form part of our own. In short, Nicole, whom I met in 1963 and who ran a small and very literary bookshop, "L'Étrave," on the Île Saint-Louis, opposite her parents' Café des Sports, was, as you've guessed by now, the partner or confederate of Mouchette, a placid, independent, razor-keen, stripy house cat, who deigned to share her life with Nicole and her family, between the bookshop and the café on the other side of the rue Saint-Louis on the corner with the rue des Deux-Ponts.

Nothing worried Mouchette, who drowsed away the hours in the bookshop window beneath the heartening warmth of the electric spotlights. She loved to lounge on Julien Gracqs published by

Facing page
The author Frédéric Vitoux with Nessie, in his study on the Île Saint-Louis.

José Corti, Michel Leirises published by Gallimard, and Becketts published by the Éditions de Minuit: what did she care if she'd been out in the gutter and daubed paw prints all over the spotless covers of books by Nicole's favorite authors? Mouchette was then no maniacal bibliophile. Only the contents of books count, isn't that right? Unless she was thinking that leaving footprints on a book's cover—her signature, or ex libris, if you prefer—amounted to a kind of tribute.

You cannot replace one cat with another. An ersatz cat cannot erase the sadness felt at the disappearance of its predecessor. Some people believe that, but it's not true. I have never understood the attitude of those people who refuse to adopt another cat (or to let themselves be adopted by one), on the pretext that they would be betraying one they once loved. How can that be a betrayal?

I have never forgotten two other tabbies that shared our life thereafter: Fafnie, the intrepid explorer, and Nessie, the huntress. Not to mention Papageno, found near Corbeil, who accompanied us for twenty-two years.

Perhaps this athletic half-Chartreux, with a little white patch beneath his throat, was too intelligent ever to feel truly happy. That, anyhow, was Nicole's conclusion, and she felt genuinely sorry for him, all the while admiring what was indisputable proof of his lucidity. Perhaps Papageno also suffered from an imagination that was too active to spend his days entirely peacefully. He examined everything. Every nook and cranny. He had understood that, if children can be kindness itself, they can also—and more often than they really should—indulge in merciless ferocity. It was better to keep out of harm's way when my then very young nephews and nieces (they were numerous) turned up where we lived on quai d'Anjou. Papageno, in short, was a sage. He entertained no illusions about mankind. A sage, but above all a skeptic. And was he that different from us? Still, none of this prevented him from possessing a hearty appetite. We had to put aside tins of cat food, biscuits, and other factory feedstuffs. White meat, poultry, and green vegetables, our veterinary surgeon advised. In any event, he wasn't a fussy eater. He tucked into everything. He shared our repasts. Finished off the leftovers. Meat, vegetables, fish, rice, and more besides. We had to hold back on pastries and chocolate, neither of which are recommended for the feline diet. Oh, dear Papageno! He also encouraged me in my work, with his kindly questioning glance. What on earth are you writing? I felt obliged

My Life in Cats

Above
"Papageno, in short, was a sage. A sage, but above all a skeptic." F. V.

to offer him a worthwhile answer. His face was quite round, very pretty and aloof, with eyes like marbles, and he almost smiled, sometimes, like the Cheshire Cat in *Alice in Wonderland*. Perhaps he smiled at the vanity of men and, also, perhaps, of cats.

After due reflection, I've concluded that Papageno must have been a follower of Pascal. He understood, like the French philosopher, that all the misfortune of earthly creatures stems from the fact that they cannot remain at rest, in their room. You want me to get into a *car*? No fear! He spat, he railed. He was seized with anguish. Nicole had to sit next to him on the back seat, while in front I played chauffeur for Sir and Madam. I just needed a cap. He would pant. He perspired and stuck out a tongue as long as your arm. Nicole helped him to drink with a syringe. She stroked him, tried to calm him down. When a semitrailer drove too close past us on the motorway, Papageno would spit at it, as if to make clear his fear and contempt. Like a tragic hero, he defied the gods (and pantechnicons).

He passed away in the summer of 2006, in a small village near Laon. Toward the end of his long life, he lost a lot of weight. But he didn't complain, absolutely not. He was always so splendid, proud, intelligent, and thus melancholy. He would generally take refuge in sleep.

A few weeks earlier, some new mice had taken up residence in quai d'Anjou. Papageno obligingly signaled their presence by mewing a bit, close to their supposed den. His zeal ended there. One day, I even saw a tiny and extremely impertinent gray mouse flit by a few inches from his paws, from his claws. Papageno observed it with detached curiosity. With age, he had become peaceful, and who can reproach him for that?

That fateful summer's day, he clearly felt tired, under the weather. He strove to keep his eyes wide open, as if death was approaching and he wanted to see it come. He dragged himself from bed to armchair. He couldn't find a comfortable position anywhere. Death was stalking him, tracking him.

Did he suffer? He did not mew, he did not complain, though usually he was such a softy. No, he just stared wide-eyed at the great Unknown circling him, brushing by him. It was heartrending.

After his death, Nicole and I remained without a cat for more than a year. No opportunity for one arose. We didn't want to hurry things, to precipitate matters. The idea of buying an animal never entered our heads.

Below
"Mouchette, an easygoing, independent, saucy female tabby."
F. V.

On December 31, 2007, in Provence, while we were walking before sunset along a little path through the plain between Cogolin and Grimaud, Nicole thought she heard something like mewing behind a bramble bush in a patch of wasteland.

We halted.

Did you hear it, she asked?

No.

We turned back.

The mewing was repeated.

And suddenly, out from the brambles rushed a tiny, very black kitten that disappeared into a ditch to reemerge bravely and start rubbing against our legs. Nicole took him up in her arms. No sign of panic. He started to purr. Had he been abandoned? Was he lost? He did not seem on his last legs, but neither did he want to leave us for a second.

We went round the houses in the neighborhood. The majority were closed up for the season. At those residences that were occupied, no one seemed to know the animal. There were some strays in the area; Nicole also showed them the little black kitten. No signs of maternity, fondness, or even recognition on their part either. In short, as snug as a bug in Nicole's arms, the black-as-pitch kitten with the funny face came back with us to our house in Grimaud. This was what he wanted. Back at the residence we found, in a cupboard, a tray and some leftover sawdust once destined for Papageno. Without a by-your-leave, the tiny kitten leaped into the tray to show us how clean he was and to make it absolutely clear that he had decided to adopt us, as well as reassuring us that he was perfectly housebroken.

A few days later, the vet at La Foux informed us after due examination that what we had there was not a tom, but a two-month-old she-cat. What name to choose? The last letter of the alphabet for the last day of the year that presided over our meeting? We chose Zelda, but hoped that she would prove less dippy than F. Scott Fitzgerald's wife.

And, of course, the young Zelda accompanied us to Paris—and then what? Perhaps, one day, I will write a whole book on Zelda (as I could have written one on Mouchette, Fafnie, Nessie, and Papageno); on her loyalty and overflowing affection, on her occasional extended claw, her atrocious character, her rather limited but touching intelligence. But the story, our story, is not yet at an end. And one shouldn't tell a story if one doesn't know the ending.

Facing page
The author at home, consulting a book during a discussion with the young Zelda.

Page 238
Mouse Eyes. Drawing by French artist Albert Dubout (1905–76).

Pages 240–41
"They've got 'cat's eyes'? That says it all." F. V.

A cat's dreams teem with mice.

Lebanese proverb

Cat's Eyes

Perhaps it's the eyes that are the most remarkable thing about a cat, the thing that really sets our imagination running?

A cat's eyes, so magical, so unfathomable, that have been believed to possess so many virtues, including that of seeing at night. If one says somebody has "cats' eyes," it's clear one thinks they see more than the average person. A cat's eyes delve into one deeply; they look at you all right, but make it hard for you to look at them. The eyes of a cat are the essence of its beauty, the emergence of its soul.

And what do they see, cats? What are they able to perceive?

One might attempt an answer on the anatomical level, but, between us, can anatomy, however enthralling a science, ever define the life and the vision of cats, the very linchpin of their originality? Well, anyhow, let us briefly note that a cat's pupil can dilate far more than that of a human and that's why they negotiate inadequate lighting conditions better than us. Of course, in total darkness, they are no better off than we are. It's not magic. When a cat's pupil closes up in daylight, one can make out little more than a vertical black slit. It is then that its iris, equipped with minute muscles, deploys an incredible range of colors that depend on its breed.

The cat is an animal of the twilight, almost a nocturnal predator. What are the implications in anatomical terms? Not only that it can dilate its pupil enormously and so collect the most insignificant dot of light. The essential fact is what the cat sees, what it perceives, whatever gets through to its consciousness. To examine the cat's eyes, the enigma of its narrowing or dilating pupils, is at the same time to address the subject of what it knows, what it understands, what it recollects but does not tell us.

And the color of cats' eyes has compromised the happiness of more than one poet, and even painter. Should one prefer the pale porcelain blue of the Siamese to the bright, yet heartwarming and unthreatening orange of the Chartreux? The Veronese green of certain black cats to the sandy yellow of the Abyssinians? All cats possess beautiful eyes. One can feel the light near a cat's eyes, as if they'd stored up so much that they can pass some of it on to us.

Nothing is more comforting than a cat's look; nothing more disturbing, either. And nothing more vital.

Nothing's more determined
than a cat on a hot tin roof.

Tennessee Williams,
Cat on a Hot Tin Roof

Zen

To conclude this miscellany with a word beginning with the letter "Z" seems a logical idea. It is a return to serenity; but haven't the foregoing pages been full of serenity?

"Very Zen," "keep Zen": both evoke the idea of unflappable indifference with respect to the vain agitation of the outside world. Take your cat, for example: it is perfectly Zen, hyperbolically Zen, resolutely unmoved when faced with the frantic frivolities of your life, supremely indifferent to what you bothers you, like the most recent presidential election or tax increment, and keeping admirably calm so as to seize the moment that passes and savor it without anxiety or remorse.

It is hard to imagine an animal, any living creature, or even a life coach, more supremely detached than the cat, so unconcerned by the uncertainties of the future, so heedless that it folds itself up within the only truth that truly exists—the one that concentrates that imperceptible droplet of present time in the torrent of the fleeting, and that opens the door to bliss and wisdom.

Cats are Zen? You can say that again. In the vulgar sense of the term, indisputably. And in the more philosophical, erudite sense too, there can be no doubt about that.

But what is Zen? To boil it down (a lot), it is a Japanese variant on Buddhism that evolved initially as a result of contact with China. More precisely, in the Land of the Rising Sun, the word Zen designates primarily silent meditation, the meditation that leads to inward illumination. For this purpose, they recommend the practice of *zazen*—the motionless, seated posture of the sage, who endeavors to drown his ego in an absence of tension and will-power, and so reach the spirit of the Way and attain Awakening.

In terms of Buddhism, all of us—from the founder himself ("Buddha" comes from the word for the "Awakened" or "Enlightened") downward—possess the necessary aptitude to gain Illumination. Such is, at least, the rather comforting conviction of the theorists and followers of the practice of Zen. All this offers an obvious contrast with the situation in the Christian tradition of the Jansenists, who convinced themselves that the grace of God was extremely unfairly distributed between men. All the same, perhaps there are beings more suited than others to attain—with

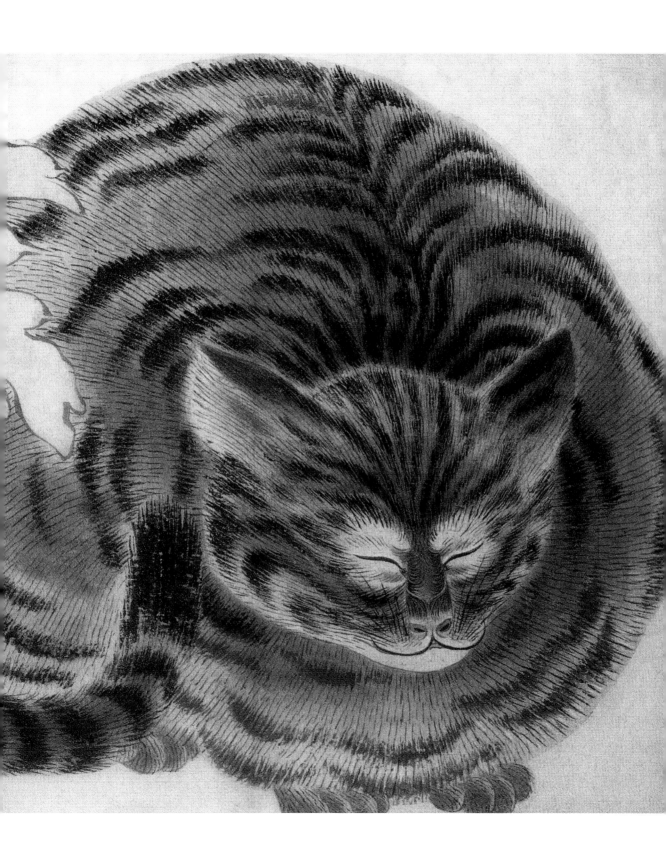

Page 242
"Cats are observers. I
snapped this inquisitive
cat in Prosper Mérimée's
house; he was a great
friend of cats." Édouard
Golbin, who took this
photograph in 1984.

Pages 244–45
"A large, satisfied cat,
perfectly Zen and
resolutely unmoved."
(Anon, Japan)

Facing page
"The cat is essentially
Zen. All the rest is
trivial." F. V.

Pages 248–49
Indifferent to all the
hustle and bustle on
the esplanade of the
Trocadéro, a kitten
snoozes on a statue's
hand.

not too many trials or tribulations—Illumination, and the Middle Way lights each of our paths with singularly variable intensity.

From this point of consciousness (or unconsciousness), when the goal is to lose the self, the better to be absorbed into Being, the cat seems better equipped than we pitiful humans.

Let us recap: the cat is *essentially* Zen. All the rest is trivial.

Have you ever visited one of those sublime Japanese Buddhist or Shinto temples, in Kyoto, Uji, Otsu, or Nara, for example? Radiating inner peace, they are places where Japan, whose contemporary face is of such abominable and despairing ugliness, regains its breath, where the flickering flame, which against all odds seems to illuminate the entire country, still shines.

Who meditates there, who reposes, enchanted by the warmth of inner enlightenment? Monks? Perhaps. Cats? You can bet on it. At least, you could have, before hordes of tourists (one of the most terrible aspects of modern pollution) started disturbing the meditation of the monks and discouraging cats from taking refuge in the temples.

Admittedly, nitpickers and shameful materialists, who doubt the irrefutable virtues of the *zazen* as they do the mystical wisdom of the cat, liberated from all desire and all stress (yeah, right), will point out that cats didn't thrive there by mere chance, attracted solely by an imperative impulse for transcendental meditation.

Monks welcomed them with open arms for centuries, and for one simple reason. Monks eat rice. Mice adore rice. In other words, the more the mice (which, it appears, are not Zen in the slightest, wretched creatures) multiplied, the less rice there was for the monks who, Illumination or no Illumination, needed to fill their bellies. So, the more cats there were to share their cenobite existence and the fewer mice, the more rice there was to fortify the monks and calm their appetites as they patiently advanced along the Middle Way. Elementary.

Probably. But this explanation seems a bit reductive all the same. It will satisfy only people who have never observed a cat; who have never seen one doze off on a mossy stele or on the stone steps of a temple; who have never watched one drowsing or curled up in the shade of a cherry tree in flower; who have never spotted one sitting bolt upright at the foot of some timeless statue of a Buddha, eyes fixed on the infinite or at some mysterious point that only he perceives and scrutinizes, and who thus has manifestly attained the same level of knowledge and revelation as the Awakened One.

I remember well two particular cats I glimpsed in the gardens of the Imperial Palace in Kyoto. They approached. Purred at my feet. As dignified, as venerable, as meditative as the shades of the dignitaries, ministers, favorites, and priests who long ago used to haunt these great paths.

What was Zen, again? What is Illumination? The greatest Eastern sages ceaselessly circle this question, striving to cast light on it in erudite tomes or pithy maxims (the famous Zen stories or *koan*), in order to free themselves from all they saw as hindrances: logical thought, the burden of time, and the scourge of the relentless chain of causality.

Zen, for example, as an adept will explain, is losing, abandoning, while Illumination is finding, recovering.

For my part, I rather like the approach to Zen summed up in the following aphorism: when you do not practice Zen, rivers are rivers and mountains are mountains; when you practice Zen, the rivers are no longer rivers and mountains are no longer mountains; when you master Zen, rivers become rivers again and mountains, mountains; when you attain Illumination, rivers become mountains and mountains rivers; and beyond that, all ceases to have the least importance.

Beyond that (but this is my own personal codicil), you'd be worthy of becoming a cat.

Credits

Acknowledgments

To Nicole Chardaire, as is only right,

but also to Mme Liliane Almanzor, M. Pierre Bergé,
Mme Ghislaine Bavoillot, Mme Pia and Bente Bevilacqua,
Mme Patricia Boyer de la Tour, M. Gabriel de Broglie of the Académie française,
M. Bernard de Fallois, M. François Forestier, Mme Dominique Hervier,
M. Stéphane Hoffmann, Mme Françoise Landeau, Mme Mitou Leyraud, M. Paul Lombard,
M. Éric de Lussy, M. Philippe Meyer, Mme Nicole Mallard, M. Christian Millau,
M. Éric Neuhoff, M. Patrick Nottin, M. René de Obaldia of the Académie française,
Mme Mireille Pastoureau, M. Michel Pastoureau, to Professor Yves Pouliquen of the Académie française,
to M. Claude Réveillard, to M. Angelo Rinaldi of the Académie française, to M. Alain Riou,
to M. Pierre Rosenberg of the Académie française, to Mme Diane de Selliers,
M. Jean-Claude Simoën, M. Jean-Noël Tron, M. Patrick Vannier,

and, especially, to Dr. Philippe de Wailly,

the author would like to address his warmest thanks for the support or information
they were kind enough to offer him and for the books or articles to which
they alerted him—in short, for a complicity that greatly assisted him in
compiling a miscellany intent solely on celebrating our shared love of cats.

The publishers would like to express their gratitude to all those who have enriched the artwork
in the present volume, in particular: Vincent Boeuf, Nicole Chardaire, Karl Lagerfeld,
Caroline Lebar, Serge Rezvani, Gérard Rondeau, Hélène Wadowski, and Jonathan Zlatics.

Facing page "The first cat I met in any real sense was called Mouchette.
Nicole, who ran a small and very literary bookshop, "L'Étrave,"
on the Île Saint-Louis, was Mouchette's owner."

This book is an abridged and illustrated edition of the original work
published in French by Éditions Plon in 2008.

———————————————————————

Editorial Director: Ghislaine Bavoillot
Original Layout Design: Isabelle Ducat
Translated from the French by David Radzinowicz
Copyediting: Penelope Isaac
Layout Adaptation and Typesetting: Gravemaker+Scott
Proofreading: Helen Downey
Color Separation: IGS, France
Printed in Singapore by Tien Wah Press

———————————————————————

Originally published in French as *Dictionnaire amoureux des chats, version illustrée*
© Plon & Flammarion, S.A., Paris, 2013

English-language edition
© Plon & Flammarion, S.A., Paris, 2014

87, quai Panhard et Levassor
75647 Paris Cedex 13

editions.flammarion.com

14 15 16 3 2 1

ISBN: 978-2-08-129717-3

Dépôt légal: 02/2014

Dragon Li · Highlander · Munchkin ·
rwegian Forest · British Shorthair · Ukrai
anx · Cymric · Devon Rex · Brazilian Sh
gean · Egyptian Mau · Siamese · German
Khaomanee · Ojos Azules · American Po
Shorthair · Maine Coon · Russian Black
ger · Minskin · Bombay · Singapura · Turk
Bobtail · Cornish Rex · Burmese · Persian
ifornia Spangled · Russian Blue · Scottish
aPerm · Somali · Tonkinese · Peterbald ·
Alley Cat · Sphynx · Abyssinian · Kora
· Dwelf · Savannah · Balinese · Ragdoll
y · Chantilly-Tiffany · Serengeti · Chartre
hausie · Thai · Oriental Shorthair · Birma
vana · Himalayan · Japanese Bobtail · H
l · Napoleon · Bengal · American Shorth
and Tabby · Selkirk Rex · Oriental Long
· Nebelung · Mekong Bobtail · Ocicat · A
y · Pixie-Bob · Kurilian Bobtail · Snowsh

Abyssinian · Korat · Dragon Li · Tigh
Balinese · Ragdoll · Norwegian Forest · Br
rengeti · Chartreux · Manx · Cymric · De
horthair · Birman · Aegean · Egyptian M
se Bobtail · Bambino · Khaomanee · Ojos
an Shorthair · Exotic Shorthair · Maine
Oriental Longhair · Toyger · Minskin · Bon
· Ocicat · American Bobtail · Cornish R
btail · Snowshoe · California Spangled ·
Siberian · Sokoke · LaPerm · Somali · T
ir · Turkish Angora · Alley Cat · Sphyn
kin · American Curl · Dwelf · Savannah
ir · Ukrainian Levkoy · Chantilly-Tiffany
Brazilian Shorthair · Chausie · Thai · Orie
e · German Rex · Havana · Himalayan
· American Polydactyl · Napoleon · Beng
Russian Black, White, and Tabby · Selkir
ngapura · Turkish Van · Nebelung · Mekon
ese · Persian · Donskoy · Pixie-Bob · Kuri